D1243361

Ex Libris

A GOOD BOOK IS LIKE A FRIEND I WOULD FOREVER KEEP

Bob Ough

8253 © APCo

# PAINTING
## WITH
# ACRYLICS

# PAINTING
## WITH
# ACRYLICS

*27 acrylics painting projects, illustrated step-by-step
with advice on materials and techniques*

### Jenny Rodwell

NEW
BURLINGTON
BOOKS

A QED Book

Exclusive to Coles in Canada

Published by New Burlington Books
6 Blundell Street, London N7

ISBN 0 906286 52 2

This book was designed and produced by
QED Publishing Ltd
The Old Brewery, 6 Blundell Street, London N7 9BH

Senior Editor  Sandy Shepherd
Art Editor  Marnie Searchwell

Editors  Hazel Harrison, Eleanor Van Zandt
Assistant Editors  Polly Powell, Rachel Huckstep

Design  Hazel Edington
Design Assistant  Ursula Dawson

Photographers  David Burch, Ian Howes
Photography  coordinated by Rob Norridge

Paste-up  Ian Wallace

Art Director  Alastair Campbell
Editorial Director  Jim Miles

Typeset by QV Typesetting Ltd
Color origination by Universal Color Scanning Ltd,
Hong Kong
Printed by Leefung-Asco Printers Ltd, Hong Kong

# CONTENTS

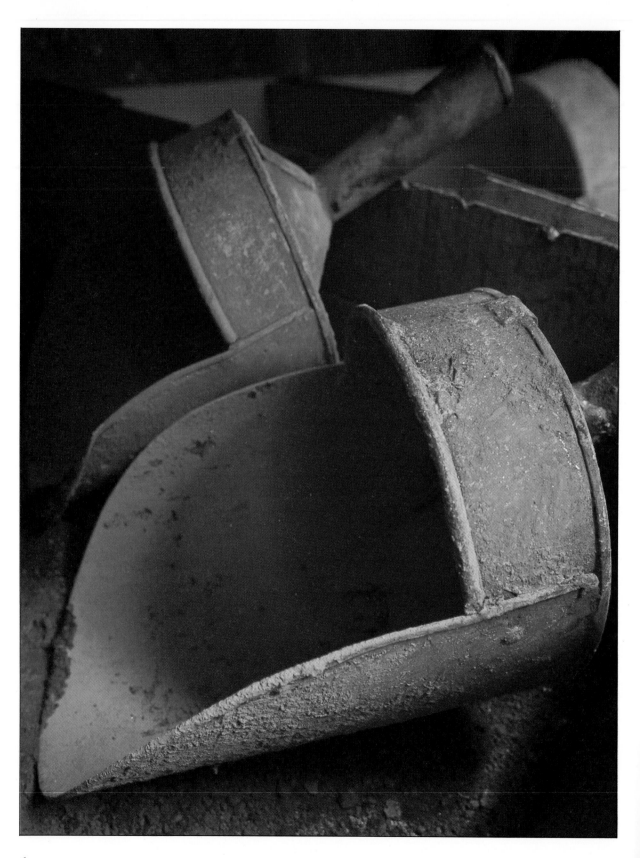

CHAPTER ONE

# THE
# STORY
## OF
# ACRYLICS

Artists, like builders, have been using the same basic materials for centuries. The oil paint mixed on the palette of Jan van Eyck to paint the Ghent Altarpiece, for example, was essentially the same as that used by oil painters in modern times. But in recent decades, a revolution in artists' materials has taken place. Artists had been working with the same materials since the development of oil paint in the early fifteenth century until, less than 50 years ago, acrylic arrived on the art scene. This new and versatile paint was based on a synthetic resin, which was invented by a science with the grand technical name of 'polymer chemistry', which had produced other, similar, resins to make a host of everyday products, including polyethylene kitchen equipment and vinyl clothing. This resin is one of hundreds, of which the paint industry uses just a few.

*Left*, metal scoops are used for the pigment powders, each color being kept strictly separate. These scoops here are reserved for cobalt blue.

All paints are made from a pigment mixed with some kind of adhesive. The pigments, or actual colors, are basically the same for all artists' materials — it is the nature of the adhesive which makes the difference. For instance, the adhesive can be water-soluble glue, as in watercolor; a drying oil, such as linseed, in oil paints; or even egg, as in egg tempera. The difference between acrylics and other paints lies in the synthetic adhesive which binds the color.

It is the nature of this resin adhesive which makes acrylic the most durable and versatile of all artists' paint. Once dry, the paint effectively becomes a plastic coating which is virtually indestructible and which can be used on almost any surface.

## ACRYLICS IN THE MAKING

Acrylic paint is made by mixing powdered pigment with acrylic adhesive. The adhesive looks milky when wet but becomes transparent when dry, revealing the true color of the pigment. In factories where the paint is made you can see the enormous vats of this raw, jellylike substance before the enhancing color is added, being wheeled to and from the mills and mixing machines which eventually produce the finished paint.

All the ingredients are carefully weighed and tested before use. It is this painstaking precision and control during the manufacture which enables thousands of tubes of paint of almost identical color, consistency and quality to be turned out at any time.

The pigment is brought in vast quantities from all over the world. Some colors, such as the siennas and umbers, are dug out of the ground; others, like cobalt blue, are mineral pigments; and some pigments come from plants and animals. But many more colors, such as naphthol crimson and diozine purple, are created in the laboratory by scientists and are as new to the world of art as acrylics are themselves.

Pigments, often strikingly beautiful in their raw state, come to the factory as powder. As with the other raw materials, each color is scrutinized and tested before being used in the paint.

Not all the pigments used by painters of the past are suitable today for making acrylics. Some of the traditional ones, such as alizarin crimson, are incompatible with the synthetic resin and tend to curdle.

Acrylic paint is mixed thoroughly in large quantities to obtain the consistent color and quality necessary for artists *right* and *below.* The paint is milled between steel rollers, *bottom,* and the finished product examined and tested to insure that a fine, flawless paint is produced, *bottom right,* ready to put in tubes, *bottom center,* and distribute to stores .

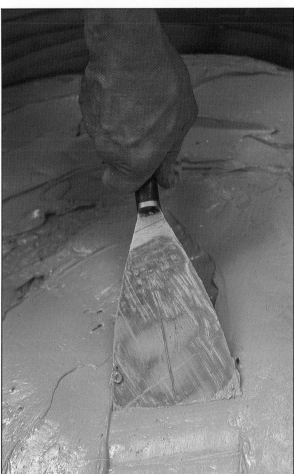

In such cases an alternative organic pigment, one which can be mixed with the resin, is used instead.

There are other pigments which will not mix quite as densely with the resin as would be ideal. Cadmium red and cerulean blue are two such pigments, and in both these cases the acrylic colors are weaker and less saturated than their oil counterparts.

Acrylic enjoys a reputation as the most hardwearing and weather resistant of all artists' paints — a reputation which depends on certain essential ingredients. The mixture of resin and pigment includes a preservative to prevent deterioration; an anti-freeze to stop the tubes from freezing up in cold weather; a thickening material to give the acrylic a consistency similar to that of oil paint; and, finally, a wetting agent to stabilize the paint and disperse the pigment evenly in the resin.

To obtain the extremely fine texture of the finished paint the ingredients are ground thoroughly in special mills. Unlike oil paint, which is traditionally ground between heavy granite rollers, the more modern acrylic is milled on steel rollers. Suitably 'hi-tech' steel is used for every acrylic color — except one. Primrose yellow suffers badly from the 'graying' effect of the metal and, like oil paint, has to be milled on granite.

By this milling process each minute particle of pigment is coated with a film of plastic. The rather milky quality of the resin emulsion that is used in the manufacturing stages disappears as the water evaporates, leaving the plastic coating as clear as any truly transparent plastic, such as Lucite.

Thus is an almost ideal paint made. This coating of each tiny particle of pigment with a practically indestructible layer of transparent plastic gives us pure color which will not rot, discolor or crack and has few of the faults and drawbacks found in more traditional artists' colors.

THE PIONEERS

An American firm, Rohm and Haas, first started to experiment with synthetic resin in the 1920s. The following decade saw it being used for making small items such as false teeth and the heels of shoes.

These early acrylics, or polymers, were eventually developed as a base for house paints, replacing the old fashioned distemper. Such house paints were found in

pastel colors only because the resin emulsions used at that time could not absorb much pigment without solidifying. This form of paint was therefore of little use to the artist. Yet it was becoming more and more necessary to find a resin which would provide a suitable base for acrylic color for painters, one which would not crack or discolor and was, above all, resistant to weather and atmospheric extremes.

As far back as the 1920s a group of mural painters in Latin America, mainly Mexico, had planned large murals for public buildings. These artists, notably David Alfaro Siqueiros (1896-1974), José Orozco (1883-1949), and Diego Rivera (1886-1957), were acutely aware of the inability of oil paints and frescos to stand up to outdoor weather conditions and were eager to help any research which would solve their problem. They realized that their solution lay in synthetic resin, already being used in industry with such success, and by the mid-1930s Siqueiros' workshop in New York was experimenting with new paint formulas. Artists and scientists worked together to further mutual interests, and so acrylic painting was born.

It was not, however, until after World War II that manufacturers of artists' materials began to put their minds seriously to making a paint based on the new resin. The first company to make a form of acrylic paint with enough saturated color to be useful in the design field was the American firm 'Permanent Pigments'. Their product was called 'Liquitex', a resin emulsion of the same consistency as poster color. This product was readily taken up by designers and its reputation quickly spread to the fine arts.

The initial problems of hardening which occurred when the resin was mixed with too much pigment, did not vanish overnight. In these early days, many companies ran into great difficulties when they first started to produce the new paint, and the slightest over-loading of a pigment would quickly cause the paint to

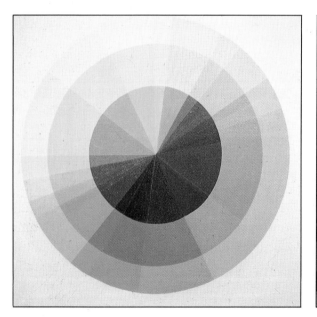

*Interpretation of Seurat's Color Wheel* by Bridget Riley (b1931). The painting is one of many commissioned by Rowney to test the quality of their acrylic range. Strong colors at the center of the wheel are extended to show a whole range of subtle pastel shades.

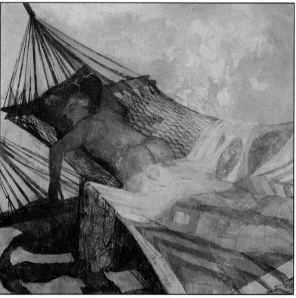

*Girl Lying in a Hammock* by Leonard Rosoman. In this Rowney 'test painting' the artist used layers of brilliant colored glazes to build up the image. The painting shows this acrylic technique at its best.

become unusable.

## ACRYLICS FOR ALL

By the 1950s acrylic paints were on sale in the United States and warmly welcomed by many young painters who were eager to experiment with the new color, notably the many abstract and Pop artists working at that time. By the 1960s the new colors were also available and widely used in Europe.

Here was a paint which had almost the same range of colors as oil paint. It could be used outdoors because, being made of tough plastic, it was resilient enough to stand up to harsh weather conditions. As far as the scientists could tell after such a short time the colors did not fade and, more important, the paint appeared to be imperishable. Acrylic could be used thickly or thinly, depending on the effect required, and was also quick-drying.

This last quality was a godsend to painters who used heavy impasto, and it opened up new vistas for many, including Jackson Pollock (1912-56), an Abstract Expressionist. Pollock could now use acrylic color straight from the tube (or poured from a bucket), building up thick layers of paint with impunity, knowing that they would dry in a matter of hours or days — their oil paint equivalent would have taken years.

However, it was this quick-drying characteristic which also caused other painters to dislike the new medium because they found it difficult to handle. Used to working in oils, which can be changed and moved around the canvas for several hours before they dry, they found the plastic paints uncompromising and unworkable. Today there are various retarding agents and even a special palette which slow down the drying process, but artists still find the softer, more pliable technique of oil painting irreplaceable.

## THE NEW ART

When Pollock said in 1951 'My painting is direct. . . The method of painting is the general growth out of the need. . . I cannot control the flow of paint. . .' he was putting into words the ideas of many artists in the Abstract Expressionist movement, ideas which were made more practicable with the advent of acrylic. It enabled them to use color freely and quickly, with no thought for anything except the work in hand. Not only were they relieved of the burden of the technical limitations of the paint, but they could also stop worrying about how long it would take their pictures to dry.

One of the great advantages of acrylics was that it could be used directly on raw canvas. With oils it had always been necessary to size and prime the canvas before starting work to prevent the oil in the paint from eventually rotting the canvas. To some extent the sizing and priming dictated the final surface texture of the picture. But some painters — such as the American abstract painter Helen Frankenthaler (b1928) — were more concerned with the immediate effect of oils than the long-term one and used oil color directly on untreated canvas despite the fact that the finished work would probably enjoy a comparatively short life.

With acrylic paint no such preliminaries were necessary and it was quite possible to brush the color straight onto the raw canvas without risk of the paint harming the fabric. This meant that the canvas texture — the weave of the fabric — could be used as an integral part of the picture.

The American painter Morris Louis (1912-62) was among the first to take advantage of this useful property of the new paint. As early as 1953 he was experimenting with acrylics to achieve the transparent, overlapping shapes characteristic of his large abstract paintings. By using thin, transparent washes he was able to 'stain' the raw canvas, laying one wash over another without losing either the brilliance or the transparency of the colors.

Louis was considerably influenced by Helen Frankenthaler. Both artists used flat washes directly on the canvas and both relied on the absorbent, softening quality of the unprimed support to obtain subtle, translucent colors. Frankenthaler's oils are composed of areas of single color, and any attempt to overlay the washes would have resulted in the paint becoming opaque. But Louis, working in acrylics, was able to exploit the sheer nature of the diluted colors and, in overlaying the washes, retained the clear brilliance of each separate pigment.

The advent of acrylics was an important factor in the development not only of Abstract Expressionism but also of American abstract painting as a whole at that time, and crucial to the techniques of artists of other styles.

Mark Rothko (1903-70), Kenneth Noland (b1929), and Robert Motherwell (b1913) all used acrylic color in work dating from this period, although in very different ways.

Motherwell used the paint freely, putting it on the canvas with strong, emphatic brushstrokes in the Abstract Expressionist tradition. His contemporaries applied the color in a more considered manner, the huge stained canvases of Mark Rothko contrasting strongly with the flat areas of even color which characterize the work of Kenneth Noland. This 'considered' approach became increasingly prevalent as the 1960s reacted against the subjective, 'messy' art of the Abstract Expressionists. This decade produced painters who had a more reflective attitude to their work. Pop art, Op art, 'Hard Edge' and the new Realism replaced the frenzied scrawl of Jackson Pollock and other Abstract Expressionists. These painters were more formal, more impersonal, and the new synthetic colors of acrylic paint were ideally suited to the new art.

Frank Stella (b1936) was a close associate of Pollock, Rothko and other American artists of the time but was one of many painters who adopted the 'Hard Edge' style — a style which started in America and soon became popular throughout Europe. These paintings have a structure and geometry which marked the beginning of a new era in American art. Like other artists of the time, Stella experimented with different techniques and materials, including acrylics, car paint, enamel and various commercial and industrial paints, but his knowledge and choice of materials were influenced by time spent as an interior decorator. The rigid composition of Stella's paintings depended on the absolute straightness and accuracy of the painted lines. He usually painted directly onto the unprimed support, allowing the neutral color of the canvas to separate the strips of color. To create the hard, straight edges, Stella used masking tape, brushing the acrylic paint into the masked-off areas of canvas. Acrylic paints were ideal for work of this kind because they dried quickly.

Outside the United States, in the late 1960s, artists were trying out for themselves what many American painters were already familiar with. The British artist

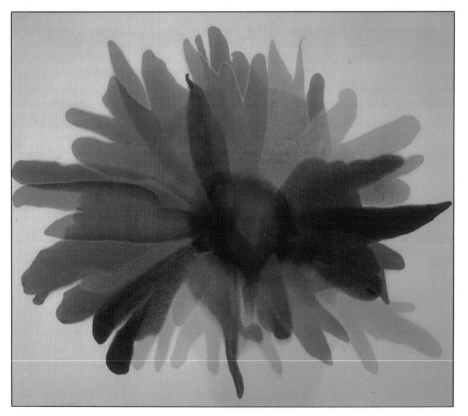

*Spawn* by Morris Louis (b1912), *left.* Louis, one of the first artists to experiment with acrylics, was painting with the new medium as early as the 1940s. In this painting the diluted color was applied directly onto unprimed canvas, producing the 'stained' effect which is now synonymous with his work.

*Marilyn Diptych* by Andy Warhol (b1930) *right.* In this painting (completed in 1962) Warhol combined modern techniques and materials (silkscreen painting and acrylic paint) with the traditional genre of portrait painting in this work. In the lefthand panel, the silkscreen image was applied on top of areas of stenciled acrylic color.

Bridget Riley (b1931), for example, a major exponent of Op, or 'optical', art began using acrylics at around this time. Her work, like Stella's, depended on technical accuracy for its success and she too used masking tape to create areas of flat paint, occasionally diluting the color to obtain subtle changes of tone and shade. Detail and finish were crucial to Riley's work, because much of the effect of Op art depended on optical illusions created by perfectly formed, flat shapes.

On both sides of the Atlantic, 'Pop' art, based on mass media images, advertising slogans and other artifacts of the 1960s 'pop' culture, was produced by artists as diverse in style and choice of subject matter as Peter Blake (b1932) and Eduardo Paolozzi (b1924) in Britain, and Roy Lichtenstein (b1923) and Andy Warhol (b1930) in America.

The 'Pop' movement was the product of a particular era and reflected the tastes and imagery of that time. Its artists were not all painters – Pop art influenced music, photography, graphics and sculpture, and also included many of the 'happenings' and 'environments' which young artists were involved in at that time.

In art the range of materials used was infinitely wide, and items of everyday life often found their way into a work of art. Plastics were particularly popular, either as sheets specially molded for a particular purpose or in the form of household items removed from their normal setting and put in a new context.

Acrylic colors, synthetically made and plastic-based, were very much in the spirit of the Pop movement. The flat, instant color was adopted by most of the painters, and was used in Lichtenstein's comic strips and Warhol's portraits, among many other works.

Many figurative painters moved away from oils at that time and began to work in acrylics. Oil paint may have been easier to manipulate – colors could be blended and 'chiaroscuro' effects could be obtained quite easily with the slow-drying oils – but acrylics had other advantages.

David Hockney (b1937) found that being able to divide the picture into large, geometric areas of flat color at the first stage of a painting gave him a new freedom.

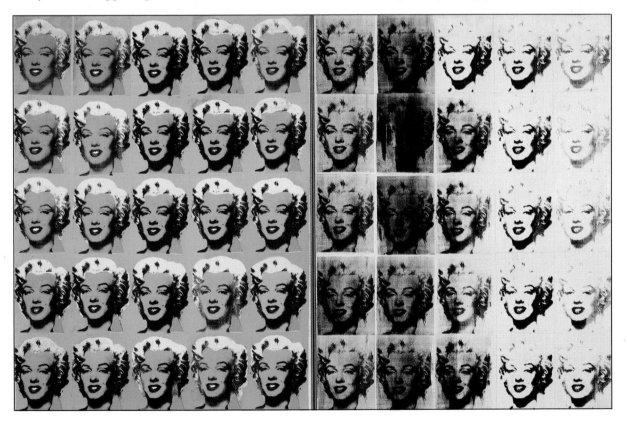

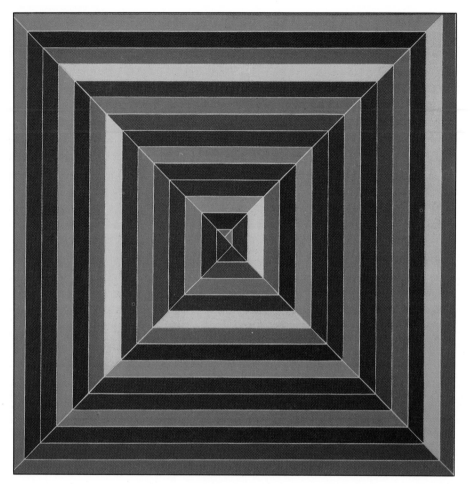

*Hyena Stomp* by Frank Stella (b1936), *left.* The precise geometry of this painting is achieved by exact measurement and the use of masking tape to obtain hard mechanical edges on the stripes. Stella used flat, opaque paint, relying on the color sequence and spiral structure of the composition to create an illusion of space in the painting.

*Whaam!* by Roy Lichtenstein (b1923), *right.* This enlarged comicstrip was painted in magna, an alkyd-based acrylic which is soluble in spirit and turpentine. Unlike hard-edge painting, with which many artists were involved at this time (*Whaam!* was painted in 1962), much of Lichtenstein's imagery is drawn and painted free-hand.

Because the initial color dried instantly, the detail, texture and rendering could be applied systematically and separately almost immediately.

It is interesting to note that Hockney made the transition from oil to acrylic when he went to California in 1964. The scenery on the West Coast was less cosy and compact than that of Europe, and the cloudless skies, vivid light and intense heat encouraged him to look for new ways of capturing these characteristics. His search led him to Liquitex and its extensive range of bright, new acrylic colors

An ultra-realistic approach to figurative painting was also prevalent in the 1960s. This was often referred to as 'Photorealism' because the technical competence of many of the artists made the paintings look like actual photographs. Some of this work was done in the traditional manner, with brushes, but often the artists used an airbrush to spray color onto the support in fine, graded layers.

Acrylic paint could be used in airbrushes in the same way as oils, watercolor and gouache could. The resulting highly finished, slick image was as popular with fine artists as with the many illustrators and graphic designers who still use airbrushing when this particular effect is required.

## THE FUTURE

One manufacturer of artists' materials has estimated that the proportion of painters using acrylics in America is 60 percent, as opposed to oils and other media. In Europe it is considerably less — in England it is probably not more than 25 percent, and elsewhere in Europe the estimated proportion is around 10-15 percent, although in art schools the percentage of painters using acrylics is

thought to be very much higher.

While these statistics are undeniably interesting as an indication of how quickly acrylic has established itself in the field of fine art, they should not be viewed as the results of a race. There is a mistaken belief that acrylics are somehow in competition with oil paints. This is a pity because the two media are actually very different and acrylic is at its best when treated as a medium in its own right, rather than when it is trying to imitate another kind of paint.

There is an increasing demand for plastic-based paints in schools and colleges where speed, cost and convenience are of the essence. An inexpensive substitute for real acrylic is paint made from the cheaper PVA (polyvinyl acetate) resins. These PVA paints are the equivalent of the 'student' range of oil and watercolor paints, and are generally made from less expensive pigments.

It is important to realize that there is nothing 'second best' about acrylic. In some ways it is similar to oils, gouache and watercolor — and it is often possible to use the same painting techniques when using acrylic as you would use with other paints — but it is very much a medium of worth on its own. It is permanent, versatile, and modern and has many uses — for most purposes it is incomparable.

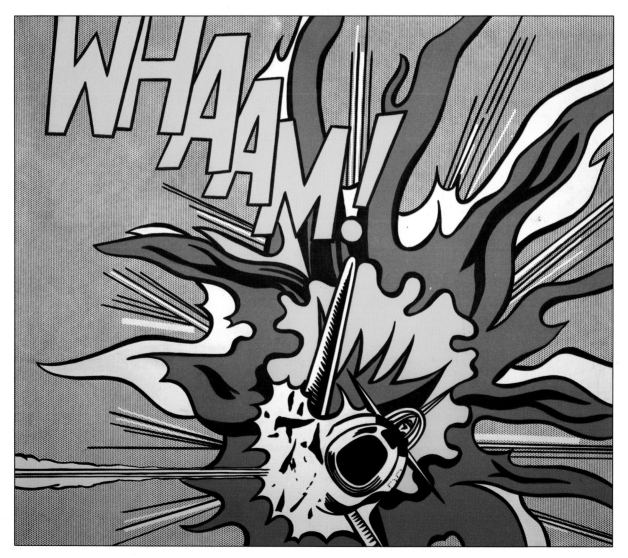

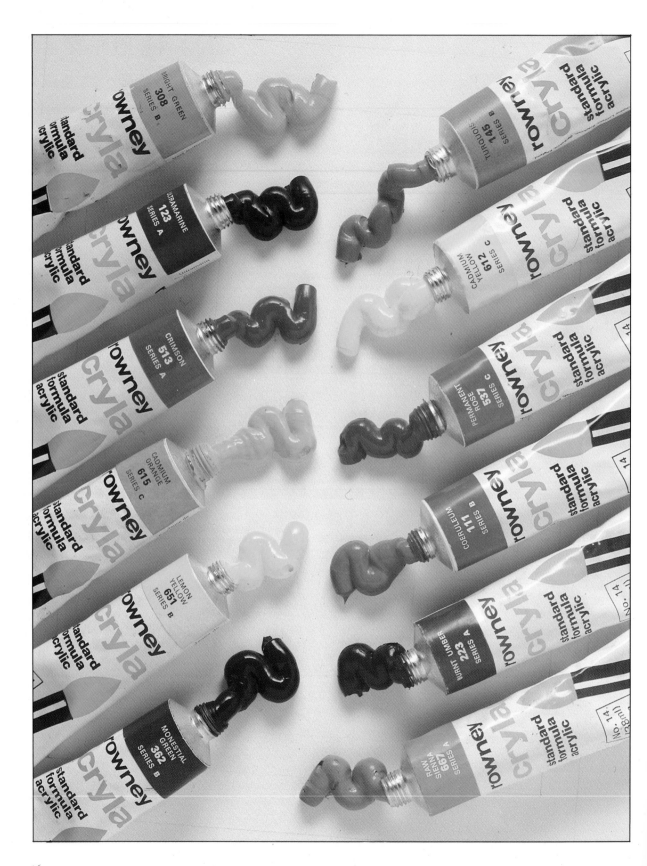

BRIGHT GREEN
308
SERIES B

'owney

standard
formula
acrylic

cryla

ULTRAMARINE
123
SERIES A

'owney

standard
formula
acrylic

CRIMSON
513
SERIES A

owney

standard
formula
acrylic

cryla

CADMIUM
ORANGE
615
SERIES C

owney

standard
formula
acrylic

LEMON
YELLOW
651
SERIES B

owney

standard
formula
acrylic

cryla

MONESTIAL
GREEN
362
SERIES B

owney

cryla

standard
formula
acrylic

TURQUOISE
145
SERIES B

owney

cryla

standard
formula
acrylic

CADMIUM
YELLOW
612
SERIES C

owney

cryla

standard
formula
acrylic

PERMANENT
ROSE
537
SERIES C

owney

cryla

standard
formula
acrylic

COERULEUM
111
SERIES B

owney

cryla

standard
formula
acrylic

14

BURNT UMBER
223
SERIES A

owney

cryla

standard
formula
acrylic

No. 14

RAW
SIENNA
667
SERIES A

owney

cryla

standard
formula
acrylic

No. 14. (38ml)

# MATERIALS

The equipment for painting with acrylics is not complicated. All you actually need are a few tubes of paint, a brush, something to paint on and a jar of water. You will probably, however, soon find this selection limited and will want to extend your choice of materials as you become more proficient in the medium. This chapter covers the whole range of tools and materials available, but we are not suggesting that you should rush out and buy every item before starting work. It is far better to begin with a few essential pieces of equipment and a limited range of colors, adding to these gradually as your needs arise from experience and increased confidence, than to make a large and often unnecessary investment in the early stages.

---

The most convenient way of buying acrylic color is in tubes, *left*; large quantities are available in plastic jars.

---

Very little 'specialist' equipment is required for acrylics and, apart from the paints themselves and the various mediums which are mixed with the paint for particular effects, most of the tools needed for acrylic painting are the same as those used with other types of paint.

## WHERE SHALL I PAINT?

The first question which arises is where to work. For those lucky enough to have a studio or a room which can be set aside especially for painting there is no problem. Otherwise, space must be found elsewhere in the home.

If you expect a picture to take a few days to finish, obviously you need to work in a place where it will not be necessary to dismantle your easel or subject every evening. Nor do you want to be painting in a place where there is a constant stream of people to distract your attention.

Whichever position you choose, it is a good idea to protect surrounding floors and furniture from spills and splashes of paint. Because acrylic is water-based it is easy to wipe up when wet, but if you allow it to dry you will discover exactly how permanent the color is. So be prepared and always have a damp cloth close at hand in case of such accidents.

Dried acrylic is virtually impossible to remove from fabrics; it is therefore best to wear an old shirt or smock when painting. If you are a particularly flamboyant painter it might be advisable to wear old shoes and a hat as well!

## PAINTS

Almost every manufacturer of artists' materials now produces its own brand of acrylic paint. Among the best known are the American products Liquitex, Aquatec and Grumbacher's Hyplar range. Rowney, Reeves and Winsor and Newton all make a range of acrylic colors in Britain, and the Dutch manufacturer Talens has its own widely available acrylic paints.

The thickness of the paint varies from brand to brand, but generally the consistency is similar to that of oil or gouache. Rowney's Cryla series, however, is available in two forms – the normal 'Standard Formula' and the slightly runnier 'Flow Formula'. The softly textured 'Flow Formula' is specially designed for covering large flat areas as required by many abstract and 'hard edge' painters.

Almost all acrylic paints can be mixed with water before use in exactly the same way that oil paint is used with turpentine or mineral spirits. The pigments used in acrylics are the same as those used in other types of paint, although the names on the actual tubes may be unfamiliar. Acrylic colors sometimes have highly technical labels, but when one realizes that phthalocyanine blue is actually Monestial blue with a new name, the color somehow seems less intimidating!

Acrylic comes in broadly the same colors as oil paint or watercolor, with the exception of a few pigments which do not mix readily with the synthetic resin. One of the notable omissions from the color range is alizarin crimson. The colors come in tubes, jars, and economy-size plastic containers holding half a gallon or more.

## ALKYDS

It should perhaps be mentioned that there is a particular

CANVAS BOARD     DALER BOARD     PRIMED PAPER

category of acrylic paints which are not water-based. Known as the 'alkyd' colors — in U.S. they are sold under the brand name 'Magna' — they are technically an acrylic product but are soluble in turpentine, not water.

Alkyds are similar to oil paint, and can be mixed with oils. They dry at a consistent rate, normally remaining moist throughout a single painting session and then drying overnight. Any supports suitable for oil or acrylic can also be used with alkyds and primed with either oil or acrylic primer.

Alkyds are especially useful for design work, when a waterproof finish and a hard edge are required; for direct painting, where the artist is working quickly and wants to complete a picture in a day; and in glazing, scumbling and drybrush techniques, where a specific effect is required in a particular area. But, like normal acrylics, alkyds are not easy to manipulate slowly to create an image by moving the color around on the support. Nor are they suitable for the traditional 'blending' method of painting normally associated with oil paints.

Alkyd-based mediums, which are also used with oil paints, are essential to make the paint fluid and easier to handle. Particularly useful are a 'flow improver' and various texture makers, including a thick paste for building up impasto effects.

## PVA COLORS

PVA colors are cheaper than real acrylics because they are made with less expensive pigments. The colors, therefore, are less permanent and reliable. Even so, PVA has all the hardwearing and quick-drying advantages of acrylic, and both paints are made with synthetic resin — PVA paint with polyvinyl acetate resin and acrylic with acrylic resin. PVA colors are used in exactly the same way as acrylics.

## VINYLS

Cheap vinyl colors, marketed in larger quantities than real acrylic paint, are sold specially for use on large areas, such as for murals and decorative friezes. The color range is fairly restricted and the pigment of a poorer quality, but they do have certain advantages in common with acrylic paints: vinyls are quick-drying; they are water-soluble when wet, yet insoluble once dry; they are flexible and can therefore be used on fabric and paper without risk of cracking or wrinkling; the color does not yellow with age, as does oil paint; and the paint is adhesive and can be used with the various acrylic mediums. Vinyl can be used on any support which is suitable for acrylic and, like acrylic, will not adhere to an oily or greasy surface.

## SUPPORTS

Finding 'something to paint on' is not usually a problem when using acrylics because you can work on almost any surface you choose. Canvas, hardboard and paper are the choices that come immediately to mind, but there is a surprising variety of more unusual supports which are just as suitable. Wood, metal, plastic and various fabrics have all been used successfully with acrylics, and it is this versatility which has made the paint so popular with so many artists. Nor is acrylic color used exclusively by painters. Many modern sculptors find it compatible with contemporary modeling materials such as fiberglass and polystyrene, and acrylics often provide the final coat of color to a piece of sculpture or mixed media work.

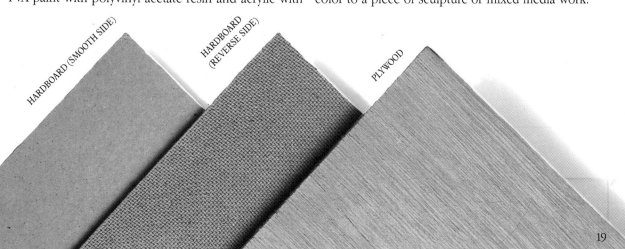

HARDBOARD (SMOOTH SIDE)

HARDBOARD (REVERSE SIDE)

PLYWOOD

There is one important thing to remember, however, when you are choosing a painting surface — acrylics will not adhere to any surface that contains oil or wax. This fact rules out all canvas and board which has been prepared for oil paint. Of course you can buy special painting surfaces, and these are fine, but if you use acrylic paint on a surface prepared for oils, sooner or later the paint will come off.

Very shiny surfaces can also cause problems. Many artists do use acrylic on metal, plastic and glass, but the color can sometimes be scratched or peeled off. It is therefore a good idea to roughen the surface before applying the paint. If you have ever cleaned an acrylic palette, for instance, you will know that it is quite possible to peel or scratch dried paint off a smooth, plastic surface, however difficult and time-consuming this may be. A quick 'roughening' with sandpaper will provide the support with a 'key' for the paint to adhere to, insuring that the color remains intact.

## BOUGHT SURFACES

Primed boards, canvases and muslin-covered supports are available from art shops. Many of these are primed specially for acrylic paints, and care should be taken not to buy those which are prepared for oils only. The linseed oil in these repels acrylic color and the paint will eventually come away from the surface of the support.

Bought surfaces are quick and convenient, especially if you prefer to work on a fairly small scale. But the sizes and shapes of ready-made supports are limited and they are by far the most expensive type of painting surface. A good alternative is to buy acrylic primed canvas off the roll. Art shops sell this by the yard, often in a choice of two thicknesses. The heavier quality is recommended for large-scale works and murals.

## INEXPENSIVE SURFACES

There are a number of perfectly satisfactory surfaces which are both quick to make and inexpensive. For inexperienced painters who are new to the medium they are particularly valuable since it can be both costly and intimidating to start each picture on a canvas which has been specially bought or stretched for the purpose.

One of the best of these is hardboard,(also called Masonite). Many professional painters actually prefer

this to canvas, and it is certainly worth trying. Most artists paint on the smooth side of the board, but there is no reason why you cannot use the reverse side if you prefer a rough texture. Large pieces of hardboard tend to be unwieldy unless they are battened from behind to stop them from bending. They can be primed with acrylic gesso if you prefer a white support, or you can seal the surface with acrylic medium, thus preserving the natural color.

Acrylic medium can be used to stick muslin, scrim or any other fabric to a rigid surface such as hardboard or wooden paneling. This produces a texture similar to stretched canvas, which can also be treated with acrylic gesso or one of the transparent mediums.

Cardboard and stiff paper are perfectly suitable for acrylics, treated or otherwise; if you are using diluted acrylics to achieve a watercolor effect, it is advisable to stretch the paper first to prevent wrinkling. This can be done by soaking a good quality watercolor paper and sticking it to a drawing board with gummed paper tape. Allow a good margin of tape to cover both the paper edge and the drawing board. The paper should be allowed to dry naturally before it is used for painting.

## STRETCHING YOUR OWN CANVAS

Stretching and preparing your own canvases can be fun and it is certainly the best way of making absolutely sure that your support fits your personal requirements.

You will need a wooden frame, or stretcher, and a length of canvas to cover it. The canvas can be attached to the wood with tacks or staples. The best way to make a stretcher is to buy the wooden sides and fit them together. These stretcher pieces are sold in most art shops and come in different lengths, giving you a choice in the size and proportion of your support. Make sure the shop gives you eight 'wedges' for every stretcher you intend to make. When the stretcher pieces are slotted together, these tiny wooden pieces fit into the corners and can be adjusted to keep the fabric taut.

There is a wide variety of canvas fabrics to choose from. Most of these fit into one of two categories — cotton or linen. Linen is generally the best, but it is also the most expensive. It is often handmade and has a fine, slightly irregular weave which makes it both easy and

**1** Slot the wooden stretchers together. Check that the corners are at right angles by measuring the diagonals – these should be equal.

**2** Cut the canvas to fit the stretcher, allowing a margin of 2-3in all round for stapling.

**3** Starting in the middle of the longest side, fold the canvas over and staple it to the reverse side of the wooden stretcher.

**4** Staple the canvas every 3in from the center point to the first corner. Do the same on the opposite side. Repeat until all sides are fixed. Turn the corners diagonally.

**5** Make the corners by folding one edge neatly over the other, then staple the corner diagonally, fixing both edges firmly in position.

**6** Tap the wooden corner wedges into place – the fabric should be tight but not taut. The canvas is now ready for priming with acrylic primer or acrylic medium.

interesting to paint on. Cotton is softer and bulkier with a regular, machine-made texture. It is lighter in color than the linens and usually less taut when stretched and primed. Both linen and cotton come in different weights.

If you prefer to paint on a surface which has a particular texture or color, you might wish to experiment with other fabrics. Embroidery linen and unbleached muslin, for example, are relatively smooth; hessian and flax both have a coarse, open weave.

SEALING WITH ACRYLIC MEDIUM

An ideal surface for acrylic paints is one which is slightly porous, absorbent enough to provide a 'key' for the paint to adhere to, yet not so porous that it becomes difficult to apply the paint. A support or surface which is too absorbent can normally be given a coat of acrylic medium to seal it. The medium leaves tiny pores which provide sufficient 'key' to allow the paint to cling to the sealed surface.

Supports can be sealed with a gloss or matte medium depending on the type of surface required. Both are colorless and therefore especially useful when you are particularly anxious to preserve the color of the support – cardboard or tinted paper, for instance, would be ideal supports if you wanted to incorporate their color into your picture. If the medium is applied thinly it will not spoil or obliterate the texture of the surface.

PRIMING WITH ACRYLIC GESSO

For a brilliant painting surface specially designed for use with acrylic paints, use acrylic gesso. Also called acrylic primer, this luminously bright undercoat brings out the vividness of the paint, enhancing the color and giving added translucence to thin washes.

Unlike traditional gesso, acrylic gesso is very flexible and can be used on canvas without risk of its cracking or chipping. Acrylic gesso is a mixture of medium and white pigment and comes in jars ready to use. Like acrylic medium, it does not affect the texture of the support if applied thinly. It can also be used on wood, paper and almost any other surface, provided that it is free of oil or wax.

If you use a brush to apply the gesso it may be necessary to add a little water. You will probably need

two coats of gesso to get a really even surface. Use a stiff decorator's brush to work it into the canvas weave.

An alternative method of putting gesso onto canvas is to use a putty knife. Starting from the center, add a little gesso at a time and spread it outward with a fairly wide putty knife. The mixture should be forced gently into the weave of the canvas, any excess being scraped off and applied elsewhere. The knife should be held at an oblique angle to prevent the sharp edge from cutting.

## ACRYLIC MEDIUMS

Used on their own acrylics are opaque and dry with a rather dull finish. There are, however, various substances which can be added to change the character of the paint and produce a range of different effects and finishes.

These substances, known as acrylic mediums, are generally mixed with the wet paint before it is applied to the picture, although one or two of them can also be used to protect or varnish the surface of the finished painting. The mediums look white and opaque until they dry, when they become completely transparent.

## GLOSS MEDIUM

When mixed with gloss medium, acrylic becomes slightly more fluid. This makes the paint easier to brush on, but otherwise there is no noticeable difference to the paint until the color has dried, when the medium gives it a soft, shiny finish. The more water you use with the medium, the less glossy the final shine will be. Because it dries absolutely clear, the medium makes the colors appear more transparent, and it is often used when one color needs to be seen underneath another.

Many artists use gloss medium as a varnish to protect the completed painting and to give it a shiny finish, but if you have used the medium with the paint as you worked, your picture probably won't need this final coat.

Gloss medium is adhesive and is often used instead of glue in collage and other mixed media work.

## MATTE MEDIUM

When a gloss finish is not required, choose a matte medium instead. This can be used in exactly the same way as gloss, but gives a matte, non-reflective surface.

## GEL MEDIUM

A thick form of gloss medium is available in 'gel' form. The gel medium comes in a tube and is thicker than the paint itself. Because it thickens the paint, gel medium can be used for building up impasto effects and creating prominent, textured brushstrokes.

## TEXTURE PASTE

If you want to make your colors really thick, use texture paste. Sometimes called modeling medium, texture paste is made from a basic acrylic medium with added filler.

The paste can be applied to the support with a brush or painting knife to build up an impasto texture before you start painting. While this is undoubtedly a useful means of enlivening the surface, it can be overdone, so use texture paste sparingly at first and avoid landing yourself with an overtextured painting surface which will eventually dominate the whole picture.

Texture paste can be built up to form a relief which is more akin to sculpture than painting. It should be remembered, however, that the paste must be applied in layers, each one being allowed to dry before the next is added. If the layers are too thick, the outside dries more quickly than the inside, and this can result in a cracked surface.

Its adhesive properties make texture paste ideal for collage, and quite heavy substances such as metal or glass can be stuck securely with it onto a rigid support. Imprints and patterns are often made by pressing objects into the paste or thickened paint while it is still wet, and a wide range of textures is possible by mixing different inert substances with the paste — sand, for instance, produces a rough, granular paint surface.

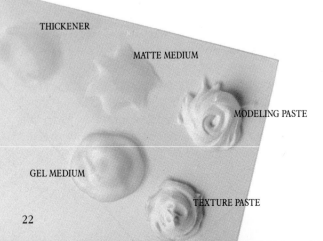

THICKENER

MATTE MEDIUM

MODELING PASTE

GEL MEDIUM

TEXTURE PASTE

Alternatively, the paste can be used like gloss or matte medium and mixed with each color before it is applied. It is very thick, so you should expect the extra texture to affect your style of painting quite radically. You will need to use bigger brushes and a painting knife to deal with the bulky paints.

## RETARDER

For those who find the quick-drying effects of acrylic difficult to cope with, a retarder could well be the answer. This is a transparent substance that slows down the drying time of the paint by several hours. It is only effective if you use the paint thickly — water affects its performance, so if you plan to dilute your colors a lot, retarder will be of little help.

## FLOW IMPROVERS AND TENSION BREAKERS

Various products can be bought to make the paint easier to apply. These are only really relevant when a large area of uniform surface color is required, and even then many artists feel they make only a slight difference.

## GLAZING MEDIUM

A special glazing medium can be used to make acrylic color more transparent, although other mediums are also available for this purpose. The glazing medium can be used on its own for overpainting prints and photographs in order to simulate brush marks.

## VARNISHES

It is not absolutely necessary to varnish your finished acrylic painting, although a protective coat is sometimes a good idea. Varnishing was traditionally used on oil paintings to preserve the surface, but acrylic paint is durable and can be washed with soap and water, hence eliminating the need for such stringent precautions. However, it should be mentioned that the surface of the picture can be enhanced by giving it a coat of medium or varnish, both of which come in either a gloss or matte finish. Other alternatives are a soluble varnish, removable with turpentine, or a coat of acrylic fixative, which gives a protective sheen to the picture surface.

## EASELS

Unless you are using thin washes of acrylic, any one of

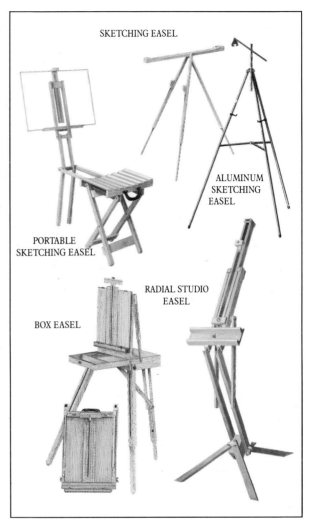

SKETCHING EASEL

ALUMINUM SKETCHING EASEL

PORTABLE SKETCHING EASEL

RADIAL STUDIO EASEL

BOX EASEL

the many available easels could suit your purpose. The final choice will depend on what size you normally work on, the type of support you paint on, whether you prefer sitting or standing and, of course, whether or not you need an easel which is portable.

If you use a lot of water with the paint, applying it in washes of thin, runny color, then an upright easel is not for you. An adjustable drawing board which tilts to any convenient angle could be the answer. Or, if you prefer something that can be folded up and carried around, an easel which adjusts to a horizontal position to prevent the paint from running off would be more suitable.

## BRUSHES

Any brushes used for oil or watercolor are also suitable

for acrylic paint. If you already have these brushes, it should not be necessary to go out and buy new ones specifically to use with acrylics. If your brushes were last used with oil paint, however, they must be very carefully cleaned to remove all traces of oil or turpentine from the bristles. These substances will not mix with acrylics and can react adversely with the paint.

If you are intending to invest in new brushes in any case, it is probably worthwhile considering buying nylon ones rather than the traditional bristle and sable. The new synthetic brushes are considered particularly appropriate for the synthetically based acrylic paint, and are generally thought to be stronger and better able to withstand the tough handling and cleaning demanded by acrylics.

## THE TRADITIONAL CHOICE
Oil painting brushes are normally made of bristle. The four basic types — round, flat, bright and filbert — are used with acrylics in exactly the same way as you would use them for painting in oils.

Round brushes are shaped like watercolor brushes, although, being made from bristle, they are stiffer and, like all oil painting brushes, have long handles so that you can stand back and assess your picture as you work on it. The bristles of flat and bright brushes are cut into a square shape, curving slightly at the sides — on flat brushes the bristles are long and flexible, making a smooth, regular stroke; bright brushes have short, stiff

bristles which are useful for laying areas of thick, textural paint. Filberts are a convenient combination of both round and flat brushes, having long, flexible bristles which are shaped to a gentle point at the end. A filbert has many uses, making marks similar to those made with a flat or watercolor brush, depending on the consistency of the paint.

When used thinly, acrylic is very similar to watercolor or ink wash, and you should choose your brushes accordingly. Real sable has a unique springiness which has made it a favorite with watercolorists for centuries. Oxhair is a slightly 'floppier' but less expensive alternative.

## THE NEW BRUSHES
All the brush shapes are now available in nylon. Some artists prefer them to the traditional types, even when using oil and watercolor. Others will use only real bristle or sable , even when painting with acrylics. It is largely a matter of preference and there are no hard and fast rules, only the vague idea that nylon brushes and acrylic paint should be used together because they are both synthetic.

It is easy to remove acrylic paint from nylon brushes — both during work and when cleaning up afterward — and they are also exceptionally durable when looked after. But, like all paintbrushes, they must be cleaned and stored properly, otherwise they soon become stiff and unusable.

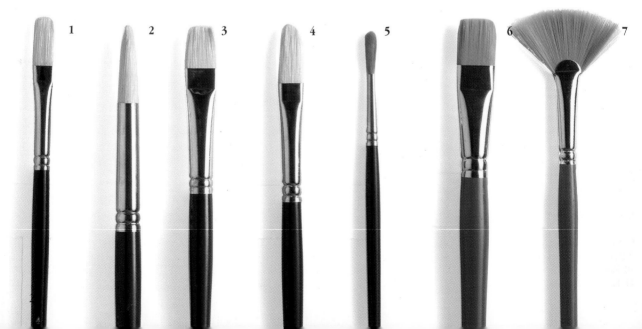

Large nylon brushes, such as those sold in hardware and decorators' stores, can be invaluable for applying large areas of color and blocking in. They come in all sizes from about half an inch wide to 6 inches and more. They are cheaper than those sold in art stores, and the better quality ones are just as good and often easier to use.

## PALETTES

Acrylic palettes are usually made of white plastic. These come in a range of shapes and sizes, and are easy to clean. If you do not have such a palette you can improvise by using a sheet of plastic, formica or glass — any smooth, non-porous surface will do. Many painters actually prefer these 'homemade' palettes because there is no restriction on size. Alternatively, children's plastic mixing dishes, old kitchen equipment, throw-away plastic containers and paper cups can all be used for mixing acrylic color.

A wooden palette is not a good idea. The paint gets into the grain of the wood, making it difficult to clean, and the stains eventually make it impossible to see what colors you are mixing.

If the rapid-drying habit of acrylics is a problem, there is a special palette now available which can help. The 'Staywet' palette uses the principle of osmosis to keep colors wet for days, and even weeks. It is basically a plastic tray lined with wet blotting paper, covered with a sheet of 'membrane' paper. The colors are squeezed onto this and absorb moisture from the blotting paper through the membrane. This makes the acrylics rather similar to oil paints, and it has been argued that the 'Staywet' palette is something of a cheat because the spontaneous spirit of acrylic painting is lost when the immediacy is taken away in this manner. But this rather purist attitude is really no reason not to use the palette if you find it helpful.

## PAINTING WITH A KNIFE

The buttery consistency of acrylics has tempted many artists away from traditional brushstrokes, encouraging them to apply the paint in thick, textural wedges and solid areas of color, put on with a knife.

Both painting knives and palette knives have flexible blades which make it easy to apply and manipulate the paint. Palette knives have straight blades and are essentially used for mixing colors on the palette (although they are also handy for applying approximate quantities of paint to the support). Painting knives have curved handles, making it easy to control and move the paint around on the picture without the end of the knife damaging the canvas. A 'cranked blade' is a cross between a palette knife and a painting knife, and can be used for either purpose.

All the knives are obtainable in a range of sizes. Some painting knives are tiny, which makes them suitable for working in detail and applying relatively small areas of paint.

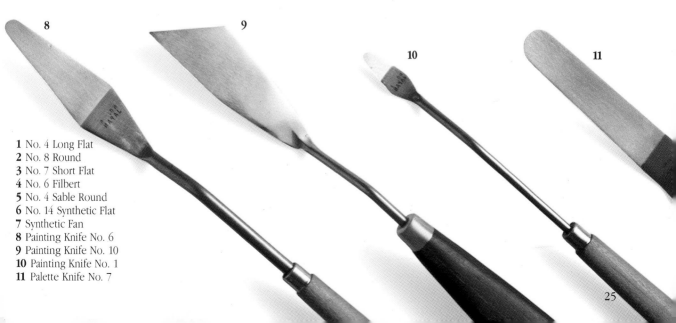

1 No. 4 Long Flat
2 No. 8 Round
3 No. 7 Short Flat
4 No. 6 Filbert
5 No. 4 Sable Round
6 No. 14 Synthetic Flat
7 Synthetic Fan
8 Painting Knife No. 6
9 Painting Knife No. 10
10 Painting Knife No. 1
11 Palette Knife No. 7

# THE VERSATILITY OF ACRYLICS

The most remarkable thing about acrylics is their extraordinary versatility. They can be used instead of watercolor, oils or gouache, having many of the advantages of these traditional paints, yet very few of the drawbacks. Used straight from the tube, acrylic is so opaque that any mistakes can be covered immediately — even when painting over a dark color with white, one coat is enough to obliterate the first color entirely. Because the paint dries very quickly, you can work on it almost at once, whereas an oil painting might have to be put aside for several days before work could resume.

By diluting acrylic paint with a lot of water, you can get an effect which is identical to that of watercolor. It is possible to mix bold, translucent washes, create spontaneous and random textures or produce tightly controlled work which looks so similar to real watercolor that the results are indistinguishable.

Acrylics are also ideal for mixed media work and combine happily with watercolor, gouache, inks, pencil and many other materials.

---

Acrylics can be combined with many other media. Here, *left*, acrylic color is applied over oil crayon.

---

Of course acrylic is not magic, nor the paint to replace all other paints, and it would be unfair to have such unreasonable expectations of it. Its quick-drying characteristic is usually an advantage but it can also present problems, especially for someone accustomed to painting in oils, which take several hours to dry. With acrylics you have to work quickly, adjusting the color by overpainting and optical mixing instead of trying to move the color around on the picture surface — the traditional oil painting method. Acrylic can be made to look exactly like watercolor but it doesn't handle or feel like watercolor while you are using it. Also, acrylic washes are insoluble once dry, so you need a more systematic approach than when using watercolor.

Although acrylic compares favorably with other mediums, it would be a pity if it was always used as an instant version of a more traditional type of paint — a substitute for something else. It requires practice and a certain amount of getting used to, but acrylic has much to offer in its own right.

THE OPAQUE TECHNIQUE

Acrylic paint lends itself naturally to an opaque method of working. The consistency of the paint used directly from the tube or jar is thick and creamy, and if you don't mix this with too much water or medium the color dries to a dense, smooth finish. For the inexperienced acrylic artist, this is probably the best way to get acquainted with the medium — especially if you are already accustomed to working with oils or gouache, where a similar technique is used.

If you are familiar with oil paints you will already be aware that some pigments are more transparent than others. Exactly the same is true of acrylics, and some colors have far less covering power. There is no need to avoid these transparent colors when using the opaque technique, but it is sometimes useful to mix them with one of the more opaque pigments to maintain the color density.

Some common colors which have a relatively poor covering power are ultramarine, phthalocyanine blue, phthalocyanine crimson, phthalocyanine green and Hansa yellow. Try mixing any of these with a small amount of one of the more opaque colors. This will, of course, alter the color slightly but you won't necessarily lose the effect entirely. Titanium white, for example, is so opaque that a very small quantity of it can increase the opacity of any color it is added to. Similarly, Mars black

OPAQUE TECHNIQUE
Most acrylic colors are naturally opaque unless diluted with water or one of the various mediums available. In *Food on the Farm* by Gordon Bennett, *right*, the artist has taken advantage of this property, applying layer upon layer of color and texture to create a solid, rugged image.

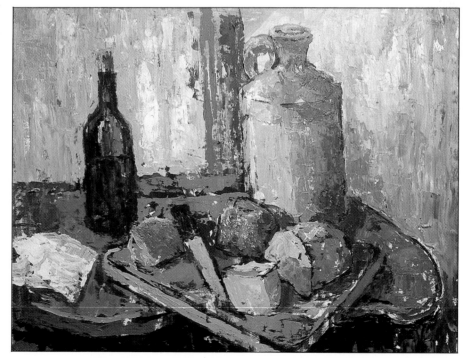

and raw umber are both very opaque, although their addition will inevitably have a darkening effect.

Remember that the gel mediums — both the matte and the gloss — will thicken your paint, but they can also turn it transparent if you use too much of the gel, so add these mediums sparingly if you are aiming for an opaque effect.

## THE TRANSPARENT TECHNIQUE

As mentioned earlier, acrylics can be used like watercolors. One of the great advantages of this is that once the color is dry, acrylic is insoluble and therefore permanent. This means that your picture is protected from damp — the longstanding enemy of watercolor paintings — and is therefore more durable than the traditional medium. This insoluble characteristic also makes it easier to apply successive washes and will give you maximum control when working with transparent overlaid color. If you have worked with watercolor, you will know that when you apply one color over another, the first color can start to dissolve and blend with the second, thus restricting the amount of color which can be added before the paint starts to turn 'muddy'. With acrylics this is not the case. The colors remain separate, and it is possible to build up intricate layers of wash to create complex yet spontaneous effects.

As mentioned above, with the opaque method of acrylic painting the transparency of some of the pigments can often be a problem. With the transparent technique the opposite is true, and the more you can restrict yourself to these transparent colors the better. You can, of course, use any color you choose, and there is nothing to stop you from trying out diluted opaque colors, but these can sometimes look chalky and dull — no matter how thinly they are applied — and will deaden any colors underneath.

Acrylics have been especially welcomed by those artists who like working in watercolor but feel restricted by the traditional small scale of watercolor materials. With acrylics, the scope is broader — not only does the paint come in larger quantities, but you also have a wider choice of supports. All the traditional watercolor papers are suitable, and acrylic washes can be used directly on fabric — including unprimed canvas — as well as gesso boards and other primed surfaces. Even though you are

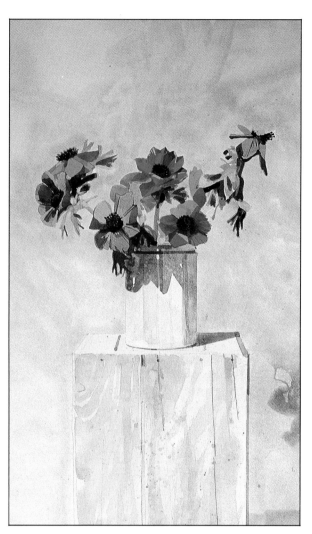

TRANSPARENT TECHNIQUE
Acrylic can be used in thin washes to produce an effect that is almost indistinguishable from watercolor. In *Anemones in an Earthenware Jar* by Ian Sidaway, *above*, layers of transparent washes are applied to create the delicate shades of the flowers and background.

using acrylic as watercolor, you are at liberty to work on a larger scale than is generally practical with real watercolor.

## MAKING TEXTURE

There are few limitations when making texture with acrylic paint. The worst problem you are likely to encounter is that you get so carried away with the different possibilities that the painting actually takes second place. This initial over-enthusiasm is not necessarily a bad thing, however, and you can take advantage of it to find out as much as possible about the potential of the paint and the different textural effects that can be made with it.

You can apply the paint thickly with a brush, palette knife, painting knife or any other suitable implement. Acrylics dry quickly enough to enable you to continue building up the layers almost indefinitely – some acrylic artists work almost in relief, their work taking on such a heavily impastoed surface that it can only be described as a three-dimensional art form.

Once the paint is committed to the support and starts to dry, it cannot easily be moved or changed. Indeed, it is usually a mistake to try to improve on the first effort because this may spoil the characteristic freshness of the paint surface. It is better to think carefully before applying the paint, making absolutely sure that the correct quantity of the right colors goes exactly where you want it to go, than to try to change it once it's on the canvas.

If a heavily impastoed surface is what you want, it is better to build up the paint in layers than put it on as one thick coat. This is because the top surface of the acrylic, which is exposed to the air, dries before the paint underneath and this sometimes causes cracking. Of course, if you don't mind this addition to the texture of the picture, you don't need to worry.

## TEXTURE WITH GEL AND MODELING PASTE

The volume and thickness of the paint can be increased by mixing the color with gel medium or modeling paste. In this way the color can be literally troweled onto the picture, especially if you are using the paste, which is

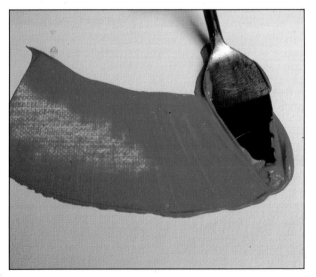

**THICKENING GEL WITH A KNIFE**

A painting knife is used to mix equal proportions of paint and gel on the palette, *top*. Like acrylic paint, gel dries quickly and the thickened color should be used straight away. The stiff, buttery consistency retains the shape of the knife marks *above*.

**THICKENING GEL WITH A BRUSH**

Used with a stiff brush, gel lends itself to a rugged, impastoed brushwork which retains the impression of the bristles. Again the color and gel are mixed in approximately equal quantities *right, above* and applied quickly to the support in direct, spontaneous strokes *right, bottom*.

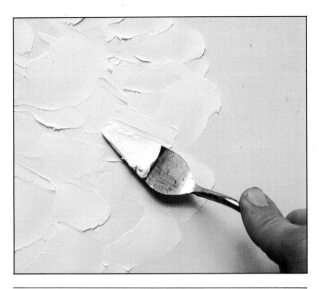

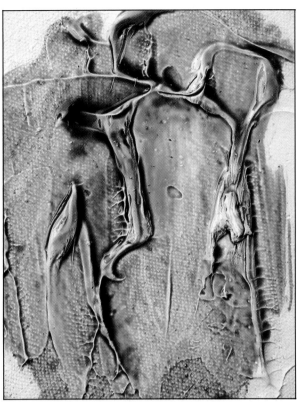

TEXTURE PASTE
The thickest medium made specially for use with acrylic color is texture, or modeling, paste. This is applied directly to the support with a painting knife *above* and can be built up in layers to achieve an almost three-dimensional effect. Paint is applied to the textured surface either as a delicate glaze *right* or opaquely to obtain an area of solid, textural color.

thick and gives the paint a cementlike consistency. This can be great fun and a very satisfying way of working, but it is important to stop and think about the effect and whether it is actually what you want. Mediums should be used as a means to an end, not an end in themselves, and it is all too easy to get carried away with texture to the detriment of the picture.

Gel dries transparently and there is a limit to how much you can use without affecting the color. This can be counteracted to some extent by restricting your palette to opaque pigments and using titanium white to give body to the color where necessary. Modeling gel dries with a shiny surface similar to that of gloss medium — the more you use the shinier the paint will be. The glossy finish makes acrylics dry like oil paints, so unless you specifically want this to happen, be cautious about using too much thickening gel.

Modeling paste is usually used as a thickener, and as such is mixed with the paint before it is applied. This gives the acrylic a stiff consistency which allows the paint to keep its shape as it dries. Any brushstrokes, palette

### SCRATCHING

Any sharp tool can be used to etch lines and texture into acrylic paint while it is still wet. Here, *right*, the artist is using a paintbrush handle, although a variety of other implements can also be used to produce different textures and patterns: old kitchen utensils, hair combs and household brushes are just a few possibilities. Most artists invent their own particular ways of enlivening the paint texture.

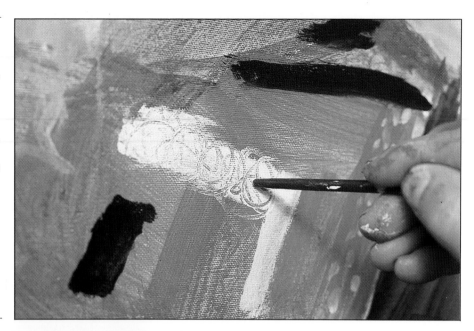

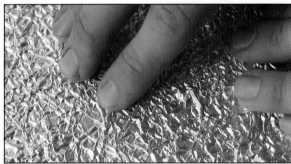

### TINFOIL

A piece of crumpled foil pressed into wet texture paste *top* produces a coarse, stippled surface, *above*.

knife marks and other textures show up clearly, insuring the crisp, fresh paint surface which is often as important to the acrylic artist as the content and form of the picture.

Modeling paste is sometimes used before the paint is applied. If you are working with opaque color this usually proves unsatisfactory, and the picture surface may seem dull and lifeless as a result. What you are actually doing is painting a thin layer of plastic onto a plastic shape — and that is exactly what it will look like in your picture. The method is more satisfactory if you use thin glazes of color over the hardened paste, when it is possible to achieve subtler effects without causing the surface to look like molded plastic.

### INVENTING YOUR OWN TEXTURES

You are not restricted to the paintbrush and painting knife when it comes to making textures and surface patterns. One of the reasons why acrylic was popular with so many artists when it first became available in the 1950s and 1960s was its extreme versatility in this respect.

Because it is so adhesive the acrylic can be mixed with almost any substance and it will take on the texture of that substance. Sand, sawdust, rice and many other materials have been used successfully to produce a gritty or granular surface. Sometimes the texture is directly

relevant to the subject — using sand for a beach or to depict the surface of a rough stone wall would be good examples of this — but more often it is used in a purely creative way to get as much textural contrast as possible into the painting.

Modeling paste is useful for making imprints. A whole range of unexpected patterns and textural effects can be created by taking impressions of various objects and materials and incorporating these into the picture. Here, too, it is usually better to be inventive than literal. If you try to imitate textures which are present in the subject itself, the result is usually decorative rather than realistic, and your picture may take on an unwelcome 'naive' quality.

Good overall textures can be made from crumpled paper, tinfoil, a stiff brush, comb, or anything else capable of making an imprinted texture in wet modeling paste. Of course these are only a few of the possibilities. Doubtless you will want to experiment and discover your own techniques, ones which suit your own style and particular way of working.

## COLLAGE

Both acrylic paint and acrylic medium are adhesive, and this makes them ideal for collage work. Acrylics are also chemically inert — this means they don't change in any way — unlike some glues which are sometimes affected by damp, heat or impact. The materials can be pressed and embedded into newly applied paint or medium and this dries to a tough, durable plastic finish which holds the collage permanently in place.

The possibilities for acrylic collage are endlessly varied, and the subject is a broad one. 'Collage' is an all-embracing term which covers a wide range of techniques. The simple stick-on pictures done by schoolchildren, the Cubist pictures of Picasso and Braque, the complex mixed media works of such modern artists as Rauschenberg and Jackson Pollock — all these can be broadly described as 'collage'.

Traditional paper and fabric are easy to stick down, and can either be used as flat shapes or be crumpled to give a rough, raised texture. Colored tissue paper is particularly effective and, because the mediums dry transparently, can be built up in many layers without losing any of their brilliance or translucency. There is no need to stick to traditional materials, however — you can literally use almost anything in a collage: plastics, dried food, dust, leaves, flowers and shells are just some of the things that will fit happily into a collage picture. If you want to use heavier items it might be necessary to keep your picture horizontal until the acrylic is dry — sometimes the wet paste is not strong enough to hold an

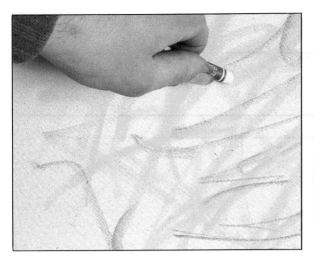

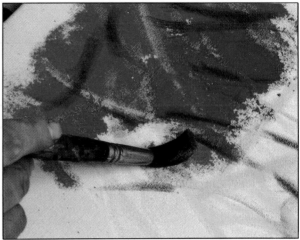

WAX RESIST
*Above* Oil, or wax, crayon is applied to the
support, but candles or any waxy, fatty
material will do as well.

Acrylic is then painted over the crayon,
*above*. The wax resists the paint, allowing
the textured pattern to show through.

object in position and it will slip downward if you are working vertically.

Occasionally the opposite problem arises, and something that you want to use — perhaps a piece of parchment or very thin fabric — will be too flimsy or fragile to stick directly onto the canvas. In this case, use the acrylic medium to encapsulate your material first, making it strong enough to move around and manipulate on the picture surface. Do this by painting some medium onto a shiny, non-porous surface. Gently press your scrap of paper or fabric into this and cover it with another layer of the medium. When it is dry, it can be peeled off the surface, and your fragile scrap will be encased in a tough layer of transparent plastic.

You can also make your own collage materials by painting fabrics and papers ready for tearing up and sticking on. In this way it's possible to get precisely the color and texture you want yet still retain the collage effect.

The most efficient collage artists keep a ready supply of materials so that there is a wide selection to choose from when occasion demands. Think twice before discarding trash — by collecting any interesting scraps and items which might otherwise get thrown out, you will insure a rich and varied supply for future collages.

## MIXED MEDIA

Acrylic lends itself to mixed media work more than any other artists' medium. Apart from being able to combine with different substances and materials to get a whole range of textures and surface patterns, it can also be used with pastel, ink, watercolor and gouache, and with many drawing materials such as pencil, crayon, conté, chalk and charcoal.

Illustrators often combine acrylic with another medium, sometimes painting a realistic image over a random background of tissue paper collage, sometimes using the acrylic to block in lively areas of local color and then drawing a detailed image over this with pencil, charcoal, pastel or pen and ink. Combinations such as these keep a picture alive and interesting and often reproduce better than an illustration done in opaque paint only.

Often regarded as a modern rival to oil paint, acrylic can also be extremely helpful to oil painters, complementing rather than competing with the oil colors. Because oil paint can be safely applied to an acrylic surface, it is possible to use acrylic for the first

stages of a painting – the initial 'blocking-in' of the main areas – and to continue the picture in oil.

This can save a lot of time, because normally an artist has to wait until the blocking-in is dry enough to be worked over. With oil paint this can be several days, but if the first basic underpainting is done in acrylic, the paint is normally dry enough to be painted over almost immediately. The artist can then use oils for the final stage, when the slow-drying colors can be worked and moved around over a longer period of time, to make final adjustments to tone, color and detail.

It is important to remember that acrylic cannot be used over oil paint in the same way. Even if the paint appears to be going on normally, an oily or greasy surface will eventually repel acrylic and your picture will be short-lived.

Sculptors and craftsmen are also discovering the advantages of acrylic and acrylic mediums. It is the natural coloring for much of the plastic and fiberglass materials now used in three-dimensional art, although it can be used equally well on metal, wood and masonry. It is especially useful if the work is to go outdoors, when a weatherproof paint is essential.

## IMPASTO

Impasto is a word used to describe the thickness of the paint applied to the canvas. When this is so heavy and thick that the paint stands out from the surface and the brush or knife marks can be clearly seen it is referred to as being 'heavily impastoed'. In one way acrylic is ideal for this method of direct painting. The color is thick and can be further stiffened by mixing it with thickening agents. It also dries quickly even when applied in quite heavy layers. It is possible to build up a whole personal vocabulary of paintmarks, and certainly well worthwhile exploring all the possibilities of different brushes, knives and other implements to do this.

Some artists, however, feel that acrylics are not particularly suited to impasto painting, and find them difficult to use in this context. They find that the quick drying time – usually an advantage – can actually be a drawback, preventing them from working the paint into the exact texture or shape that they require.

Generally speaking, whether you like using acrylics to produce an impastoed effect depends on what type of painter you are, and how you like to handle the paint. Certainly the medium does not lend itself to being

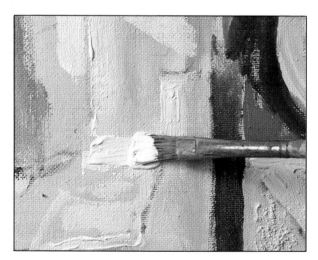

### BRUSH IMPASTO
Acrylic paint can be applied thickly with a brush, *above*, either by itself or mixed with texture paste or medium.

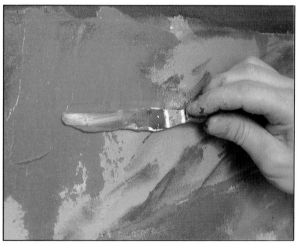

### KNIFE IMPASTO
A palette or painting knife creates solid wedges of color with a characteristic 'ridged' effect, *above*.

painstakingly moved around once it is on the canvas. The paint has to be applied with as few strokes as possible and these should be allowed to stay exactly as they are without any attempt to move them around or tidy them up. If you try to interfere with the initial, spontaneous effect you will only succeed in softening the crisp edges and destroying the freshness of the directly applied paint. When using acrylics thickly you must decide what you want to do, what effect you want, and apply the paint as boldly and unhesitatingly as possible.

## GLAZING

A glaze is a transparent film of paint, usually applied over another color. It can change the underlying color without actually obliterating it, producing a subtle filmlike quality instead of a flat opaque finish. If the glaze is to show up clearly, the underlying color must be paler than the glaze itself. Occasionally a light colored glaze is used over a color which is the same tone, or perhaps even darker, but in this case the result is always subtle, adding a barely noticeable sheen to the glazed area rather than actually changing its color.

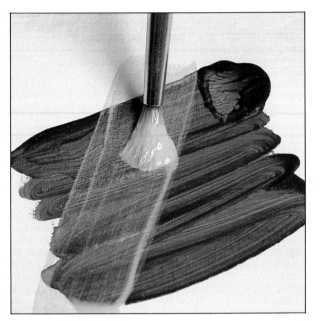

The strength of a glaze depends partly on the staining capacity of the particular pigment you are working with and partly on how much water or medium you use to dilute the color. Some pigments produce a stronger tint than others. For instance, phthalocyanine green makes a bright glaze which will tend to dominate the color underneath; a color with low tinting strength, such as raw umber, will tone down or modify the underpainting without overpowering it.

If you use water by itself to dilute the color, the glaze dries to a dull, matte finish. When the paint is diluted with acrylic medium, it dries gloss or semi-gloss, depending on how absorbent the underneath surface is. A glaze mixed with medium is usually richer in color than one mixed with water, but the dullest of finishes can be enlivened and the color brought up to its full potential by applying a coat of acrylic varnish, gloss medium or acrylic fixative.

Multiple glazes can be superimposed to create complex color variations. Always work from light to dark, gradually building up the tone and color until you arrive at the effect you want.

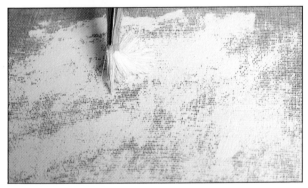

Glazes are often used over thickly impastoed paint and highly textured surfaces. The glazing gives a touch of delicate transparent color to an otherwise heavy finish. If the glaze is gently wiped with tissue or rag while the paint is still wet, the darkest color will remain in the crevices, cracks and indented marks. This produces an effectively varied surface which — if the glaze color is neutral and subdued enough — can often resemble that of an old oil painting or even a texture from nature. The bark of a tree or a mossy stone wall, for instance, could easily be depicted in this way.

## SCUMBLING AND DRYBRUSH

Color can be applied to change and break up an area of paint without completely covering it over. Both drybrush

GLAZING

Dilute the glaze with water or acrylic medium — medium usually produces a richer, livelier color — and apply this over the underpainting, *left*. If a thicker glaze is desired, build up the color in several thin layers.

SCUMBLING

*Below left*, use short, irregular strokes to produce an area of broken, 'scumbled' color.

DRYBRUSH

Pick up a trace of color on the brush and move this lightly across the support *below*. Drybrush is useful for blending or painting areas of finely broken color.

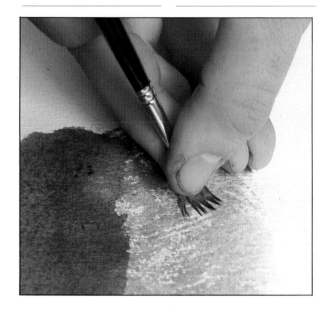

should be fairly stiff, and only a trace of the opaque color picked up on the end of the brush. This is applied lightly across the picture surface and will pick up the texture of the support provided that the paint underneath is thin enough. Because the color is used opaquely, drybrush can be applied as light over dark or dark over light with equally successful results.

Unlike oil paints and watercolor, acrylics cannot easily be blended to get a smooth gradation from one color to another. The gel mediums and retarder can help to some extent, but the result is never perfect. Many artists prefer to make a virtue of necessity and to adopt scumbling or drybrush techniques to merge colors. The lively, prominent brushmarks play an important part in the final effect.

UNDERPAINTING

The term 'underpainting' refers to the preliminary blocking-in — the first stages of a painting, when the composition and tonal values are worked out before any detail is added. Occasionally some basic color is used, but traditionally the underpainting is in monochrome, its purpose being to establish the correct tones before the problem of color is tackled. It is especially helpful if you plan to use a lot of glazes, because here the tonal design will show through the transparent layers of color to some extent, giving a sense of form and solidity to the painting as a whole.

Until the advent of acrylics, the business of underpainting took a long time. Oil painters were obliged to wait for each stage to dry before they could proceed with the picture, and many of the Old Masters had to put their underpainted canvases aside for several months before the paint was dry enough to enable them to carry on working. These days, with quick-drying acrylics there is no need to wait so long between stages, and the whole process takes hours and days instead of weeks, months and even years.

Modern oil painters have the best of both worlds. They can use acrylics for the early stages of a picture, often establishing the main color areas as well as the structure and tonal composition, in an acrylic underpainting. The work is then developed in oils, using the slower, traditional oil painting techniques to complete the painting.

and scumbling are techniques which effectively change a color yet allow the original color to show through in places. This can be important when a color theme has been established in a picture, yet a change of tone or color becomes necessary in one area and you want to do this without destroying the overall composition.

A scumbled surface is an irregular one, where the brushstrokes are in evidence and where the underlying color shows through — usually in tiny flecks and dashes. The strokes can be long and parallel, short and stippled, or completely random. Ideally, the color should be thick and slightly transparent — gloss or matte medium produce an ideal consistency for scumbling.

The drybrush technique is also used to apply broken color over another, flat, undercolor. Here the paint

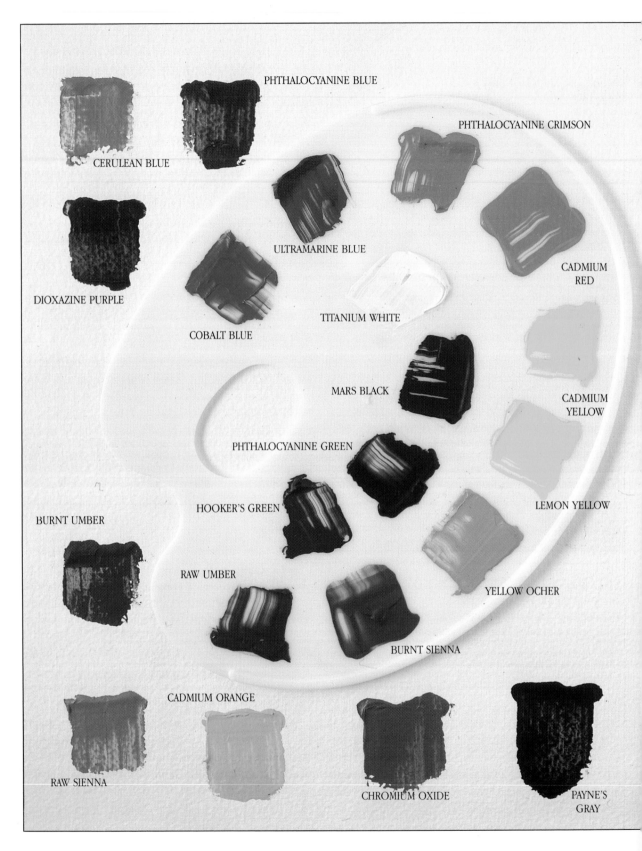

PHTHALOCYANINE BLUE

PHTHALOCYANINE CRIMSON

CERULEAN BLUE

ULTRAMARINE BLUE

CADMIUM RED

DIOXAZINE PURPLE

TITANIUM WHITE

COBALT BLUE

MARS BLACK

CADMIUM YELLOW

PHTHALOCYANINE GREEN

HOOKER'S GREEN

LEMON YELLOW

BURNT UMBER

RAW UMBER

YELLOW OCHER

BURNT SIENNA

CADMIUM ORANGE

RAW SIENNA

CHROMIUM OXIDE

PAYNE'S GRAY

# COLOR IN ACRYLICS

Acrylic paints come in a vast range of colors which includes almost all the traditional pigments available in oils and watercolors as well as a few new synthetic ones which are used only in acrylics.

The colors are so good and the choice so wide that the initial temptation is to use as many colors as possible so as not to miss a single one of them. But, as with all good things, a little discipline is necessary. Too many colors, indiscriminately mixed, will result in none of them being used to any advantage, and you will almost certainly be disappointed.

A little practice is the best way to develop your own color sense, and this means developing your ability to observe and then to record what you see. The best way to do this is to start with a very limited range of colors and to gradually add to this until you find the combination that best suits your needs. Only by mixing and using the colors is it really possible to become acquainted with the properties of the different pigments.

---

Some of the most popular acrylic colors are shown here *left*, with a suggested selection for a basic palette.

---

The opacity of the paint is sometimes referred to as the hiding, or covering power; this varies considerably from pigment to pigment. Another variable is the color strength, or tinting power, of a particular paint.

The following list is a guide to the characteristics of some of the most common colors, but it is by no means comprehensive and you will need to carry out your own investigations to get a complete understanding of the available range.

## THE COLORS

**Cadmium red** There are three cadmium reds — light, medium and dark. Most artists choose light or medium when a bright red is required; dark cadmium red is extremely deeply colored. They are opaque with great tinting power and being a warm red, mix well with yellow to make orange. They cannot, however, be mixed with blue to make purple — the warm, orange pigment will merely produce a dull brown color.

**Phthalocyanine crimson** This new pigment is the acrylic substitute for alizarin crimson — a pigment which is incompatible with synthetic resin. Often called phthalo or thalo crimson, it is a vivid and highly transparent color with good staining power.

**Ultramarine blue** Used by nearly all painters, this 'primary', rather warm blue can be mixed with crimson reds to make rich purples and violets, and with yellows to create natural-looking greens. It is transparent and the color is not particularly strong.

**Phthalocyanine blue** A cold, vivid color with an extremely strong tinting power, phthalocyanine blue can easily dominate a color scheme unless care is taken to prevent this. It will make bright purple when mixed with crimson reds, and bright green when mixed with yellow.

**Cobalt blue** A subtle blue, popular with both landscape and portrait painters for the cool shadows and subdued tones it produces. It is neither particularly opaque nor strongly tinted.

**Cadmium yellow** A strong, opaque color, cadmium yellow comes in three tones — light, medium and dark. This standard, or primary, yellow is useful for making strong greens and oranges when mixed with blue or red respectively.

**Lemon yellow** As its name suggests, lemon is a light,

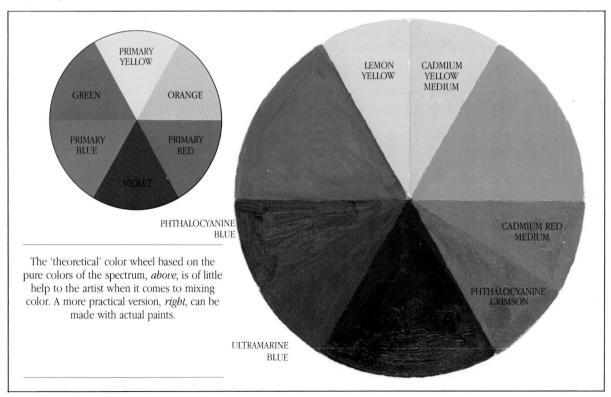

The 'theoretical' color wheel based on the pure colors of the spectrum, *above*, is of little help to the artist when it comes to mixing color. A more practical version, *right*, can be made with actual paints.

cool yellow with rather weaker tinting power than the cadmiums. It is a transparent, clear color and can be used to make vivid oranges and greens.

**Yellow ocher** This dark, dull yellow is indispensable to most portrait and landscape painters. Those who don't use it usually substitute yellow oxide, which is similar. Yellow ocher is fairly opaque, and often used with blacks and blues to make muted greens. It is an almost essential color for mixing white flesh tones, when it is often mixed with white, burnt sienna and a little blue.

**Phthalocyanine green** Like the other phthalocyanine pigments, this green is very bright with a strong tinting power. It can be overpowering, but if used judiciously, phthalocyanine green is extremely useful, either on its own or mixed with other colors.

**Hooker's green** A subtler color than phthalocyanine, Hooker's green is a traditional landscape favorite — it mixes well with the earth pigments such as ocher and umber to create the seasonal colors of rural landscapes.

**Chromium oxide** A dull gray-green, chromium oxide is opaque. It is often used as a subdued landscape tone and, occasionally, as an undercolor for figure and portrait painting.

**Cadmium orange** This strong, opaque orange can actually be mixed from cadmium red and cadmium yellow, but it is useful to have on hand. It is the most vivid orange available.

**Dioxazine purple** A comparatively new color, this dense purple is opaque but can also be used for glazes. When mixed with water or medium the color becomes lighter and brighter.

**Raw umber** Many artists use raw umber instead of black to tone and darken other colors. Its yellow-brown color has poor tinting power, but it is found on almost every artist's palette.

**Burnt umber** This warm brown is widely used — mainly for mixing with other colors to produce a range of rich tones. It is reasonably opaque.

**Raw sienna** A mixture of ocher, orange and brown, raw sienna is a fairly opaque, sandy color which, when mixed with greens, blues and purples, produces a range of earthy hues for use with many subjects.

**Burnt sienna** This rich, coppery red is often used to add warmth when a brighter, more dominant red is not wanted. It is transparent and frequently used in glazes and washes.

**Payne's gray** Many painters rely on Payne's gray a great deal. It is a cold, dark gray with a weak tinting strength and is useful for modifying and cooling other colors.

**Titanium white** The only available acrylic white, titanium has a good covering power. It is therefore necessary to add only a little titanium white in order to lighten any color quite substantially. This enables any transparency to be preserved.

**Mars black** Many artists work without using this colour at all. However, Mars black provides a good, dense tone when used alone or when a small amount of another colour has been added to it. Black should not be overdone, even so, and should not be the automatic choice for darkening a color.

## THE BASIC PALETTE

Most artists use a palette of between 12 and 15 colors, but there is nothing magical about these numbers and they vary considerably, some artists using more and others a lot fewer. The choice of colors is also a personal one, depending on the painter and the subject to be painted.

A basic general palette might consist of the following colors — black, white, ultramarine blue, cobalt blue, cadmium yellow, lemon yellow, cadmium red, phthalocyanine crimson, yellow ocher, phthalocyanine green, Hooker's green, raw umber and burnt sienna.

## BASIC COLOR THEORY

Some knowledge of color theory is necessary to artists of all levels, and it would be difficult to know how to start painting if, for instance, you didn't know that red and yellow make orange, yellow and blue make green, and so on. Without wanting to discourage the pursuit of a subject which is both useful and fascinating, however, there is a limit to how much theory is actually relevant to the artist.

One of the main problems for the painter is that the theory of color is based on the pure colors of the spectrum — red, orange, yellow, green, blue, indigo and violet. These seven pure colors, the colors of the rainbow, are the basis of all theoretical studies of color, for scientists and painters alike.

The artist's color wheel is a simplified version of the

spectrum colors, minus the indigo. The wheel, which is used universally as a guide to color, is usually divided into six sections. These comprise the three basic colors – red, yellow and blue – known as the 'artists' primaries', which cannot be mixed from any other colors. Between the appropriate primary colors are the colors which are mixed from these – orange, green and violet. These are the 'secondary' colors.

Thus, in the artist's color wheel, green is opposite to red; violet to yellow; and orange to blue. These pairs are referred to as 'complementary' colors.

Unfortunately for the painter, however, artists' pigments do not mix in the same way that Newton's spectrum colors did. While it is true that primary red and yellow paints do mix to make orange (though not a particularly bright one), it is not accurate to say that primary blue and red make violet. In fact they produce a rather dull brown.

It is important to know how to mix the color you want from the pigments on your palette and how this will affect your painting. In other words, there is only so much to be gained from charts and diagrams and a great deal to be learned from experience and practice.

### MIXING COLORS

You can make your own, more practical version of the color wheel in the following way. Do not begin with only the three primary colors, the equivalent of which would be cadmium red medium, cadmium yellow medium and ultramarine blue. Instead make a wheel which starts off with two yellows (cadmium medium and lemon), two blues (ultramarine and phthalocyanine) and two reds (cadmium medium and phthalocyanine crimson).

By arranging these colors in such a way that the warmest blue (ultramarine) and the warmest red (phthalocyanine crimson) are mixed together you will achieve a range of bright, color-intense purples without the muddiness that would result from directly mixing the

two primaries – ultramarine and cadmium red. Similarly, use lemon yellow and phthalocyanine blue for a range of intense greens, and cadmium red and cadmium yellow for the oranges.

Harmonious colors are those that are close together on the color wheel. Complementary colors are opposite to each other. The complementary pairs are green and red, blue and orange, and yellow and violet. The 'complementary' colors should not be confused with 'discordant' ones, a term referring to those colors which are optically incompatible and 'clash' when placed next to each other.

It is useful to remember that a color has three separate properties – hue, chroma and tone. The hue is the actual pigment; chroma refers to the brightness or intensity of a color; and the tone describes how dark or light a color is.

Only by mixing colors and experimenting with different combinations will you really discover what the possibilities are. Some systematic color exercises such as the ones shown here will save a lot of haphazard mixing later on, as well as providing you with some reference charts for future use, so it is worthwhile making a note of which colors you used.

### OPTICAL MIXING

It is not always necessary to mix the color you want before applying it to the painting. You might decide to let the color mix 'optically', in the viewer's eye, instead of pre-mixing it on your palette. This is done by applying two or more colors in small dabs. For instance, instead of painting an area of flat green you could use tiny brushstrokes of pure yellow and blue directly on the canvas. When viewed from a normal distance these blue and yellow dots combine to create the illusion of green.

### COMBINING COLORS

A color is always affected by its surroundings, and a change of background can completely alter its

A color is always affected by its surroundings. In the four pairs of boxes, *left*, the color in the center of each pair is the same. When placed against different backgrounds, however, the colors actually look quite different.

appearance. A pale green, for instance, will often seem warmer and darker against a cold blue background than it does if placed on bright orange, when it takes on a cool, bluish tinge.

Tones, too, are affected by their surrounding colors. Try putting a blob of the same gray on a variety of colored papers and you will notice that the gray looks slightly different against each one, becoming lighter, darker, warmer, cooler and so on. Any color seen against a white or a black background is affected by the tone of that particular background.

Thus it becomes apparent that a color does not 'exist' on its own, and its character is changed as soon as you put another color on the same canvas. This is especially relevant when painting the background of a still life, for instance, when a slight change in the tone or color can determine the mood of the picture.

Nor do all colors 'lie flat' on the canvas. Certain colors appear to jump out while others seem to recede behind the picture surface. Generally speaking it is the warm, strong colors, such as bright red or vibrant orange, which 'advance', whereas the receding colors tend to be the cooler, muted tones of gray, green and blue.

## THINKING ABOUT TONE

Every color has its own tonal value. This measures how light or dark the color is. Yellow, for instance, is tonally light, whereas purple has a comparatively dark tone, and so on.

If you are painting from a subject it is just as important to establish the correct tones as it is to get the colors right. This can sometimes be difficult because you are not just dealing with the local color of an object, you also have to look at how the light and shadows affect that color. For example, a shiny red jug standing in a strong directional light will be very light on one side and very dark on the shadow side.

A good way of assessing the tone of a color is to try to imagine how it would look in a black and white photograph. If you are trying to gauge the relative tones of a still life landscape scene it is often easier to look at what is in front of you through half-closed eyes. This eliminates some of the detail and local color and makes the broad areas of light and dark easier to pick out.

*Left*, the tonal scale runs from white to black, and every color has a tonal equivalent somewhere on that scale between the lightest and darkest gray.

# PLANNING YOUR PAINTING

What shall I paint? The question will almost certainly arise sooner or later, and the acrylic artist is more fortunate than most when it comes to finding an answer. The medium is flexible enough to accommodate almost any subject you want to paint, and the colors can be used in a variety of ways, creating a range of different effects with a versatility not found in any other medium. With acrylics the question is far more likely to be one of how the paint can best be adapted to the subject, than whether a particular subject is suitable for the paint. All subjects are possible, and the more familiar and practiced you are in acrylic painting, the wider your choice when deciding what to paint and how to paint it. Once the subject is chosen, the next decision is how the subject is to be placed in the picture. This involves not only arranging your subject on the support, but also deciding what shape and proportion that support should be.

Everything around you can become the subject of a painting, *left*. There is no need to be bound by categories such as still life, landscape and so on — these are merely labels of convenience.

In the past art students made painstaking copies of other people's pictures in order to learn about technique, color and composition before being thought competent enough to embark on their own work. While this method undoubtedly encouraged sound draftsmanship and high technical standards – and copying should never be underrated as a means of learning – it seems a pity to neglect the real world for so long in pursuit of academic skills.

Knowledge of color, composition and tone is just as important as it ever was, and there is still no easy way of learning how to draw. But the best way to find out is to have a go – if possible, working directly from the subject. Whether you choose landscapes, still lifes, figures or abstract compositions, find a subject that really interests you. Do your best to make it a success but, above all, enjoy doing it!

## GATHERING INFORMATION

Painting is not an activity that is separate from everyday life. The more involved you become, the more you will come to realize that choosing a subject is not an arbitrary decision to be made when the paints are out and the easel set up. How we perceive the world around us is bound up with other aspects of our lives – who we are, what we do and where we live are all factors which influence our perception, affecting not only what we see but how we see it.

The problem is how best to record our experiences and ideas for when we need them. Quite often we are impressed by something we see – possibly a scene or how the light falls in a particular way, or perhaps a flash of memory, a reminder of something from the past. We are all struck by certain things at various times, and these moments can provide a rich source of subject matter, provided they are somehow recorded and stored for future use. It is not easy to define 'personal vision', but it is certainly simpler and far less mysterious than it sounds. For the artist, a great deal depends on documentation – on developing a visual filing system which will jog the memory and can be referred to when occasion demands.

## THE SKETCHBOOK

A sketchbook is an ideal tool for recording what you see.

A quick sketchbook drawing becomes the subject of a painting. *Above*, the artist uses a grid to enlarge the image onto a support.

You do not have to work on a large scale, and a small pad which you can slip easily into your pocket is all you need to record a wealth of information which might otherwise be forgotten.

You may feel self-conscious at first, and dislike the idea of people looking over your shoulder while you work. But once you get into the habit of sketching in public places you will find that people become less interested as you become less embarassed, and that once you have started work you won't notice what is happening around you.

Your scribblings don't have to look like a finished drawing, and it doesn't matter if the image is unrecognizable to anyone except yourself. The important thing is that you are providing yourself with a clue, a starting point for a painting — however far into the future this might be. By taking the trouble to keep your eyes open, you will begin to identify your own particular likes and dislikes — in fact, to develop your own style.

A sketchbook can include color notes — either in the form of written reminders or by indicating the actual color in paint or crayon. It can also be used to record tone — the comparative light and dark areas of the subject as well as where the highlights and shadows fall — and other information which can be invaluable when composing a painting from memory or imagination.

One of the most difficult subjects to paint without reference is the human figure. Here the sketchbook can be especially useful because most of us come into contact with people every day of our lives, often at times when there is ample opportunity to make a quick sketch. At work, at home, on a train, in cafés — all of these places, and many more, offer a vast range of human activity and a chance for you to capture poses, expressions and movements which can be stored and drawn on at a later date. There is nothing more frustrating when planning a figure composition than not having enough reference to hand and having to rely on memory.

## A PERSONAL FILING SYSTEM

Sketching is not the only means of collecting information. Many painters are also keen photographers, and take snapshots of all kinds of visual and technical details which catch their interest and which they feel could possibly be useful to their work at a future date.

Cutting a picture out of a magazine, collecting postcards and other objects, taking a photograph — these are just some of the ways you can record your experiences, and which will eventually help you to establish a personal reference file. All the things you record will then be permanently fixed, and will help you to establish a working pattern and, eventually, to realize your own individual style of painting.

## LEARNING BY IMITATION

Copying the work of other artists is not a satisfactory long-term solution to the problem of finding a subject but there is no doubt that working from images that have already been 'processed' can be extremely helpful in some circumstances.

For instance, when confronted by a real subject, whether it is a landscape, a person or a group of objects, you are also confronted with a bewildering mass of detail which could not possibly be accommodated in a painting. The problem is one of selection — of deciding what to include and what to eliminate. Here the experienced artist has the advantage and, whereas the amateur painter can lose confidence and feel undermined if every detail is not accurately included, the more experienced painter will already have developed a sense of priority, and be able to pick out those elements that are of special interest.

There are, therefore, occasions when it can be helpful to copy the work of other artists and to gain first-hand knowledge of how they cope with the process of selection and elimination. In the same way, painting

Snapshots, cuttings and vacation postcards, *above*, are all useful sources of reference when looking for a suitable subject to paint.

from a photograph — where the subject has already been selected and the three-dimensional image presented in a two-dimensional form — leaves you free to concentrate on the formal problems of color, tone and composition without having to worry about making it 'look real'.

Copying a picture is far more beneficial than just looking at it. However much you concentrate, and however familiar you become with a painting or the work of a particular artist, there is no substitute for actually reconstructing the picture. Not only will you find out how the artist worked, what colors were used, and so on, but you will also learn something about what the artist thought and felt about the subject.

Obviously it would be boring and counterproductive to imitate other people's style indefinitely. Hopefully you won't be content with copying for long and will want to get on with your own work. But learning from others can do no harm. For the serious student it is probably the most effective means of finding out about technique; for the less confident beginner it can often be a painless way of starting to paint.

## WORKING FROM A SUBJECT

Practical considerations play a crucial part when it comes to deciding what to paint. Generally speaking, you can only work outdoors if the weather is good, and even then you need to go prepared — appropriate clothing and a portable easel are essential if you want to work in comfort. Working indoors is usually easier but, unless you have a room which is used specifically for painting, you should set up your equipment and subject in an area where they can stay undisturbed until the work is finished, and where there won't be a constant stream of people and unwelcome interruptions to distract you.

Working outdoors can be daunting because there are so many unknown factors. Not only is the weather often unreliable, but the light too can change constantly, making it difficult to establish the basic colors and tones in a painting. These are occupational hazards, but a little planning is often helpful. Take a sketchbook and camera with you and make sketches or take a photograph if you feel the elements are against you or that you aren't going to finish your work in the available time. At least this will provide you with reference and enable you to complete your painting at home in more stable conditions.

WORKING FROM THE SUBJECT
Many painters prefer to have the subject in front of them, whether working from a model, *top*, out-of-doors, *above*, or from a still life, *left*. Photographs and drawings are indispensable aids, but it can be difficult to capture the atmosphere of the subject when working entirely from such references. Your personal feelings and reactions to a scene or subject are just as important as accuracy — and for this there is no substitute for working directly from the subject.

Keep an open mind about the subjects you choose. Obviously, some things will attract you more than others and certain subjects will be more available and more convenient, but don't close your options too early and miss the opportunity of painting from a broad range of subjects to find out what really interests you and what you are best at. Many artists eventually become involved with a particular theme or develop their own specialist area, but no successful painter has ever worked exclusively from one subject without at least starting off from a broader base.

Nor should subject matter be divided too readily into separate categories. The terms 'landscape', 'still life', 'portrait' and so on are labels of convenience rather than rigidly different types of painting. The wildlife painter who understands landscape, for instance, is better able to place the subject in a convincing setting than one who does not; and the portrait painter who is also interested in still life is more likely to produce an integrated overall composition in which the background and surroundings play a positive role than is an artist who is concerned with the head and shoulders only.

## THE GEOMETRY OF COMPOSITION

Unless you have made a deliberate choice to do otherwise, it is almost always advisable to avoid a totally symmetrical composition. Once the picture is equally divided, either horizontally or vertically, it is extremely difficult to complete the picture so that is is not unnatural and uncomfortable to look at. Occasionally one sees a landscape or still life where the horizon or the background cuts the painting into separate halves, but where this has succeeded the artist has generally compensated for the symmetry elsewhere in the composition or — less often — used the equal sections as a positive aspect of the picture.

A successful composition depends on the artist's ability to see the subject in broad, abstract terms, and in order to do this it is necessary to cut out all the details and to concentrate initially on the main structures and shapes which hold the composition together. If these are established in a satisfactory way, the rest of the picture will fall into place naturally.

It is a good idea to make several sketches — each one simplified into an arrangement of geometric shapes —

Interior scenes and still life paintings are usually easier. Here you have a captive subject, and can work in your own time. Sometimes, of course, you will be painting perishable things, such as flowers and vegetables, and this obviously imposes a time limit. But, generally speaking, the pace is slower and you can take a more leisurely approach. The problem of changing light is still present, but this can be solved by working on two or more paintings at different times of the day — perhaps catching the morning light in one and working on another subject in the afternoons.

A rectangular support can be used either horizontally or vertically. When a composition is horizontal, it is referred to as 'landscape', *top*; a vertical or upright composition is called 'portrait', *bottom*. These descriptions apply regardless of what the subject may be.

before committing your final composition to the canvas. In this way you will be able to see immediately what the various possibilities are, choosing your basic composition from the sketches in front of you rather than relying on your first attempt — which won't necessarily be the best one.

Traditionally, a good composition is one which manages to hold the viewer's attention within the main picture area. The best way of achieving this is to imagine an oval shape within your rectangular canvas — or a circle, if your painting happens to be a square one. By keeping all the main activity within this oval the viewer's eye will not be led out of the picture but will stay comfortably within the central shape. Of course, any obviously discordant element in the composition, such as a figure facing or pointing toward the edge of the picture, will inevitably lead the eye directly out of the composition, whether it is placed in the central oval or not.

## THE GOLDEN SECTION

One time-honored method of working out a composition is to use what is known as the Golden Section. This technique divides a rectangular shape into what are generally considered to be the most harmonious and satisfying proportions possible.

The concept of the Golden Section, which has been recognized for at least 2,000 years, holds that the most harmonious relationship between unequal parts of the same rectangle is achieved if the smaller section is in the same proportion to the larger section as the larger section is to the whole.

No one knows exactly why or how this particular division works, but it has been used repeatedly throughout the history of civilized art, and the same proportion occurs naturally in many of the organic structures found in plants and simple animal life. The number of paintings which are based on the Golden Section is surprisingly large, particularly considering that many of the artists who painted them were unaware of this concept at the time.

The Golden Section division is worked out geometrically, although most artists do not go to such lengths, preferring their decisions to be visual rather than mathematical. Even so, the majority of their paintings will contain the Golden Section somewhere in the composition. Generally it is better to be guided by your own eye and instinct than to feel bound by a theory which will probably inhibit rather than help your composition, but the Golden Section can sometimes be a useful starting point if you are stuck for an idea or don't know where to begin

There are, in fact, no rigid rules about what makes a good or bad composition — and what is suitable for one painter might be quite inappropriate for another. The most important thing is to be aware of what you are doing and why you are doing it, and to carry out your decision with confidence. No one knows better than yourself what interests you about a particular subject or how to arrange that subject on the canvas.

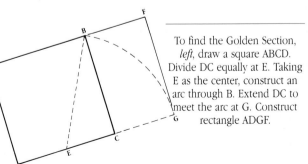

To find the Golden Section, *left*, draw a square ABCD. Divide DC equally at E. Taking E as the center, construct an arc through B. Extend DC to meet the arc at G. Construct rectangle ADGF.

THUMBNAIL SKETCHES
Before embarking on a painting it is a good idea to make a series of small, quick sketches to help you to decide on the final composition. The artist made several, tiny, 'thumbnail' sketches of a boatyard, *left*, trying out the various alternative arrangements before committing the composition to canvas.

## BRACKETS AND WINDOWS

Unless you are very experienced it is practically impossible to look at a landscape or group of objects and be able to visualize exactly where the edge of the painting will be. You may vaguely decide that a certain tree or other object should be on the lefthand side of the picture or that some particular foliage would look good in the foreground. But the human eye is not designed to select perfectly rectangular compositions from a shapeless vista of forms and colors, and you will need to resort to other means.

One way of isolating your subject from its surroundings is to use a 'window'. This is simply a rectangular hole cut from a piece of cardboard or paper which represents your intended painting. By looking through your window you can survey the broad scene, moving the hole around until you find exactly the composition you want. Not only will you be able to see how your tree or foliage looks in its chosen position, but you will also be able to maneuver the composition until everything else is satisfactorily placed in relation to it.

*Above*, cut a window to the same proportion as your support and move it around the drawing to find the best composition for a painting.

L-shaped brackets enable you to change the shape of the 'window', *above*. This method can also be used when working from the subject itself.

You are not confined to rectangles — a square picture may be more suitable for certain subjects, *above*.

Because your window shows you where the edge of the picture would be, it is also possible to see the 'negative' shapes between your objects. For instance, the shapes of the spaces between the branches of the tree will be defined by the edge of the rectangle, and these can be changed and incorporated into the composition.

A pair of L-shaped brackets placed together to form a rectangle have the added advantage of being adjustable, and the proportions of the rectangle can be altered by moving the brackets. This method gives you absolute control of the composition without the restrictions of a predetermined shape.

If you decide on an arrangement which is obviously part of a larger scene this is known as an 'open' composition. Many landscapes inevitably fall into this category because the space, indicated by the horizon and the sky, suggests that the scene continues past the boundaries of the painting. Many artists avoid a totally open composition because the viewer's eye is led across the picture area too quickly, and even when painting spacious subjects such as landscapes and seascapes it is usually possible to arrange them in ways which discourage the eye from traveling outside the picture.

In the more conventional 'closed' composition the subject fits comfortably into the canvas shape, all the elements in the picture being designed to work together within the main picture area. Most easel paintings, including still lifes and portraits, are arranged as closed compositions.

## THE TONAL PICTURE

Tone plays an important part in any picture. It is seldom sufficient to arrange the subject as a series of related shapes, however satisfactory this linear arrangement might be. Unless you pay proper attention to the light and dark tones of those shapes the subject is likely to lack form or any illusion of three-dimensional space, and a flat, uninteresting composition could be the result.

Every color has a tone. Pale colors, for example, are tonally light, and if you were planning the tonal patterns in a composition of flat shapes, they would be represented as very light grays. Should you be painting a still life that included a pale vase, however, the color could not be interpreted as a single light tone. Light and shadow create their own tones, and the local color of the base would probably play a very small part in the tonal composition compared with the contrasting light and shadow tones caused by light falling on the vase.

Therefore, although a subject is intrinsically light or dark — and these 'local' tones should not be overlooked when considering the overall abstract design of a picture — it is those tones created by light falling on the subject that are more important in most realistic paintings in which the illusion of three-dimensional form is crucial.

In the same way that tone describes form, it can also be used to create space. By accurately rendering the tonal variations of objects receding into the distance, for instance, you will capture the atmospheric haziness, or aerial perspective, of three-dimensional space.

Careful and accurate representation of tonal values is therefore essential in any painting where a sense of three-dimensional reality is important. It is advisable to think about this tonal content in the very early stages of your painting and to plan your initial composition not only in line but also in broad areas of relative light and shade.

### COMPOSITION
The three paintings, *right*, are 'open' compositions, in that the figures could almost walk right out of the picture. In contrast, the cozily designed scene *far right* is a 'closed' composition, with the focal point enclosed in the picture.

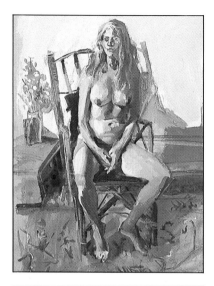

## TONE

The tones of a painting are as important as its composition and color. Before embarking on the painting *above*, the artist first made a black and white sketch *right*, in which the tonal design of the composition was worked out.

# PAINTING THE FIGURE

The figure is a familiar subject to most practiced painters who first began to work from a live model during their student days at art school; it is also a subject for which most artists have a great deal of respect. A complicated arrangement of form and color, the human figure presents a challenge to the most experienced of artists, and the old idea that 'if you can paint people you can paint anything' is not far from the truth.

Establishing the tones and colors of human flesh requires skill, practice and some accurate observation. Flesh tones vary markedly, not only between one race and another but also among individuals within the same race. Art students painting white models are sometimes told to mix the skin color from white and a little red and yellow; but this is an oversimplification. Skin color may differ noticeably between a person of Scandinavian descent and one of Italian descent, for example, between an old person and a young one; between a healthy person and a sick one. Even the same person's skin color will change subtly as lighting conditions change. And being slightly reflective, it will pick up colors and tones from surrounding objects.

Whether you are painting the figure nude or clothed, the task is much easier if you have a basic knowledge of anatomy to help you to understand the underlying structure of the body. This doesn't mean you have to know every muscle and bone in the body before embarking on a figure painting, but it does mean that the more you think about how the figure works — how it moves, what the basic proportions are — the more successful your painting will be.

# *Figure of a Young Man*

By using a tint on the white ground before doing anything else, the artist has provided himself with a tonal base from which he can make variations and which he can use as a guideline. The artist has taken a slight liberty in this opening stage. The main part of the tint has been made up of ordinary water-based house paint. While many artists in fact do this, especially when a large quantity is involved, it should be pointed out that manufacturers of acrylic paint are often reluctant to recommend this procedure, because some brands of house paint may eventually have an adverse chemical reaction with the acrylic and come away from the support.

This painting had to be done fairly quickly because standing poses are always tiring and cannot be kept up with any comfort for very long periods. The artist therefore gave the model a few minutes to settle thoroughly and comfortably into position, and also stopped for regular pauses for rest. This procedure illustrates how important it is to remember that when painting the human form you are actually painting a person. You should not become so absorbed in paint and technique that you forget that your subject is human. Moreover, bearing this factor in mind can often help the finished picture. The breaks and movement constantly bring the artist back to the realization that something living is being painted and therefore calls upon the artist to insure a lively rendering rather than a stagnant composition.

Using a large brush much of the time, the artist sketched in the main features rapidly. A lot of the original warm tint was left alone, to show through and act as a solid base for the lighter and darker planes painted on top. In order to allow the tint to show through, the artist applied the flesh colors — lighter and darker, warmer and cooler — quite thinly and transparently. He also used the 'drybrush' method to give a layer of broken color.

Because the flesh-colored tint was chosen to establish a tone for the figure, it became necessary to re-establish the white wall before the artist could make the tones and colors of the figure work together.

**1** *Right*, the model stands in a relaxed manner against a plain wall. To offset the upright pose and plain background, the artist has decided to position the figure to one side of the canvas and to make a feature of the expansive white background.

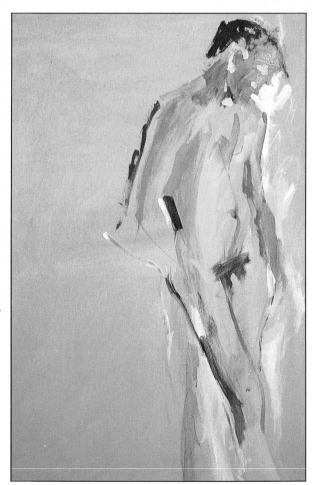

**2** White emulsion mixed with raw sienna and cobalt blue is used to establish a middle tone over the whole canvas. This can now be lightened and developed with the rest of the painting. Using a small decorator's brush and working in sweeping strokes, the artist blocks in the figure with raw umber, red oxide and Payne's gray *right*.

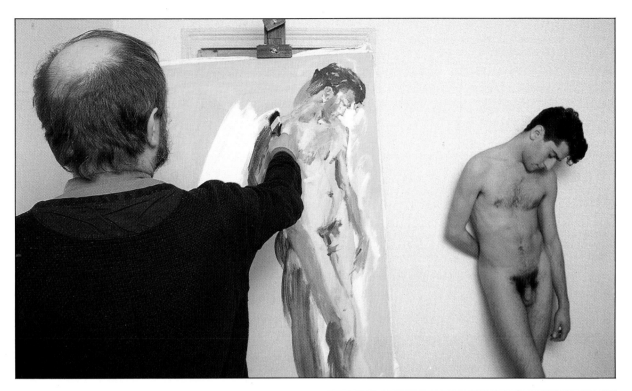

**3** Background tones are blocked in around the figure *above*. The new, light background color relates to those general tones already established on the subject.

**4** *Below*, the head is treated in the same broad terms as the rest of the figure. Chromium oxide green is added to the basic flesh colors to establish the dark, cool, shadow areas.

## APPLYING A TINT

Here the artist is using a tint to block out the dominant white tone of the primer. He wanted to create a 'middle tone' so that all lighter and darker colors could be related to this. In this painting the tint is mixed from white emulsion, raw sienna and a little cobalt blue. It is being applied with a decorator's brush.

**5** Broad planes of light across the abdomen are painted with a large decorator's brush, *right*. Working with a big brush encourages the artist to concentrate on the basic forms within the figure. It also produces a lively and spontaneous paint surface — something which is often sacrificed in very detailed and highly finished works.

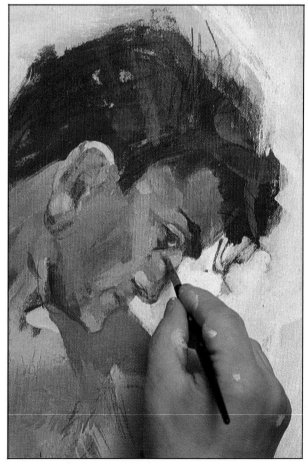

**6** With a soft drawing pencil the artist works into the features, defining and strengthening the outlines to bring out the character of the young man's face, *above*. The loosely scribbled pencil lines introduce fresh texture into the work as well as tightening up the painting in these final stages.

**7** A small sable brush is used for some final touching up, *right*. Here the artist develops the fine planes around the eyes. These final touches should be kept to a minimum — it is not necessary to disguise and blend the larger brushstrokes. Overworking will destroy the fresh, bold paintwork.

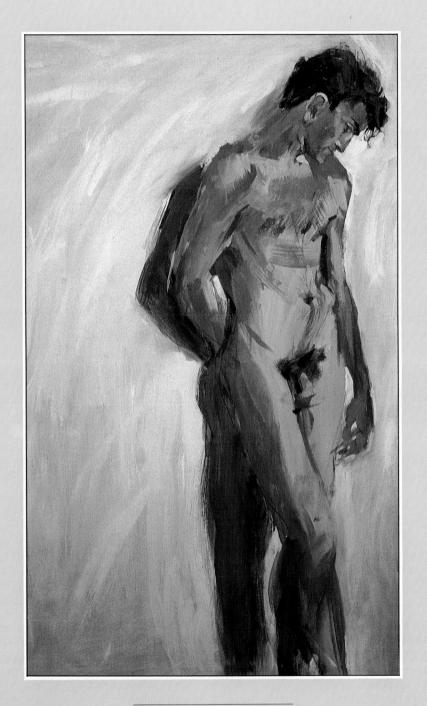

*Figure of a Young Man*

## What the artist used

The primed cotton duck canvas measured 30in × 20in. Red oxide, raw umber, chromium oxide green, Payne's gray, cobalt blue, titanium white, flesh pink, raw sienna and yellow ocher were applied mainly with a selection of decorator's brushes. A number 10 round bristle brush was used for developing facial details, and a black pencil for rendering shadows on the figure. The overall tint was based on white water-based house paint.

# *The Figure seen Differently*

The artist used a 'negative and positive' technique — and her own very personal taste in colors — when she completed this vividly individual painting.

Because she was working on a large scale, she used large brushes and confident strokes. She painted intuitively, without too much concern for light and shade. The danger here is that the painting will end up merely as lines and shapes without any real form, more like a flat pattern, whereas the objective was to achieve a more substantial representation of the living human form. One of the ways in which she overcame this problem was to vary the outlines. For instance, on the arms she used a bright and positive outline on one side, with a negative white line on the other. Thus the rounded arm is already given a three-dimensional form even before the final colors are applied. It could so easily have simply become a flat color between two lines on a flat surface, instead of an 'arm'.

She began by drawing the subject lightly in charcoal. The drawing looks casual, but she has in fact given herself quite a precise structure on which to work. It is a light drawing which will fade into insignificance during the ensuing stages of the work.

She did not use a rigidly systematic approach — that is, doing the outlines and then filling in the large areas of color or vice versa. Instead, she moved from one area to another, developing the outlines and the color across the whole image.

Offbeat colors were used in an impulsive way. Flesh pink, for instance, is not a color which most artists would take seriously, yet it is not used literally here but interacts spontaneously with yellows and blues; therefore it does not pretend to be 'skin' color, but reflects the personal taste and technique of the artist.

**1** No two artists work in the same way. The pose used in the previous pages *right* is interpreted completely differently by another painter. Instead of the expected flesh tones, this artist chooses bold outlines and brilliant, unrealistic colors.

**2** The subject is drawn directly onto an unprimed cotton canvas, with light charcoal lines and bold areas of flesh pink *right*. The drawing is loose and the paint applied in large, free strokes, but this initial mapping out is actually very accurate. The subject is placed centrally on the rectangular support, with enough space around the figure to avoid a cramped composition.

**3** Working in pink, yellow ocher, Payne's gray and white, the artist blocks in the figure and some background tones *far left*.

**4** Cerulean blue and cadmium yellow are introduced into the painting and smeared on by hand to vary the paint texture *left*.

**5** Moving across the canvas, the artist develops the colors, integrating the background tones with those on the figure *below*.

## USING A NEGATIVE OUTLINE

Negative outlines, or *anti-cerne* as the technique is often called, was used by the Fauvist painters to create contours and define shapes. It is the opposite of a black outline and, as such, does not intrude on the painting. Here the artist leaves a narrow white space between two areas of color to separate the background from the figure.

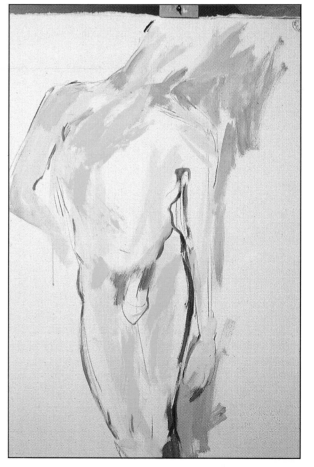

**6** A small bristle brush is used to draw into the form *left*. This is done in the same pure colors, but here the emphasis is on drawing rather than flat areas. Bold lines emphasize the structure of the head and neck, with particular attention paid to structure. Here the artist concentrates on the angle of the head and face in relation to the neck and torso.

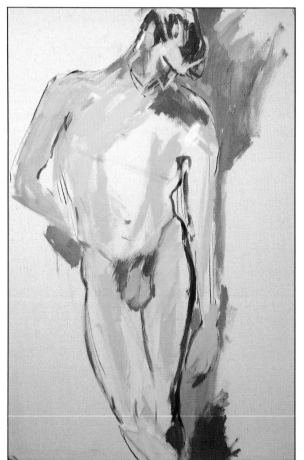

**7** The figure is seen essentially in terms of flat color and bold line, but a sense of form is created by the varied outlines *left*. For instance, the arms and legs seem solid and rounded because a dark outline on one side creates shade, while a weak or non-existent outline on the other suggests light.

**8** The background is blocked in, *above*, with layers of glazed color, with some of the same tones being incorporated into the figure. Here the artist uses a mixture of Payne's gray and white over cadmium yellow for the background, taking the gray through into the shadow under the arm.

## What the artist used

The paint was applied directly to an unprimed cotton duck canvas measuring 48in × 36in. Flesh pink, cerulean blue, yellow ocher, cadmium yellow, quinacridone violet, Payne's gray and titanium white were applied with a decorator's brush and round bristle brushes, numbers 12, 9, and 4. A number 6 sable brush was used for some of the lines, and the outline was drawn with charcoal.

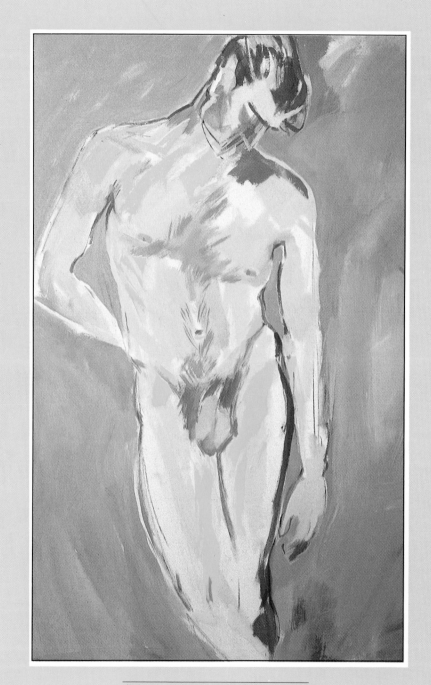

*The Figure seen Differently*

# *Sitting at a Sunlit Window*

The artist was concerned to capture the notion of light falling upon the girl seated in a chair at a window. Another important fact about this work is that it was carried out with mixed media – acrylic and gouache.

Because the sun was very bright, compared to the dark and shadowy room, the figure contains stark contrasts. Hard shapes, made by shadows, are thrown across the contours of the human body. But by the time the painting is complete, with color and detail added to give it life, we see that much of the sharpness of the shadows has been eliminated from the background. A little of the original harsh shadow has been preserved, but the artist has concentrated his main attention on depicting the effect of sunlight upon the girl's form.

In producing this effect, the artist has used a traditional approach – a method known as *grisaille*, sometimes called monochrome underpainting – in which the palette is restricted to two colors: usually white and black or a neutral color. In this case he has used white with raw umber. The purpose of this approach is to establish the form of the subject and the structure of the painting, tackling the problem of light and shade in the early stages before introducing the added complication of color. Thus the method is a simplifying one, allowing the artist to deal with the tonal composition first and the color later.

Because the underpainting acts as a guide to the eventual color, artists following this tradition often use glazing as a means of building up the color gradually. This enables the monochrome to show through the transparent glazes and have an effect on the final tone.

The artist used gouache as well as acrylic in this picture. These two types of paint are compatible. The difference between them is that when acrylic is laid down it cannot be dissolved (unlike gouache and watercolor, which can be manipulated with water even after they have dried). Acrylic, therefore, is very useful for the monochrome underpainting technique. It dries as quickly as gouache, and gives a stable undercoat on which the color can be applied. The artist can manipulate the gouache with water, moving it around and blending it, but the acrylic beneath will not be affected. Thus the artist can work in genuine stages. If the acrylic undercoating were to dissolve, the white and neutral color would soon make the top color very gray. This method keeps it pure.

**1** *Right*, the model is seated beside a window with bright sunlight streaming into the room. Stark patterns of contrasting light and shade are thrown across her body, clearly defining the contours and forms within the subject.

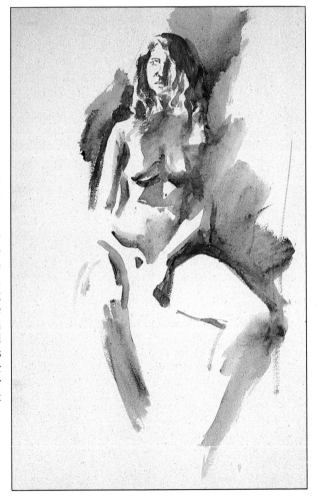

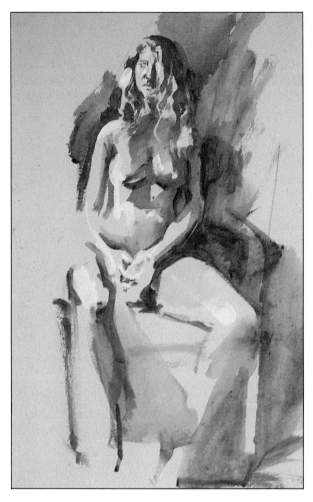

# MONOCHROME UNDERPAINTING

The artist used just two colors, white and raw umber, to establish the structure of this painting. This monochrome underpainting enabled him to solve some of the basic problems in the early stages before any real color was introduced. For instance, here he is working out the effect of the strong directional lighting on the contours of the woman's figure. The highlights are indicated in bright white, although these will later be modified to the appropriate light flesh tones.

**2** In this painting, *left*, the artist takes advantage of the quick-drying properties of acrylics by using them for the tonal underpainting before applying the top color in gouache. Acrylic does not dissolve, once dry, and therefore provides a stable base for the water-soluble gouache. The acrylic underpainting, built up in thin layers of raw umber, will not mix with the wet gouache when it is applied — this would cause the final colors to turn muddy.

**3** Contrasting tones are introduced into the underpainting *above*. Deep, opaque color indicates the dark shadows behind the model, and white acrylic is introduced into the lighter areas. This underlayer of bright white will produce luminous, semi-transparent colors when thin layers of gouache are applied over it.

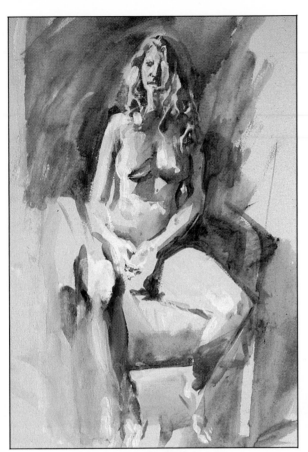

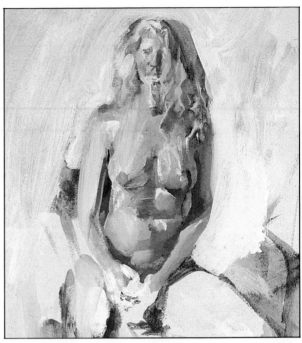

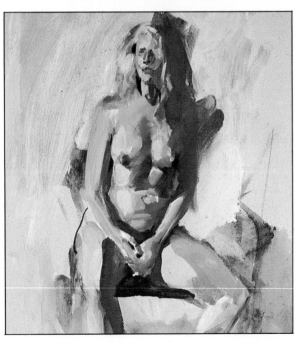

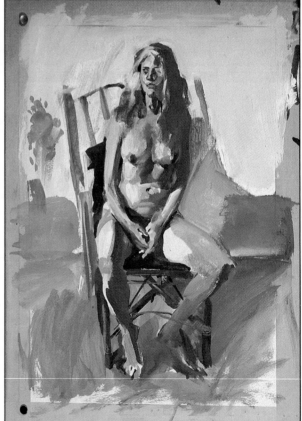

**4** The background is roughed in, establishing the approximate tonal values in relation to the figure *far left*. A tinted paper was chosen deliberately, and the artist used this as a middle tone, leaving areas of paper blank to indicate a tonal value.

**5** Gouache color is now worked over the acrylic monochrome structure *left*. Yellows and red-browns are introduced into the torso, face and hair. Because gouache remains workable even after it has dried, the color can be blended to produce a finished surface over the roughly blocked-in underpainting.

**6** Warm, dark tones are laid on the inner thighs, *far left*, and equivalent deep shadow areas, such as the hair and chair seat, are strengthened to match these newly-established dark tones. The face is developed in planes of light and dark flesh color.

**7** A sense of space is given to the composition when the floor and wall are blocked in *left*. The general composition is now almost complete, ready for the background details and some final remodeling on the figure.

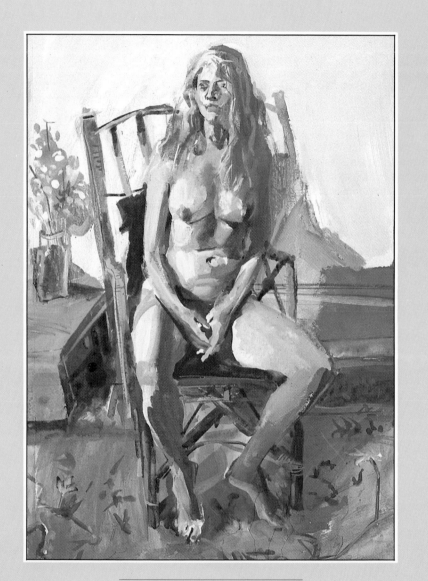

*Sitting at a Sunlit Window*

## What the artist used

Working on tinted watercolor paper, measuring 18in × 12in, the artist used titanium white and raw umber acrylic for the initial blocking in. Most of the color was painted in gouache — Payne's gray, magenta, lemon yellow, Naples yellow, red ocher, ultramarine blue, and yellow ochre — and applied with sable brushes, numbers 7, 5 and 2.

# *Working Quickly with Color*

Here we have three rapidly-done sketches on a large scale. They could have been given a much more finished look, yet in this case, because of the big scale and the bold and quick brushstrokes, they benefit from being left at a vigorous stage which preserves a certain sense of liveliness. The artists were less interested in the details of these paintings than in taking part in a spontaneous exercise in color, capturing the most important elements without worrying about the final touches.

Even the painting of the reclining nude on the patchwork quilt, a subject which would normally require intricate attention to patterns, avoids detailed finish. The artist has treated the subject in broad terms, in this instance deliberately painting the patterns on the quilt with a decorator's brush to maintain the idea of sketchiness.

This approach, with its quick gestures, is extremely valuable as a painting exercise. It is highly recommended for inexperienced painters, building up their confidence as they successfully cope with big scale compositions, capturing an overall image rather than concentrating on the more familiar details. It helps to avoid the bad habit of obsession with superficial pattern and detail to the detriment of the main structures and general composition of a picture.

**2** *Left*, painting directly onto the support without any preliminary drawing or sketches, the artist indicates the position of the model and starts blocking in some of the cool shadow tones of the head and torso.

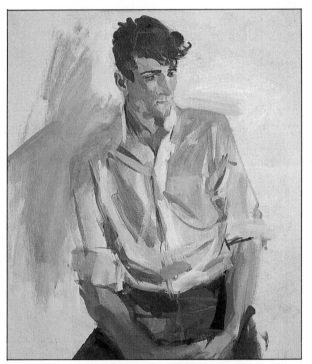

**1** *Right*, the young man in the striped shirt is sitting upright, a pose which is not easy to maintain for a long period of time. However, this color sketch was executed very quickly — it took less than two hours — and the model took several rests during that time.

**3** Color is rapidly built up in loose brushstrokes *above* Emphasis is placed on establishing the essential, broad areas of tone and color rather than on detail or getting an accurate likeness. Cerulean blue, black and yellow ocher are used for the model's jeans, and the shirt is painted in a diluted version of the same color.

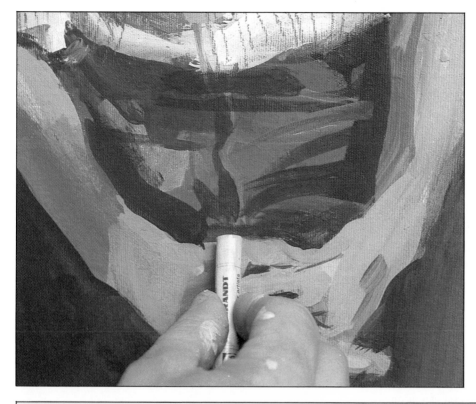

**4** The artist uses soft pastel for the light flesh tones *left*. This enables him to produce a thin, controlled line along the upper edge of the hands and arms. Acrylic paint lends itself to mixed media work such as this. Many artists make a basic painting with acrylic, adding pastel, pencil, ink, collage and a variety of other materials to vary the texture of the work. Graphite pencil and oil crayon are also used in this painting for surface texture and linear patterns, as on the striped shirt.

## PENCIL AND PASTEL WITH ACRYLIC

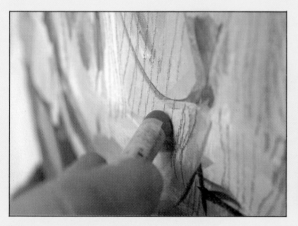

The artist used soft pastel, oil pastel and pencil to introduce some lively texture and pattern into this sketchy portrait. The picture shows him drawing the red stripes on the model's shirt.

These are sketched in quickly but are accurately observed to show the contours and folds of the fabric. The artist is using a drawing pencil to render the shadow areas.

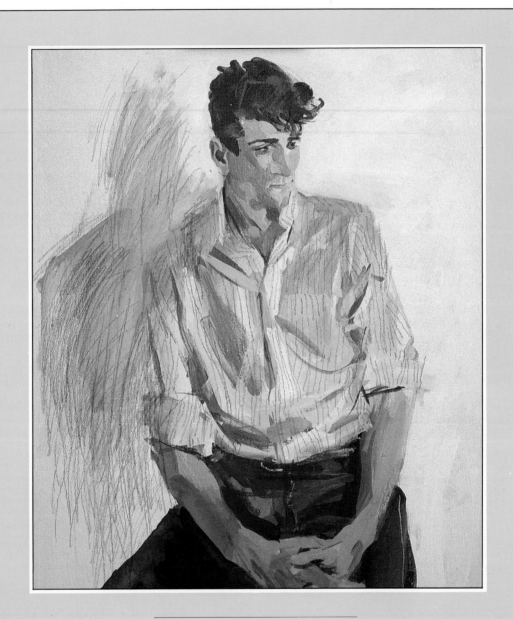

*Young Man in a Striped Shirt*

## What the artist used

A primed board, measuring 24in × 20in was used for this color sketch. The artist worked from a basic palette of ivory black, titanium white, chrome oxide, naphthol red, yellow ocher, and cerulean blue. He applied the color with round bristle brushes, numbers 6 and 10, and a number 4 flat bristle brush. Other materials included oil pastel, soft pastel, and a 2B pencil.

**1** *Right*, this subject would take weeks to paint if every detail were to be included. Here, however, the artist works quickly, getting down as much information as possible in a short period of time.

**2** No outline is used here, *left*. Instead, the artist starts by blocking in the reclining figure as a flat shape and indicating the position of the pillow and some of the quilt colors. The entire canvas area is utilized in this composition, with the model taking up almost the whole length of the rectangle. A decorator's brush is used to apply these large areas of thin color.

**3** A large brush is used to block in the bright-colored squares of the quilt, *right*. Each area is treated as a separate block of color, but the artist is careful to match the tones to those on the subject. By looking at the model and quilt through half-closed eyes, he is able to eliminate some of the dominant color from the composition, thus making it easier to pick out the tones and to establish them correctly on the canvas.

# PAINTING WITHOUT AN OUTLINE

No outline was used here. Instead the artist started work by blocking in broad areas of color with a large brush. Here he tackles the complicated quilt, not by drawing the shapes and then filling them in — which would be the conventional approach — but by simplifying the pattern into slabs of approximate color or tone. The paint is applied thinly so that the area can be developed and worked over.

**4** The general colors are now established. Very little light and shade have been used to indicate form — the shape of the bed, for example, is described by the perspective of the square patches, *right*. The figure has become slightly 'lost' against the busy, colorful background, so the artist changes to a small sable brush to add facial details and to emphasize some of the dark tones on the figure.

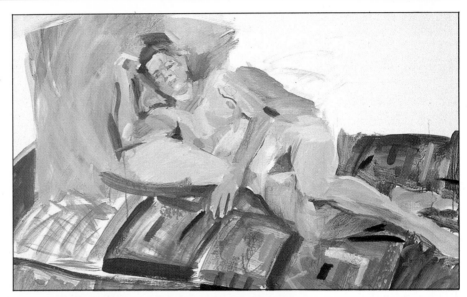

**5** *Left*, the artist moves into the face area, defining the eyes with a thin black line. The picture is a color sketch at the moment, but should the artist so desire, the composition is at a stage when it could be successfully developed into a more finished painting. The acrylic has been laid in layers of thin wash — an ideal underpainting for further detail.

## What the artist used

A primed cotton duck canvas, measuring 48in × 36in was the support here. The artist used cobalt blue, flesh pink, Payne's gray, cadmium orange, cadmium yellow, cerulean blue, titanium white, red oxide, quinacridone violet, burnt umber, yellow ocher, cadmium red, medium magenta and phthalocyanine green. He applied the color with decorators' brushes and flat bristle brushes, numbers 10 and 12. Details were added with a number 6 sable brush.

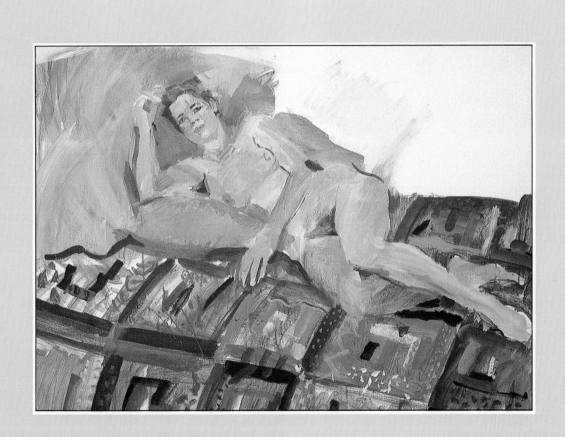

*Reclining on a Patchwork Quilt*

**1** *Right,* the pose is simple, with the model sitting in a relaxed and comfortable position against a white wall. This is used as a starting-off point, a vehicle for a vibrant and colorful painting.

**2** Texture is instantly important *right* because the artist is working on unprimed 'scrim', a woven fabric glued to board. The neutral color of the fabric represents a middle tone as the artist paints light flesh color over a charcoal outline.

**3** A cerulean blue background and brilliant outlines set the tone, *above.* The color choice is highly personal, but the way this is handled is far from arbitrary. Warm and cool tones are carefully balanced and bright lines describe the delicate form and contours of the figure.

**4** The untreated support is absorbent, producing areas of broken color with the scrim showing through the paint in places, *right.* This characteristic is exploited by the artist, the textured beige fabric being contrasted effectively with the bright acrylic colors.

# DRYBRUSH

Drybrush can be used instead of glazing, and is particularly effective when laid over a contrasting tone or color. It produces a lively texture with the broken color of the underlying paint showing through between the feathery brushmarks. A small amount of thick color is picked up on the end of the brush and brushed lightly onto the painting. Here the artist is drybrushing the light flesh tones with a decorator's brush.

## What the artist used

The artist painted directly onto a support of 'scrimmed' board measuring 40in × 30in. Scrim is a loosely woven fabric which the artist glued to the board with acrylic medium to obtain a neutral, coarsely textured painting surface. She worked from a palette of red oxide, raw umber, chromium oxide, Payne's gray, titanium white, flesh pink, yellow ocher, cadmium yellow, medium magenta, quinacridone violet and cerulean blue. The initial drawing was done in charcoal, and the paint applied with flat bristle brushes, numbers 12, 10 and 4; round bristle brushes, numbers 12 and 4; and a number 6 sable brush for the finer lines.

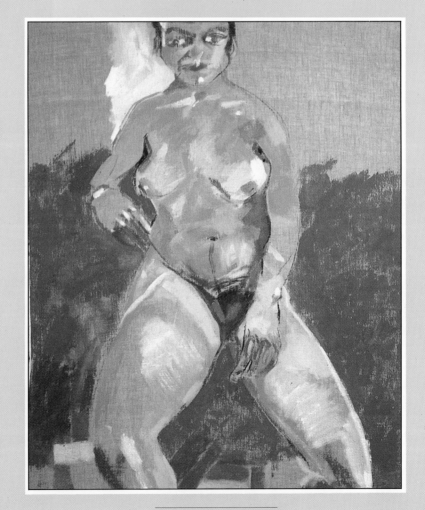

*Francesca Seated*

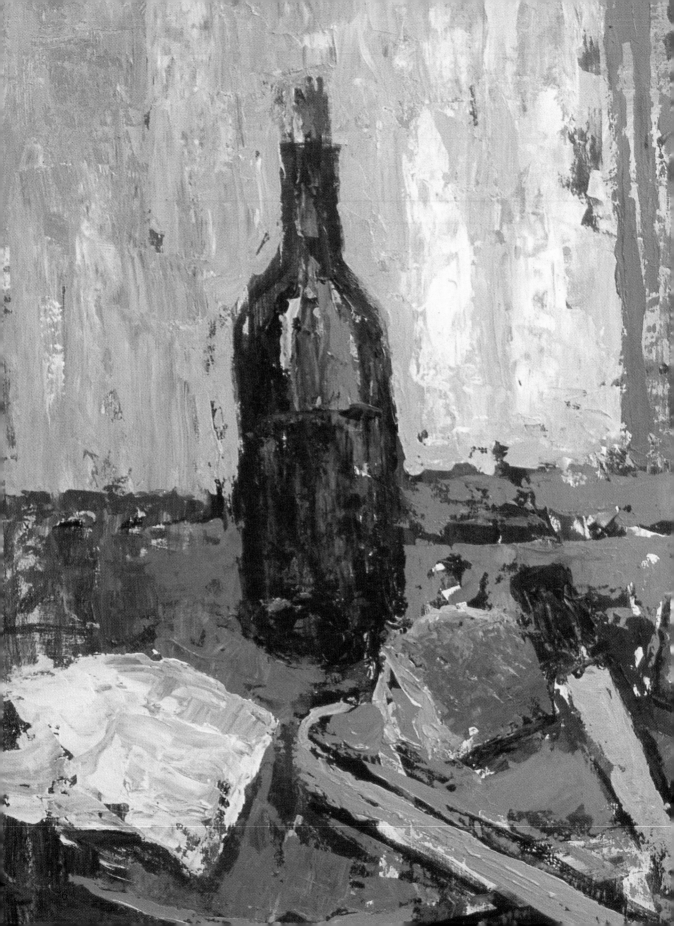

# CHAPTER SEVEN

# STILL LIFE

The removal of objects or groups of objects from the normal scenery of life is the essence of what has become known as 'still life'. It is almost as if a cameralike process has been in operation throughout the history of still life painting, picking out the detail of the world and bringing it into focus, which makes us aware of its visual properties.

One tradition of still life painting has been to capture elements from everyday life, taking such domestic items as a piece of bread on a plate, an unfinished meal, or a pair of shoes left on the floor. These are fragments which fascinate the viewer because they 'freeze' a small component of that routine which is so often ignored but in fact makes up the stuff of people's lives.

Still life has yet another attraction for artists – it can be something which is totally controlled, an artificial arrangement of those objects that interest the painter. Thus not only can it capture fragments of a scene, but it can also extract objects from their immediate environment and place them in situations which bring out their own characteristics and individuality.

Giorgio Morandi (1890-1964) is a good example of a still life painter who went to great lengths to choose subjects that fitted into his scheme of things. He concentrated on simple shapes placed in uncomplicated surroundings and painted everything in the same muted tones – earth colors and whites. He controlled things to such an extent that he would find a shape he liked – usually a bowl or bottle – and then give it a coat of white paint, forcing it into his own visual arrangement.

Showing how to capture both of these approaches – the 'moment-in-time' view of a fragment, and the deliberate rearranging of a close-up scene – will be one of the main objectives of this chapter.

# *Food on the Farm*

The remains of a simple, rustic meal lie on the table. The earthenware jar provided the beer, and the food was basic bread and cheese. The finished painting, with its earthy simplicity, belies the way in which it was constructed, because this was an exceptional case in which a composition was painted, not on a white support but on another painting beneath. This was an incomplete picture which the artist had rejected, and the picture shown here was built up over the rejected one.

When working on a white support it is important as a first step to get rid of the glaring white canvas, either by blocking in the main shapes or by applying a tinted wash. In this case, the artist deliberately avoided painting out the original image. Pieces of it, therefore, showed through during the work. The artist chose to directly overpaint the original picture because it contained some bold lines. These lines were not incorporated into the new picture, yet faint traces of them could be seen between the new blocks of color during the work process. Thus they acted as a connecting theme – something to work onto, rather than facing the untouched space of a normal white ground. They helped to remove that certain flatness which, in the early stages, afflicts painting done with a knife.

Acrylic paint has a thick, buttery consistency which makes it very satisfying to work with, when applying the color with either a palette knife or a painting knife. The finished effect, of knife strokes rather than brush marks, dries quickly when it is done with acrylic. With oil painting, however, the same strokes would take much longer to dry. The artist in fact completed the painting shown here in less than two hours – much faster than his normal rate of work. This was because he paid minimum attention to drawing the subject, but started working almost immediately with the knife.

Sometimes the surface of a painting done with a flat palette knife can look monotonous. A whole painting done in this way can look plastic, like the cheapest of reproductions. The artist avoided this by varying the paint surface. When he was painting the bread, for instance, he dabbed and stippled instead of simply laying on the color, in order to achieve a contrasting texture.

The artist used earthy colors, pigments such as red oxide, yellow ocher and bronze yellow, to reflect the rustic warmth of the subject. Earth colors like these actually come from the earth; they are natural substances dug directly from deposits in the ground.

**1** *Right*, warm ochers and earth tones are abundant in this still life arrangement and are reflected in the artist's palette, which includes red oxide, yellow ocher, bronze yellow and cadmium yellow.

## PAINTING WITH A KNIFE

Palette and painting knives can be used for creating surface patterns and texture in wet paint as well as for applying thick, opaque color. Here the artist adopts a brisk patting motion with a painting knife to create a rough, stippled texture on the loaf of bread.

Strictly speaking a palette knife, as the name suggests, is made for mixing and scraping paint on the palette. Palette knives are generally more difficult to use for applying color than the purpose-built painting knives that have properly constructed blades – rigid at the handle end, but with the right degree of flexibility overall.

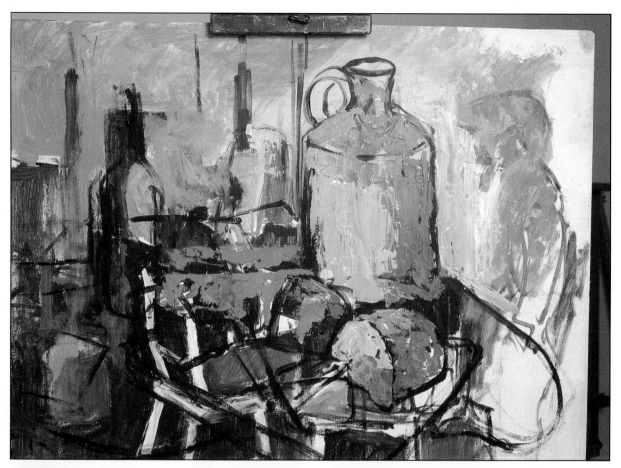

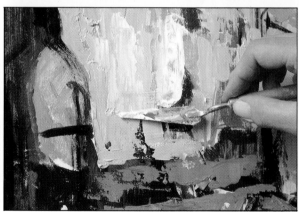

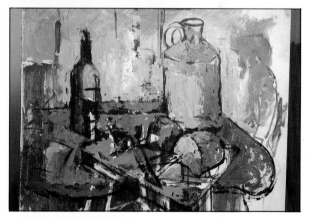

**2** *Top*, working over an old painting, the artist starts by laying the main color areas with a painting knife.

**3** Color is applied thickly, often being mixed directly on the picture instead of the palette.

**4** The old painting shows through in places, the broken up image becoming integrated into the new composition, *above*.

**5** Yellow ocher, bronze yellow and white are applied separately to create the rough texture of the brown bread. The artist uses a painting knife to partially mix the colors and to roughen the paint surface, *right*. Thick acrylic paint is ideal for creating thick impastos in this way, but you must work quickly to get the desired effect before the paint dries.

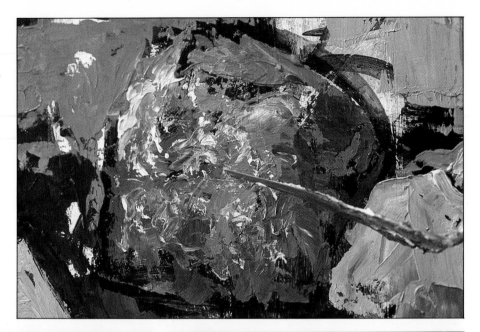

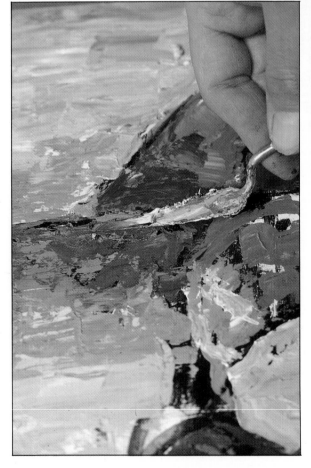

**6** Thick layers of brown are scraped onto a yellow ocher base to indicate the shaded side of the rounded earthenware pot, *left*. The artist deliberately left the surface rough and unfinished, thus preserving the freshness of the color and a lively spontaneity. Black outlines show through in places and strengthen the image.

**7** Various textures are introduced, each one reflecting the nature of the subject it portrays, *above*. For instance, the steel knife blade is laid in thick wedges of flat gray; the crusty bread is criss-crossed in heavy, matte strokes; and the crumbled brown loaf is painted with a rough, stippled texture.

## What the artist used

This painting is unusual in that it is constructed over another picture — one of the artist's rejects. The support is hardboard treated with acrylic primer, measuring 30in × 22in. A painting knife and flat bristle brushes, numbers 3, 6, 7 and 11, were used to apply the color — cadmium yellow medium, yellow ocher, bronze yellow, red oxide, sap green, black and titanium white.

*Food on the Farm*

# *Quiet Interlude*

This painting was done by an artist who works almost exclusively in the style known as *trompe l'oeil*, an illusionist technique designed to deceive the eye into believing that what is seen is really there in front of it, rather than existing only in a picture.

The picture shown here doesn't fall strictly into this category, but the artist's general approach is evident in the way in which he has handled the color and the method of application. Most artists will have developed a personal palette; they will have become used to working in certain colors which gradually come to be identified with their work. But a *trompe l'oeil* painter does not put any personal interpretation into a picture. It is purely the objects and their own shapes, tones and colors, which are represented – not the artist, who has remained totally anonymous. These less personal styles help to give a refreshing variety to the world of painting when they are supplemented by the works of artists who impose more individuality onto their pictures.

This painter is not setting out to represent 'life' or some philosophical concept . This is why he carefully arranged the objects in order to provide a visual contrast and effect in the picture shown. He chose objects he liked the look of. What is being said here, in other words, is in strictly visual terms. The bound leather volume rests upon the newspaper, which displays its crossword. An ashtray lies on top of the book. To us it may suggest a 'quiet interlude', as the title states – but to the artist it has been the juxtaposition of object, line and color which has governed the composition.

The artist has also dissociated himself from concerns about the quality and texture of the paint. He has not attempted to make the paint interesting in itself. He has not used washes, or tried to vary the texture – the paint surface remains bland. He is more interested in imitation, in 'copying' the subject. The result is a painting with a certain sharpness, which many find pleasing, and which has much in common with a color photograph, or the world of advertising and posters.

This style delivers itself up entirely to 'content'. It can have dramatic effect in murals, when objects of everyday life – perhaps small, intimate and domestic – can be transferred onto large murals, covering an entire wall or perhaps the side of a building.

The burning cigarette introduces a surrealistic aspect to the composition. The picture has captured a moment in time, although the viewer knows that the painting must have taken much longer to complete than it took for the cigarette to burn!

**1** *Right*, the subject is carefully arranged because the artist wishes to convey a certain idea – the notion that the picture encapsulates a moment in time. The casual crossword, the ashtray and the cigarette – these are deliberate 'props' rather than random items.

**2** A hard 4H pencil is used *above* to draw the position of the subject on the canvas before the artist starts to block in the main areas of color. The paint is used thinly at this stage.

**3** The image is built up gradually with layers of thin color, *right*. Here the artist develops the leather-bound book with washes of red oxide, black and white. The artist wants to create a highly finished work, in which detail plays an important part. Unlike many painters, he prefers to concentrate on one particular area, taking it to a finished state before moving on to another part of the painting.

**4** A small sable brush and slightly thicker paint are used to pick out the surface details, *left*. Gray is mixed from black and white for the shadows and white is used for the highlights. Again, this is an unusual approach — most artists avoid using too much black and white, preferring to mix 'living' grays from other colors. They also avoid bright white for highlights.

## USING PENCIL OVER ACRYLIC

A 2B drawing pencil is used here to indicate the delicate tonal variations of the shadow areas underneath the book and papers. The lead pencil is used in light cross-hatching strokes, so giving the artist absolute control over the subtle, graded tones. These are carefully faded out at the edges, capturing exactly the spreading, diffused nature of the shadows on the actual subject.

**5** The rounded form of the ashtray is accurately copied in a darker tone of the local color *right*, and the tiny patterns are faithfully rendered to produce an instant and convincing likeness of the object. However, seen from close quarters, the detail is not photographically reproduced — it is painted just tightly enough to deceive the eye, but does not stand up to close scrutiny.

**6** *Above*, the artist develops the shadow underneath the sheet of paper, darkening the tone to match those established elsewhere in the picture. A characteristic of *trompe l'oeil* painting is the exaggeration of tones and colors, often making them starker than the actual subject. Using pure black for extreme shadows — as the artist is doing here — is typical of this approach.

## What the artist used

The artist chose a bought canvas, measuring 18in × 14in and pre-treated with acrylic primer. He used a 4H pencil for the initial outline of the composition and a softer pencil (a 2B) for working into the shadows. Ivory black, red oxide, cobalt blue, burnt umber, raw sienna, titanium white, naphthol red, quinacridone violet, phthalocyanine green, cerulean blue and cadmium yellow light were applied with a selection of synthetic and bristle brushes — flat brushes, numbers 2, 4 and 10; round brushes, numbers 2 and 6; and sables, numbers 2 and 4.

**7** Moving across the whole picture, the artist adds details and tidies up any areas that appear less finished than the rest of the painting, *right*. It is essential that no part be left undefined or incomplete. Such areas look wrong and out of focus, tending to destroy the photographic impression that this particular painting technique produces.

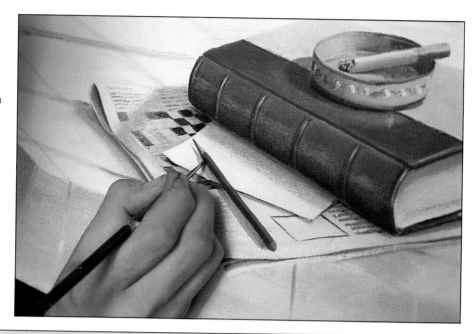

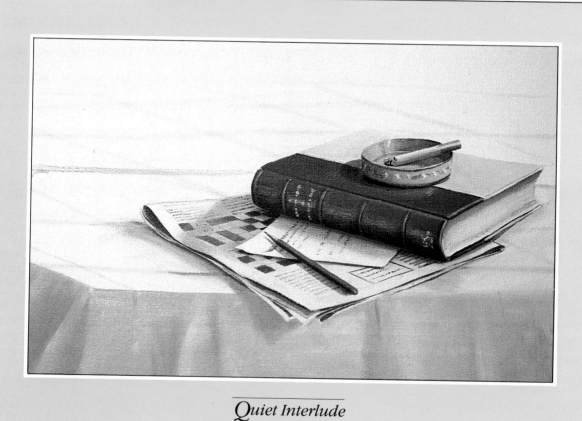

*Quiet Interlude*

# *Flowers in a Blue Vase*

Here is a classical arrangement of cut flowers in a vase on a table. The artist has used the vertical and horizontal lines of the window and the table top to divide the rectangular picture in a harmonious way. Yet these rather severe, straight lines do not dominate the picture. They are interrupted by the organic variety of the shapes of the flowers and leaves, which modify and soften the effect.

Because the delicate balance between the subject and the background, and the scale of the flowers in relation to the space around them, were crucial to the composition, the artist decided to begin by using a sketchbook. Before committing the composition to canvas, he made a rough drawing in his sketchbook to work out exactly how the shapes would relate to each other.

The sketch was divided into squares, so that when it was enlarged onto the canvas, each shape was kept in its proper place on the whole rectangle. The squares were first drawn on the sketch. Then the large canvas was divided into the same number of squares — bigger ones, of course. Thus a flower appearing in the top right hand corner of square number three could be depicted occupying the same position and proportion of space in the top righthand corner of the same square on the canvas, becoming automatically enlarged in the process.

A common approach, in a painting of this nature, would be to deal with the most obvious subject first, and start by painting the flowers, because of their prominent colors. The artist, however, chose to block in the background, table and vase beforehand. This insured that these tones and colors were correct in relation to each other, before going on to the flowers. It also made it easier for him to pick out the rather delicate, complicated petals and foliage, exploiting the opaque quality of acrylic paint by taking the brushstrokes over the background instead of having to fill in the background later around the flowers.

For the background the artist made use of acrylic 'flow-improver', making it easier to spread the paint on the canvas. The actual shape of a brushstroke, with its fluent sweep, was used by the artist to depict the flower petals, capturing the natural curve of their growth. The artist built the flowers up from lighter to darker tones, and used a matte thickening gel to make the brushstrokes stand out slightly and thus emphasize the shape of the petals.

**1** The subject as it stands *right* is too symmetrical to make an interesting composition. To counteract this, the artist places the vase of flowers slightly off-center in the painting, substituting an expanse of white for the darkened window.

**2** A precise drawing *right* helps the artist to decide how much of the background to include in the composition. The image is then enlarged onto the support.

**3** *Above*, acrylic flow-improver is added to the water in a ratio of approximately one part flow-improver to ten parts water.

**4** The artist blocks in the main color areas *right*, using the solution of flow-improver to help the paint spread more easily.

## ENLARGING A DRAWING

Here the artist is working from a small sketch which he is reproducing on the canvas on a larger scale, ready for painting. The method used here, known as 'squaring up', involves drawing a grid of squares or rectangles over the sketch. A larger version of the same grid is then constructed on the support, and the image reproduced section by section to obtain an accurate enlargement.

**5** Chromium oxide green is mixed with a little black for the foliage *above*. Titanium white is added for the lighter tones. The local color of the leaves is actually quite a bright green, but the dark shaded wall immediately behind makes them look much darker.

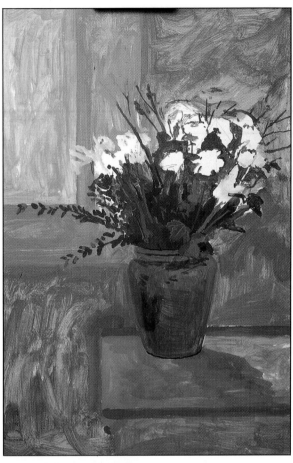

**6** Gray background tones behind the flowers are blocked in *left*. The artist uses the background color to redefine the characteristic shape of the leaves, taking the gray over the edge of the existing green where necessary.

**7** *Below*, some of the flower heads are painted in cadmium yellow and white; others in yellow, red and white. Gel medium is mixed with the paint, enabling the artist to show the form of the petals with impastoed brushstrokes.

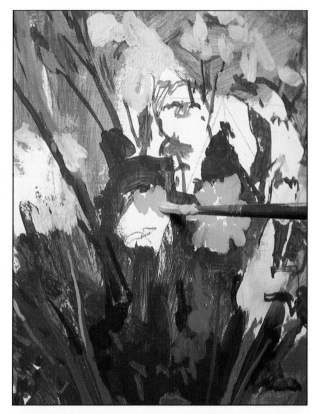

**8** Before returning to the flowers, the artist adjusts the background tone. This is initially lightened with pale gray *left* which is eventually replaced with a more accurate medium gray.

**9** *Right* Finally, the flowers are developed and the detail is picked out — deep orange for the dark tones of the pink flowers, gray centers for the yellow ones. The artist uses the tip of a sable brush for this fine work.

*Flowers in a Blue Vase*

## What the artist used

A piece of plywood measuring 24in × 18in, found by the artist in a builder's refuse container, is the support in this colorful flower painting. This was primed with a solution of rabbitskin glue and an equal mixture of titanium white pigment and French chalk. Acrylic 'flow improver' was introduced for the initial blocking in, and matte thickening gel for the slightly textured petals. The artist chose a palette of cobalt blue, phthalocyanine blue, chromium oxide green, cadmium red, red oxide, cadmium yellow medium, quinacridone violet, ivory black and titanium white. Colours were applied with round brushes, numbers, 6, 8 and 10, and flat brushes, numbers 10 and 12. Sable brushes, numbers 2 and 5, were used for detail.

# Old Tennis Shoes

As with the previous picture of a leatherbound volume, this artist also was emphatic about his subject before he lifted a brush. He insisted on old – not new – tennis shoes, pointing out that the old, squashed ones reflected the shape of the human foot. Unlike many still lifes, this one has no background, exploiting to the full the white canvas. The shoes sit almost in space, linked to reality by their shadows. The only concession to conventional composition is that they are offset, rather than being placed in the center of the picture. Again, the message, such as it is, consists entirely of a visual representation – in this case of a pair of old tennis shoes.

The artist has used tonal contrast in this picture to describe the form of the shoes. He has taken the white – the lightest tone and also the local color of the shoes – as one extreme of his spectrum, and then he has switched to the other extreme – black – for the deepest shadows. Most artists would not work in this way. They would avoid using extreme whites and blacks, tending to prefer a less stark range of tones. Ironically, although the result is a literal reproduction of the objects, the extreme tones used are rarely found in the real world, where atmospheric conditions usually restrict objects tonally to varieties of grays. When looking at white or black, the eye usually does not perceive these colors as literally white or black, the intervening haze will change them to very light or very dark gray.

This type of painting is dependent upon accurate detail. Within this style it is possible for an artist to get away with some glaring mistakes in shape, form or color, so long as the finish is perfect and the details are convincing. In fact, in the picture shown here, there are no such glaring errors. Even if there had been, however, the artist would probably have distracted the viewer's attention by some impressive detail work. The precise rendering of the lettering for the brand name and of the eyelet holes gives these details considerable impact, so that they immmediately capture the viewer's attention.

The artist has taken trouble to depict the brand-name on the shoes in the correct style of printers' typeface. When painting detail like this, you must insure that you remain disciplined by what is before you. It is the exact image of what lies in front of you that you are painting. If you slavishly reproduce a detail such as the correct lettering, but omit a curve or shadow in the object itself, the result will look distorted and naive.

**1** A pair of old tennis shoes *right* is the subject of this still life. These are placed on a sheet of white paper because the artist intends to paint them without any background and wants as few distractions as possible.

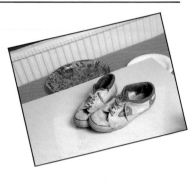

**2** *Left*, the initial form is roughly blocked in with diluted, washy colors and a large bristle brush.

**3** Continuing with the same loose brushstrokes, the artist works into the image, darkening the tones and developing the form, *below*.

# USING TONE

In the first picture the artist is using a medium gray, a middle tone, to indicate the position of the shadow in the center of the shoe. As the painting progresses, the tones are developed to create a sense of form and space in the whole composition, and in the second photograph we see the introduction of black to increase the depth of the shadows and emphasize the form of the shoe. The artist chooses to exploit this extreme tonal contrast — the black shadows on the white tennis shoes — to create a strong, clearly defined image that stands out from the stark, bright background.

**4** *Right,* this ultra-realistic style of painting depends on close observation for its success. The detail is accurately described but cannot exist merely as isolated decoration. Surface patterns and details, such as the molded rubber soles and green trimmings on the shoes, relate closely to the main forms and must be precisely placed if they are to contribute to the overall composition.

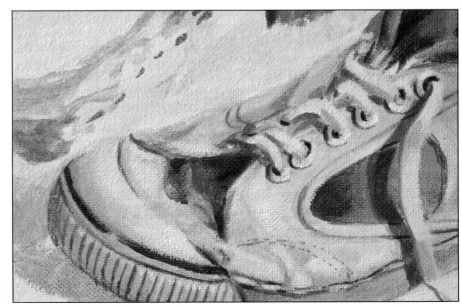

**5** *Left*, the shadow tones inside the shoes are darker versions of the local green color. This is mixed with varying amounts of black to obtain the different shades.

**6** A light gray shadow is indicated under the shoes, *below*. Apart from this, the artist does not attempt to create a sense of space around the subject, preferring to place the shoes against a flat white background.

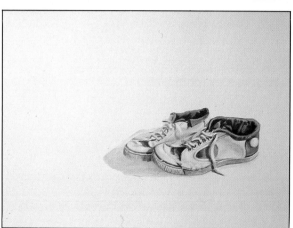

**7** The subject emerges from the white canvas in a startlingly realistic way *above*, looking convincingly three-dimensional against the contradictory flat background.

**8** A fine brush is used for the lettering, *right*. Lettering always becomes a focal point in a painting and must therefore be rendered with absolute accuracy. In this case the artist is taking care to make the letters follow the form of the shoe.

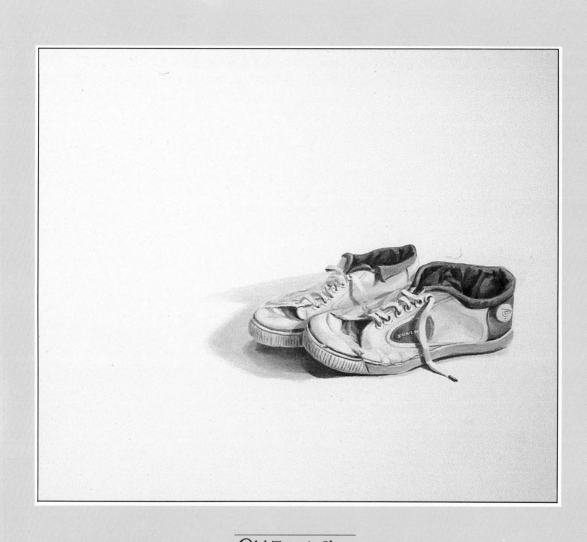

## Old Tennis Shoes

### What the artist used

A bought canvas, measuring 20in × 16in and primed with acrylic primer, was the support for this still life.

Most of the painting was done with flat bristle brushes, numbers 6 and 10, the detail being applied with a number 2 sable brush. The artist used titanium white, ivory black, raw umber, Hooker's green, phthalocyanine green, yellow ocher, burnt sienna and cobalt blue.

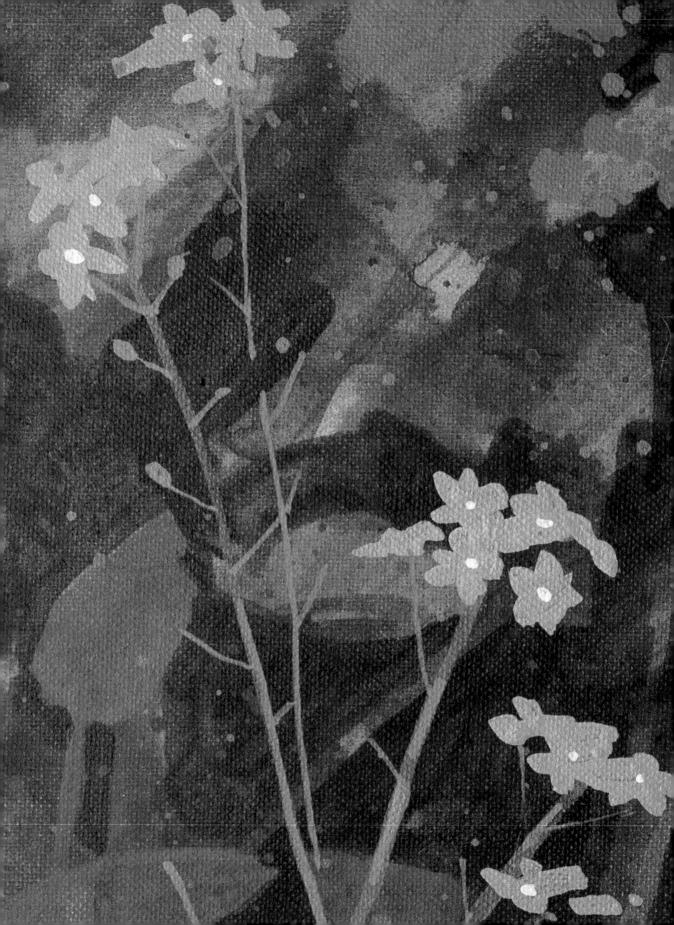

# PAINTING
# FROM
# NATURE

There is a category of painting which forms a bridge between still life and the more grand and sweeping depictions of landscape. This is what we have chosen to call 'painting from nature' — the representation of shapes and colors which have grown or been otherwise formed without the help of humans.

Inevitably, a major factor of interest for the painter and the viewer in this category must be the attempt to capture on paper or canvas the essence of growth, the idea of something organic. This can be the obvious, such as flowers, animals and plants; or it can be something 'still' and reliclike, such as pieces of driftwood or the skulls of animals.

Many shapes from nature have an individuality which requires looking at them afresh, without preconceived ideas of what a shape should be. For instance, when painting a bottle, or the human figure, the painter is helped — many would say hindered — by the common knowledge of what such a shape should be. Many forms can be found in nature, especially such things as stone and pieces of wood, which are surprisingly unlike what you expect them to be. Natural objects need to be looked at, observed directly with a fresh eye. The painter must be on guard against jumping to conclusions over what such a shape should be.

# *Wallflowers and Forget-me-nots*

For this picture, the artist wished to work outside in the sunshine and light, without doing a landscape, so he has done what is in effect a micro-landscape, concentrating only on the flowers close at hand. When painting flowers growing naturally in this way, it is impossible to control the composition as you can with a still life painted indoors. In the case of this painting, the flowers took the form of a scattered pattern across the whole picture surface instead of being a carefully arranged focal point.

Paint in this picture was used comparatively thinly, because the artist worked on good quality stretched watercolor paper. Thus the delicate appearance of a watercolor painting was achieved, rather than a painting on a textured canvas. The artist started the picture without a sketch or plan. He made random splashes with green until the whole paper was covered in a blotchy, light green wash. The light green color was now available to be used for the lighter toned parts of the leaves and stems. The artist then took a sable brush and mixed a darker tone of the same color. He worked into the shadow areas and gradually sculpted out the foliage and leaf-forms. While the paint was still wet, the artist took the opportunity to introduce a little texture into the work. With screwed-up tissue paper he dabbed the surface to attain a mottled effect, suggestive of natural leaf texture.

It was now necessary to redefine some of the lighter leaf shapes, to give them a harder edge and make them stand out from their green shadowy environment. Without overdoing this, the artist selected a few prominent leaf-shapes and painted these in with an opaque light green, made by adding a little titanium white to the foliage color.

The next stage was the easiest, yet the most effective. The artist, still using his fine sable brush, painted the flower shapes over the leaves – light blue for the forget-me-nots and a range of glowing oranges and reds for the wallflowers.

This was not an exercise in accuracy. The artist necessarily avoided being over-concerned to represent each leaf and flower. There were so many flowers that he contented himself with achieving an overall effect.

**1** This close-up view of a flower bed *right* is a scattered pattern rather than a composition. The artist does not set out to depict every single flower, but to find a way of capturing the overall effect.

**2** Working from light to dark the artist applies an uneven, random wash of Hooker's green mixed with a little cerulean blue and black *above*.

**3** A second, slightly darker wash is worked into the first *left*. Selected areas of the light green are left unpainted to represent the lightest leaves.

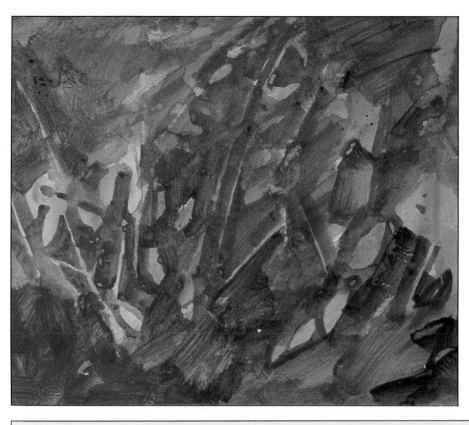

**4** More layers of green are worked across the image *left*. Each time a wash is applied the artist leaves certain parts unpainted. The very dark areas deepen the shadows between the leaves and stalks; the pale greens highlight some of the more prominent foliage. A mottled effect, suggestive of natural leaf texture, is achieved by blotting wet areas with tissue paper.

## MAKING TEXTURE

The artist dabs the wet wash with a tissue to obtain a natural, mottled effect. This texture is applied randomly rather than to specific areas, the blotchy, overall pattern being similar to the tangled foliage of the subject. Various techniques can be adopted to create a wide range of effects in wet paint — in this case, the light, mottled patches are introduced to break up the deeper shadow areas, giving a convincing, realistic touch to the shady undergrowth.

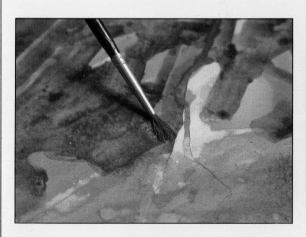

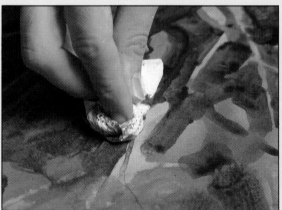

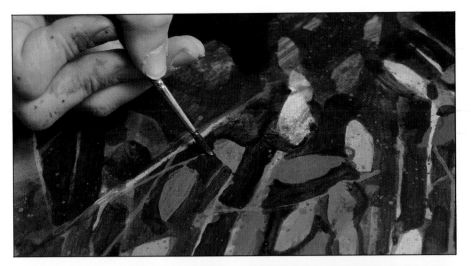

**5** *Left* The basic green has been mixed with black and a little white for the deepest foliage shadows. Now the artist uses the paint more opaquely, tightening up and redefining the shapes as the deep shadow tone is painted in between the leaves and stalks.

**6** Pale opaque blue is dotted in for the forget-me-not heads *left*. The opacity of the color enables the artist to paint over the darker foliage. The subject is referred to constantly for the correct shape and scale of the flowers, even though each individual flower is not faithfully included and the artist has concentrated instead on giving a general impression.

**7** The varied tones of the orange wallflowers are mixed from cadmium orange, cadmium yellow, red oxide and naphthol crimson *left*. Again, the artist is not concerned with putting each flower in place, but uses the subject as a general reference.

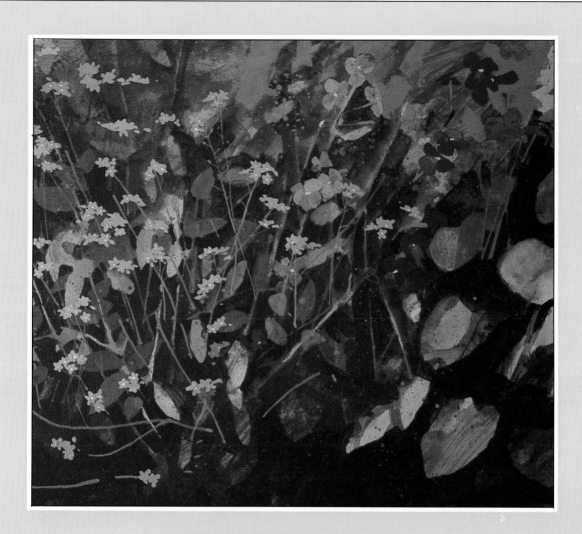

*Wallflowers and forget-me-nots*

## What the artist used

Because the artist wanted to put the color on thinly, and to use the acrylic paint transparently rather than opaquely, he chose a heavy Arches watercolor paper, 18in × 12in, to work on.

Titanium white, ivory black, Hooker's green, cerulean blue, cadmium orange, cadmium yellow, red oxide, sap green and naphthol crimson were applied with sable brushes, numbers 8, 4 and 2.

# *Skulls on a Shelf*

The skulls of two animals, probably a cat and a sheep, lie on a shelf — a ghoulish subject, perhaps, but one which interested the artist because of its limited tones and its simplicity. The artist approached the painting in what, for acrylics, is a classical way. He diluted the paint, using it almost like a watercolor wash, to block in the main shapes. The background tone was laid very roughly. It was made deliberately darker than the anticipated final color of the white wall — the acrylic titanium white. This densely opaque color will totally obliterate anything it is painted over. With acrylic, therefore, the artist has firm control over the final degree of whiteness in the picture — unlike the situation with watercolor, where it would be necessary to work from light to dark because one can never really prevent an underlying color showing through.

The subject's tones are limited but they are not without interest. The artist has made full use of the warm and cool colors. Muted though the tones of these skulls may be, they are not dead or muddy.

Some subtle yet lively differences are available for exploitation by the artist. The cold bluish grays in the wall shadows have been made to contrast subtly with the warm brown-grays of the wooden shelf. These warm and cool tones are brought together by the artist as he works into the bone formation of the skulls.

The composition is calculatedly stark. It reflects the fact that the artist has striven to maintain a certain spacious bleakness — notice how he has moved the vertical background division from one side to another to emphasize the angular construction of the picture. The composition is unusual in that this upright vertical division is the only element to offset what would otherwise be a totally symmetrical arrangement.

In some areas of the painting which have threatened to become flat, the artist has introduced texture with a drawing pencil. The pencil has also been used to redefine the crisp edges of the skulls, conveying to the viewer an almost tactile sense of their brittleness.

**1** *Right* Placed in a stark, geometric setting against a white wall, the fragile structure and subtle tones of these two animal skulls are shown to advantage.

**2** The subject is first drawn on the canvas with an H pencil. Because the skulls are structurally complex, with irregular curves and contours, the artist takes care to make the initial drawing as accurate as possible. The background is toned down with gray mixed from whites, black and yellow ocher *left* — although this will later be lightened to tone with the subject.

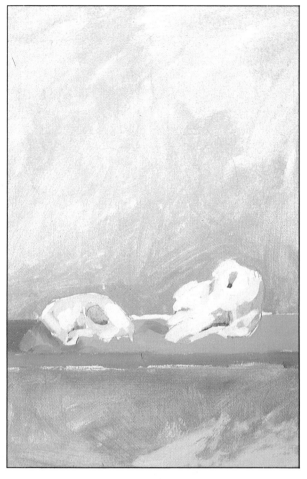

To get an absolutely straight edge along the back of the shelf, the artist uses masking tape. This is pressed firmly down and the paint mixed to a smooth, creamy consistency — if the tape is loose or the paint too thin, the color will seep under the edge of the masking tape and spoil the effect. The paint is taken carefully over the edge of the tape and, when this is completely dry, the tape is peeled off to reveal a crisp, clean edge.

**3** More general blocking in is done on the background and shelf *above*. The shelf tones are mixed from black, white, orange and yellow ocher.

**4** The artist establishes the wall color in opaque white mixed with a little black *right*. This is left deliberately uneven to avoid a flat background.

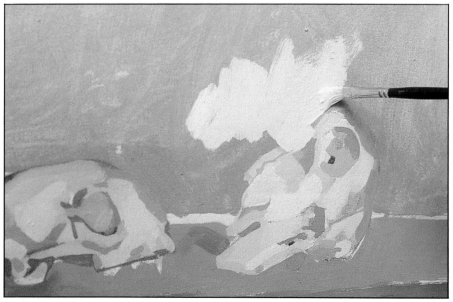

**5** Cool gray is worked into the shelf, the same color being echoed in the shadow areas of the skulls *left*.

**6** *Right* The artist constantly corrects the shape of the skulls as various tones mixed from black, white and yellow ocher are blocked in.

**7** Shadows are strengthened *above* with a mixture of Payne's gray, white and cadmium yellow. Pencil shading scribbled over these breaks up the flat texture.

**8** A strip of orange is painted along the edge of the shelf to set off the muted tones elsewhere in the picture. The artist uses masking tape to get a straight edge *right*.

*Skulls on a Shelf*

## What the artist used

For this painting the artist stretched his own canvas, using cotton duck over a wooden stretcher measuring 24in × 20in. This was primed with a mixture of equal parts emulsion and emulsion glaze, diluted with water. The artist worked with a limited palette of six colors — yellow ocher, Payne's gray, titanium white, ivory black, raw umber and cadmium orange. A small decorator's brush was used for the background, a number 4 flat for the main blocking in, and a number 4 sable for the detail. Some shading and the initial outline were drawn with an H pencil, and masking tape was used to obtain the hard edges.

# *Fragments of Nature*

Many artists develop an instinctive eye for 'fragments of nature' — natural objects that one happens to come across. The professional term for the painting of such random collections is *objets trouvés* — found objects.

Many people have this instinct without realizing it. Their homes are decorated with bits and pieces found on beaches, in woodlands, or in other places at home or abroad — often the mementos of a vacation. The objects will usually be organic. Something in the twist or curve of natural growth has fascinated the collector. The artist who paints found objects has merely taken this instinct a stage further.

The artist in this case lives in the country, and is always on the lookout for this type of subject. From his objects he has chosen a group which has a consistent color theme — warm autumnal reds and browns. He has picked out the objects for their completely contrasting textures and shapes. They include a piece of white curved chalk with a smooth, hard surface, the spiky roughness of a wild husk, and the wrinkled skin of a dried pomegranate. The collection covers a wide variety of round, twisted, simple and complicated shapes. Not only do they vary in themselves but, when they are arranged on a surface in a certain way, they can create a whole new series of negative shapes — the shapes of the spaces between them. The background has been chosen deliberately to echo the tones and colors of the subject.

After boldly painting the shapes in outline, the artist turned his attention immediately to the problem of representing texture. He used texture paste to lay in the areas where interesting textures were needed to indicate the surface of the actual objects. For instance, on the husk he stippled the paste with the flat side of a painting knife, to roughen the paste's surface.

Usually a painter will want to develop the whole rectangle of a picture, bringing up the colors and tones together. Here, however, with a simple background containing no bold shapes or colors, the artist was more concerned with relating the objects to each other and to their immediate space. So he began from the center, just filling in pieces of background in the spaces immediately around the objects.

The background consists of a simple piece of paper, but it is not a flat color. The artist therefore varied his representation of it with cool grays and patches of warmer tone which pick up the reflected colors from the objects. He wanted to avoid having a flat pattern.

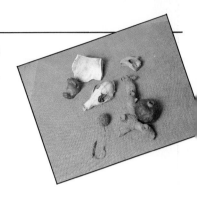

**1** *Right* An avid collector, the artist has a vast assortment of found objects lying around his house. These particular items were chosen for their contrasting shapes and textures and their earthy colors.

**2** The composition is first sketched lightly in charcoal *left*. The purpose of the drawing is to establish the correct position and proportion of each of the various objects. No detail or tone is included in this initial drawing.

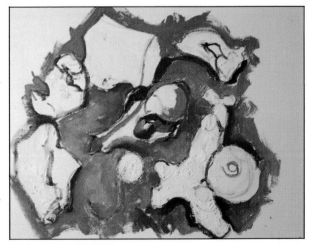

**3** Before starting detailed work on the objects, the artist first establishes the warm, brown tones of the surrounding board *above*. Color is used thickly to produce lively textured brushstrokes.

**4** Working across the picture, the artist blocks in areas of thickly impastoed paint, relating the tones to the established brown background *left*. Acrylic is the best medium for most types of texture, from subtly ridged brushstrokes to the thick impasto created when paint is squeezed directly from the tube. In this painting, the artist takes advantage of the quick-drying medium to experiment with the effects of thick color. The richly textured paint reflects the variety of textures in the objects themselves.

## USING TEXTURE PASTE

Texture paste can be used in two ways. The paste can be mixed with paint, making the color, thick and stiff before it is laid on the canvas. Alternatively, it can be used by itself — as the artist is using it here — and applied to the bare canvas to create a particular texture before the color is painted on top of it.

**5** Texture paste can be used to build up the surface of a picture before the color itself is added. Here the paste has been applied to simulate the roughened texture of a piece of wood. When paint is laid over this *below*, the resulting broken color is similar to the effect of drybrush technique.

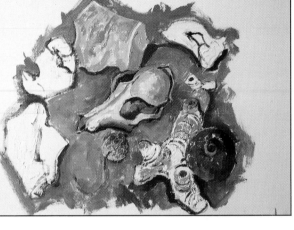

**6** Gradually the artist moves across the picture, blocking in tones and colors *above*. Once a color is applied, the artist prefers not to interfere with it. The freshness of the painted surface depends on a decisive, spontaneous approach, and the quick-drying paint does not lend itself to being altered or worked into once it is on the picture surface.

**7** The completed painting is sprayed with a special acrylic fixative *right*. This treatment is not strictly necessary for the protection or preservation of the picture, but the spray brings out the best in the acrylic colors, some of which look less vibrant when dry. An alternative treatment is to use a special acrylic varnish, available with a gloss or matte finish, or to give the painting a coat of acrylic medium to obtain the desired finish.

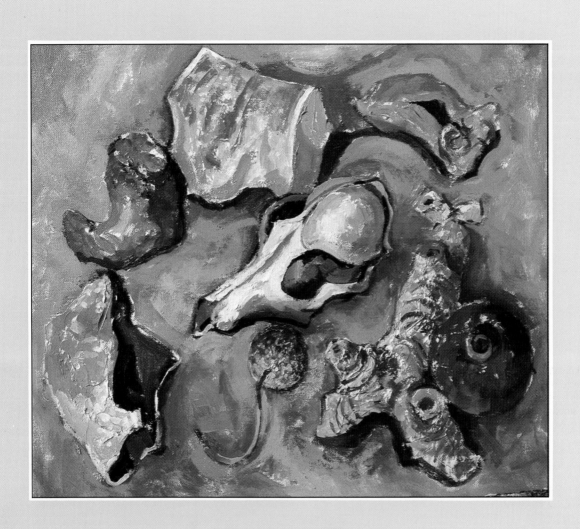

*Fragments of Nature*

## What the artist used

This still life from found objects was painted on a piece of hardboard measuring 22in × 18in and treated with acrylic primer. The artist worked from a palette of titanium white, ivory black, Payne's gray, yellow ocher, red oxide, burnt sienna, raw sienna, naphthol crimson, raw umber, cobalt blue and cadmium yellow. A painting knife was used to apply texture paste, and flat bristle brushes, numbers 8, 6, 4, and 2 for the color. The artist sprayed the completed picture with acrylic fixative.

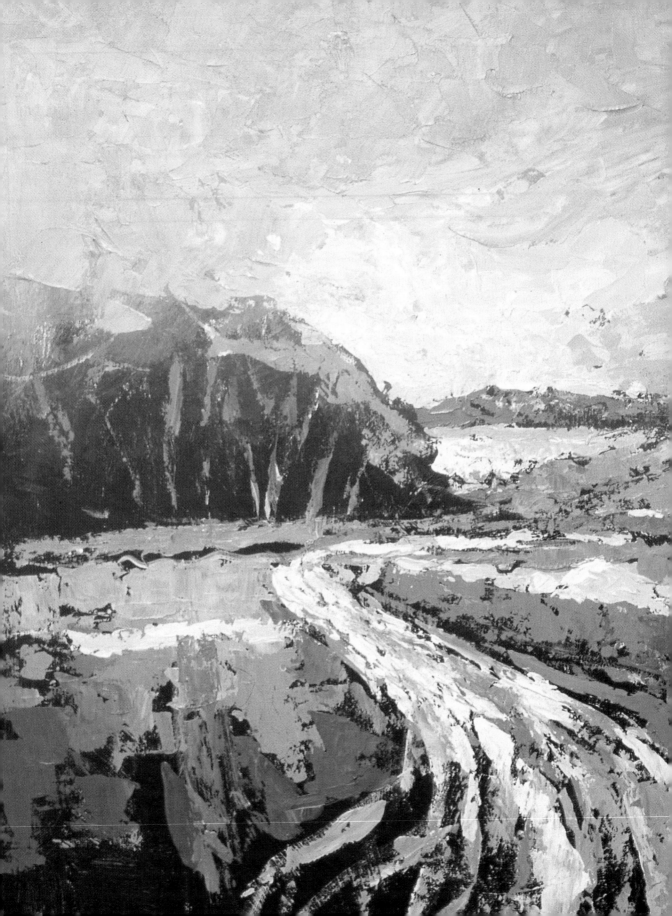

# CHAPTER NINE

# LANDSCAPE

Acrylics give the painter a prime advantage when painting landscapes. They allow for on-the-spot painting to a far greater degree than traditional oil paints. Because of their quick-drying properties, they can be taken to a viewing location and applied to paper, canvas or board with the scene laid out directly in front of the artist. The rapidly-dried painted surface can be speedily packed up to escape a shower , or be carried safely home between sessions, without fear of smudging.

The drying quality can also present disadvantages to the landscape painter, however. On a very hot day, the colours can dry while they are still upon the palette, hardly giving the artist a chance to get them onto the picture. Fortunately a new palette has been developed especially for use with acrylics, and goes a long way toward solving this problem by keeping the paint moist.

The artist using acrylics, therefore, can enter with a great deal of confidence the world of landscape painting − a world of vast scope. There is much more to landscape painting than the pretty green fields and woodland streams so often associated with it. The category can also cover a grim industrial landscape, or a mass of urban sprawl. Nature, too, can be bleak and formidable. It can be a challenging project to paint in some of the more inaccessible areas.

A major problem for the landscape painter also presents one of its most fascinating aspects: the landscape is constantly moving. Clouds, for instance, have to be captured at certain moments. They need to be quickly sketched, so that their shapes and their role in a composition are not forgotten. The picture as a whole needs to be something that the artist has definitely decided upon and keeps constantly in mind.

# The Lighthouse

Here is a picture done by a painter who used to be an illustrator, which shows in the bold graphic style that he used. He also applied techniques to obtain different textures with the paint. The result is an interesting variation on the more usual seascape.

This is very much a picture about composition. Yet it breaks a basic rule which states that no major line or division should cut across the center of the picture, chopping the rectangle into two equal halves. Here the horizon does just that, but the artist has counteracted the effect in two ways. Tonally, the top half is light and the bottom half dark, and the artist has also placed all the activity and interest in the lower half. The composition is helped by the fact that the shoreline falls diagonally, dividing the lower section into two definite wedge shapes.

The sea and the lighthouse have been painted 'graphically' – in other words, sharp and clear, using bold, flat shapes. Even the shadows on the rounded lighthouse building have been picked out in flat terms. The life in this painting comes not from any specific event or action, but from the way the artist has captured movement in the grass and clouds.

The initial grass area has been quickly and roughly painted. The artist has not even worried about covering the whole of the white surface in this first layer. Over this, he has introduced different tones, has splattered diluted paint onto the surface with a decorator's brush, and has painted long, wispy brushstrokes to achieve a sense of movement in the grass.

Because this artist has worked as an illustrator, he has at hand a useful 'vocabulary' of techniques to produce visual effects. These 'tricks of the trade', such as stippling and splattering for texture, and using a quick flick of the brush to produce an instant grass effect, have given life to what could have been merely dense slabs of paint.

At first sight the lighthouse might be seen simply as a gray and white object, but the artist has introduced color into the shadows which was not there in the first place. This artificial blue light lends a sense of drama to the picture, evoking a theatrical feeling of loneliness and mystery in the solitary, windswept scene.

**1** This dramatic seascape *right* with its stark white lighthouse, moving sky and windswept grass, inspired the artist to capture the scene in this graphic painting.

**2** A wash of cerulean blue with a little yellow is applied to the sky area *left*. The wet paint is then dabbed with rag to insure thin, manageable color in the early stages.

**3** *Above* The sea is Payne's gray and cobalt blue, mixed with matte medium for added transparency. Deliberately runny paint and loose brushwork provide the foreground texture.

## SPATTERING

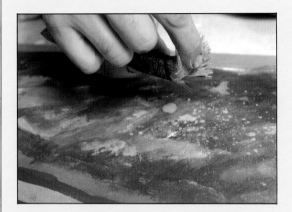

A variety of techniques have been used in this picture to introduce different textures into the landscape. Here the artist is creating a speckled pattern across the grass in the foreground, breaking up what might otherwise have been a rather flat, boring shape. This effect, known as 'spattering' is achieved by flicking color from a decorator's brush directly onto the painting.

**4** When the main areas are blocked in, the artist works back into the composition, developing the textures. Dark grass tones are stippled by rolling a sable brush *above*.

**5** Shadow areas on the buildings are painted in a range of tones mixed from Payne's gray, black and white. When these are dry, detail is added with a small sable brush. Here the artist paints the metal trellis at the top of the lighthouse as a series of finely drawn criss-cross lines *right*.

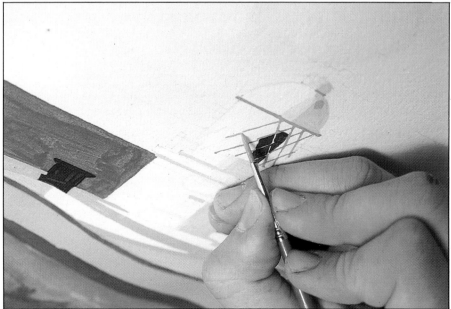

**6** *Right* The painting so far shows a simple, graphic composition with all the main elements and areas of light and shade depicted as flat shapes. Because opaque acrylic can sometimes dry to a rather 'dead' finish, the artist has taken care to vary the consistency of the paint and the textures.

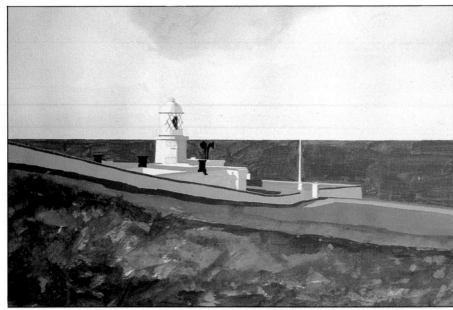

**7** A mixture of yellow ocher, Hooker's green and white is spattered onto the foreground (see Special Technique), and wispy blades of grass are added in the same color with a sable brush *below*.

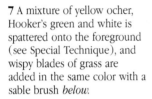

**8** *Above right* Thick opaque paint is worked into the sky in short, lively strokes, with a decorator's brush. The artist leaves the colors — white, black and yellow — partially unmixed, trying to capture the movement and varied tones of the sky and clouds with the thick, streaky brushwork.

**9** *Right*, the artist makes some final adjustments to the tone and texture of the sky. Using a smaller brush and white paint directly from the tube, he applies the stiff, dry paint in soft, diagonal strokes to indicate the shape and character of the moving cloud formation.

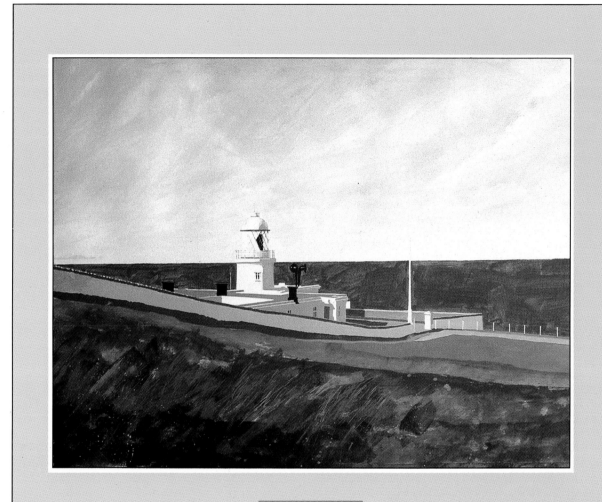

<u>*The Lighthouse*</u>

## What the artist used

This striking seascape was painted on Bockingford watercolor paper measuring 22in × 16in. The artist used a small decorator's brush to block in large areas, such as the sky; otherwise the paint was applied with sable brushes, numbers 2, 4 and 8. Hooker's green, yellow ocher, titanium white, Payne's gray, ivory black, raw umber, phthalocyanine green, cadmium yellow, cobalt blue, cerulean blue, brilliant blue and quinacridone violet were on the artist's palette, and a little matte medium was mixed with the paint in the early blocking-in stages.

# Plowed Fields

This subject is a very simple one. Yet it ideally illustrates the two main ways of creating the illusion of distance — linear and aerial perspective.

The artist was interested in how the view in this case presented a good example of aerial perspective. The air acts upon light in such a way that a haze is created in front of objects a long distance away. They appear fainter and more blue — quite different, in fact, from some medieval paintings and many pictures done in the naive style, which show far distant objects such as mountains and trees as bright and clear, even though tiny. Art galleries display many interesting examples of how painters sometimes ignored aerial perspective. This type of perspective has always been more important to artists living in parts of the world where the atmosphere is dense or misty, such as northern Europe, but it is always there to some extent in any region.

In the painting shown here the row of trees on the distant horizon is bluer and paler than the row which is closer. The use of the blue and pale tones automatically makes the eye assume distance, when viewing the finished painting.

Perspective to most people means linear perspective. This involves the use of a hypothetical vanishing point, at which all lines on the same plane would meet if they extended far enough. In this picture linear perspective is clearly demonstrated by the furrows in the plowed field which take the viewer's eye immediately over the first hill toward the receding distance.

We have seen how acrylic can be used transparently and opaquely; here the artist has used it transparently to achieve a quick color sketch of the sky as it appeared at a particular moment. He wanted to give an impression of fast-moving clouds caught on a windy day. The artist mixed acrylic with a lot of water to obtain its transparency, then used a big brush to block in areas of color without worrying about detail.

He used a watercolor technique, known as 'wet into wet', when painting the plowed field. He did not allow the light brown underpainting to dry completely before painting in the slightly darker furrows. In this way he avoided too sharp an edge to the brushstrokes, managing to create a fuzzy quality in parts which was truer to the subject.

The artist moved quickly when painting this picture, capturing a freshness in the scene and avoiding what could have become simply an over-academic demonstration of perspectives.

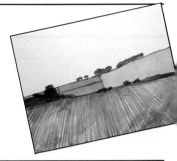

**1** Distance in a painting is often indicated by the use of perspective. This rural landscape *right* demonstrates how both aerial and linear perspective can be used to create space and distance.

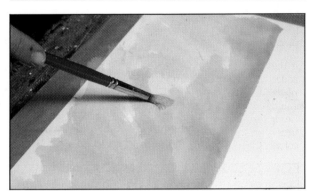

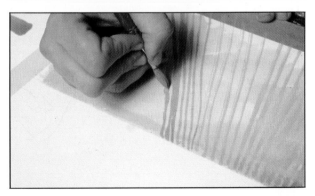

**2** *Top* Using a diluted mixture of raw umber, burnt sienna and deep violet, the artist blocks in the plowed field in the foreground. Color is spread quickly to prevent tide marks and blotchiness as the paint dries.

**3** A darker tone of the wash color is used to paint the furrows, *above*. This is done before the wash is completely dry, allowing the new color to blend in slightly, thus preventing a hard, unnatural edge on the furrows.

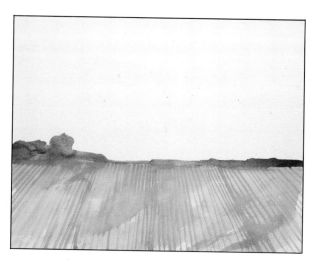

By painting the furrows before the underlying wash is properly dry, the artist avoids a hard line, achieving, instead, a soft, blurred edge to the painted shapes. This 'wet into wet' method is a popular watercolor technique and is equally useful when using diluted acrylic color as the artist is doing here.

**4** The first row of trees is added in Hooker's green, *above*. This strong color insures that they will stand out clearly from the distant horizon trees to be added later. The color is allowed to 'run' slightly into the field color, thus preventing a harsh outline.

**5** The far fields are painted in bright green and cadmium yellow *left*, applied as flat shapes. No attempt is made to create distance by grading the color of the fields to indicate recession. Instead, the artist relies on the optical effect of the receding lines on the plowed fields to convey space and distance in the painting, even though the furrows converge only slightly.

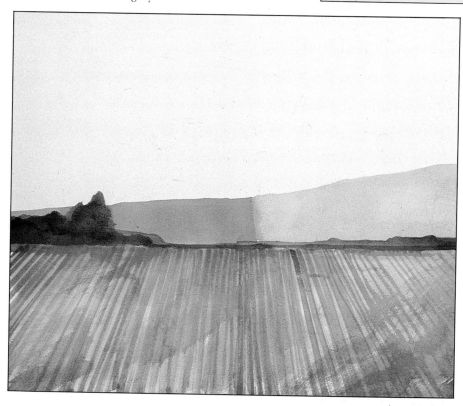

**6** Payne's gray with white is used for the horizon trees *right*. They are paler and have less local color than the near trees, which creates a feeling of distance by indicating the atmospheric haziness between the foreground and the far distance.

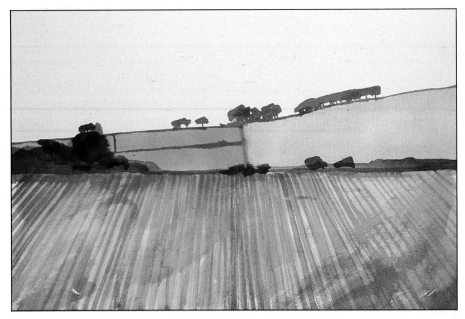

**7** When the correct tone and main shapes are established, the artist works into the trees, refining the outline and touching up the color *below*.

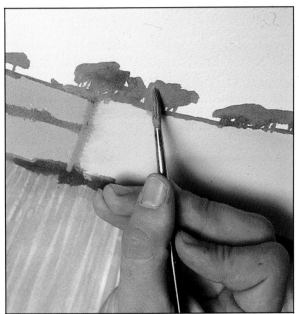

**8** An irregular blue wash is laid across the sky area *right*. The artist works quickly with a sable wash brush, leaving patches of white paper visible to suggest the clouds.

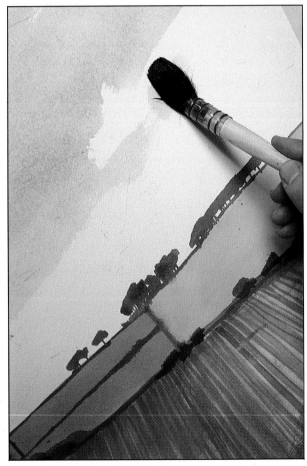

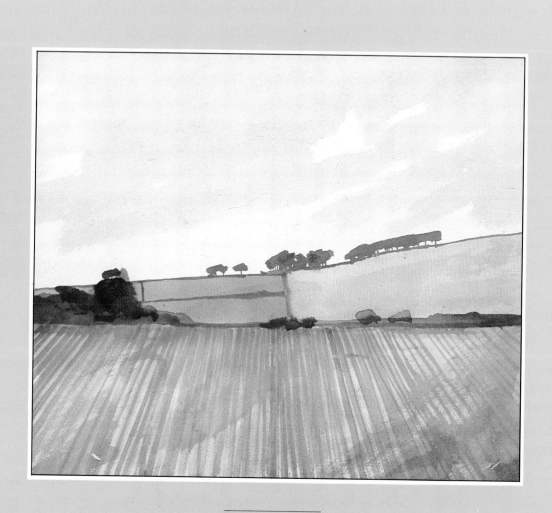

*Plowed Fields*

## What the artist used

This 'watercolor' sketch was done on Bockingford paper measuring 14in × 10in. The colors — ivory black, raw umber, burnt sienna, Payne's gray, ultramarine blue, deep violet, Hooker's green, bright green and cadmium yellow — were applied with a number 8 sable and a number 6 synthetic round brush. The sky was blocked in with a sable wash brush.

# *Fruit Trees in the Sunshine*

The artist who did this picture takes his sketchbook on vacation to capture interesting scenes and objects in outline. The sketches are never meant to be finished products. They are records of what he has seen, and they can be used either as the foundations for complete paintings done later in the studio, or as fragments to be inserted into other compositions. In this way he has amassed a collection of these sketches ready for later use.

The habit of always carrying a sketchbook is invaluable. You may be staying in a hotel, or you may be in a hurry, and yet a scene or object presents itself as an ideal subject for a painting. A quick sketch is the answer. A photograph may also help, but with a sketch you retain a more personal reminder, recording those aspects of the scene that you particularly want to bring out, so that later you can set down a visual statement, isolating and emphasizing those elements which appeal to you.

What appealed to the artist in this case was a sunlit street enveloped with shadow. He began this painting with an already prepared sketch of some citrus trees. The sketch is rough but the artist has actually indicated areas of shade quite precisely and has written notes to remind himself of what colors appeared in the original scene.

Because he sketched a sunny scene from the shade of a café, there is a frame of shadow around the picture which helps to focus the eye upon the brilliantly sunlit street.

A central theme of the picture is brightness of color and light, which the artist has captured by using a lot of white in that area and some quite dense black by way of contrast in the near foreground.

Because acrylic is adhesive the paint can be mixed with other substances to achieve different consistencies and obtain texture effects. The artist, aiming at capturing the rough sandy surface of the stone wall, mixed ordinary builder's sand with the paint and applied it generously.

The adhesiveness of acrylic opens up a wide range of creative possibilities. Soil, sand, even dried foods such as rice or lentils — anything in fact — can be mixed with acrylic paint. It is a refreshingly direct approach: after all, why not use sand itself, in order to depict sandiness?

**3** The artist changes to a bristle brush to block in the flat shapes of the tree trunk and leaves, *right.*

**1** A small sketch *right* rapidly executed while the artist was on vacation several months prior to this painting, is the basis of the composition. The artist relies partly on memory for the correct colors, but also refers to the color notes that he made on the drawing at the time.

**2** The image is transferred onto a primed canvas in black paint which is applied with a sable brush *left.* Only the general outlines are indicated at this stage.

**4** Color is laid on in small, thick dabs *left*. The paint is used opaquely, the colors being selected more for their suitability to the bright, sunny nature of the subject than with the intention of producing a realistic picture. The artist moves across the whole canvas, building up the entire image bit by bit. A little gel medium is mixed with the paint throughout this painting to help create an interesting textural paint surface.

**5** Areas of white canvas color are preserved to separate the various elements in the painting *above*. These patches of flat white scattered across the picture surface contradict any illusion of space in the picture and emphasize the strong design element in the color and patterns of the composition.

## MAKING TEXTURE WITH SAND

The artist mixes ordinary builder's sand with the paint to capture the rough, sandy texture of the wall. This technique is only possible because of the adhesive nature of the paint and cannot easily be achieved with any other medium. It is important not to overload the paint, but to keep the consistency manageable — by adding a little acrylic medium, if necessary.

**6** *Right*, the artist works into the black tree trunks with tones of warm brown. Acrylic dries opaquely — especially when being used thickly as it is here — enabling light tones to be laid over darker ones. Sand is added to the paint for certain textured areas, such as the wall and the trees, and the direction of the thickly loaded brushstrokes is exploited to indicate form and surface texture in these areas.

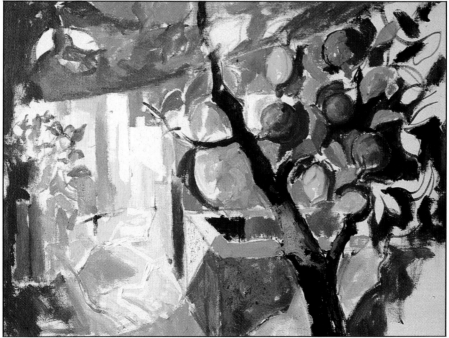

**7** A loose blocking-in is now complete, *above*. The color is intuitive, applied with a variety of strokes. Most of the shapes are laid flatly, but the use of texture and the mutually enhancing bright and somber colors create a highly personal interpretation of the scene.

## What the artist used

For this colorful holiday landscape, the artist worked on a piece of hardboard treated with acrylic primer, measuring 18in × 14in. The colors were cadmium yellow, lemon yellow, cadmium red, red oxide, chrome green, Hooker's green, bright green, titanium white, ivory black, burnt sienna, raw sienna, raw umber, cobalt blue, cerulean blue and ultramarine. These were applied with flat bristle brushes, numbers 2, 5 and 10.

**8** The artist was sitting in the shade of a café awning when he first sketched this scene. This effect is recreated in the painting by emphasizing the dark tones around the outer edges of the composition *right*. The bright fruit and the sunny street, seen from the shadows, become the focal points of the painting as the viewer's eye is led outdoors and into the sunshine.

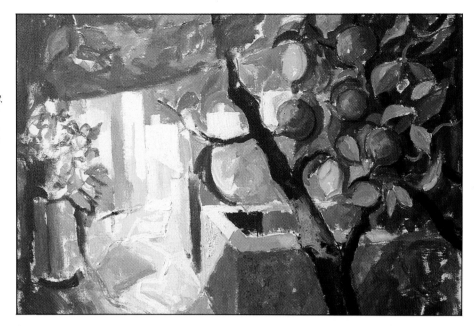

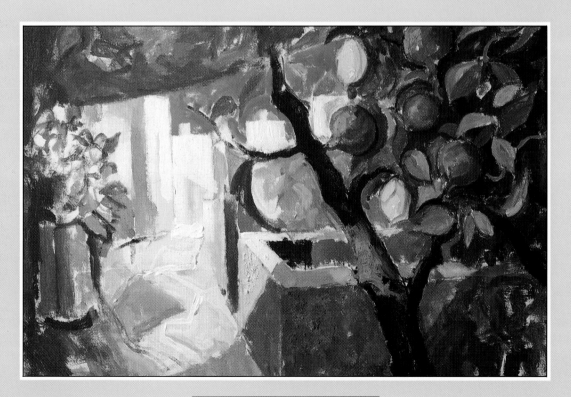

*Fruit Trees in the Sunshine*

# *Wintry Landscape*

A problem occurs with snowscapes which at first seems almost ludicrous in its simplicity – how to paint white snow on a white background.

The artist's way around this in the picture shown here was to cover the bottom half of the support, the area where most of the snow is found, with a coat of dark tint, black and burnt sienna. Over the sky area he put a lighter coat of yellow ocher mixed with a little black. He quite deliberately chose a warm tone to go underneath the snow, to achieve a contrast with the coldness of the subject, avoiding that rather amateur feeling of overall grayness and chill that plagues so many snow scenes. Warm earthy tints show through the snow in this picture, making it true to nature in which warmth exists beneath the winter covering, and giving more substance to the image as a painting.

Normally when painting on a white ground you have to draw the composition in a darker color, so here – once the dark tints were laid down as a foundation – the artist drew the outlines in white. This produced a strange and attractive effect rather like a photographic negative.

The artist worked from two original sketches. In the sketch he preferred, with its winding lane and distant copse, the tree in the foreground was not a strong enough shape to be enlarged as a dominant factor in the picture. He therefore brought in a second sketch, with a much more defined tree involving far more detail, and combined both sketches.

A thickening substance – gel medium in this case – was used so that the artist could build up a thick impastoed texture with a painting knife. He used this stiff mixture to block in the sky and the main areas.

When painting snow, it is a popular error simply to paint it in as pure white. Here the artist worked from dark to light, first laying down the darker, muted colors – these would eventually represent indents and shadows – before painting in the white highlights of the snow. The actual amount of pure white was surprisingly small for a snow scene. Yet the effect is truly naturalistic and convincing.

After blocking in the sky, the artist developed the whole picture surface in stages rather than completing one area. He took one tone and applied this to various parts of the picture where it was needed, before moving on to another tone. This gradual building up helped to establish the broad tones and colors smoothly in relation to each other.

The final picture benefits from the initial warm undertones, containing rich earth colors which show through the paint across the whole picture surface.

**1** When the artist made these sketches the weather was too cold to encourage painting on the spot! Instead, he captured the scene in a sketchbook *right* and did the painting in the comfort of a studio.

**2** Two sketches form the basis of this winter landscape. The composition is mainly that of the larger drawing *left*. The tree, however, is 'borrowed' from a second sketch *above* because it provides a stronger, structural shape, which is more suitable for the central feature of a painting.

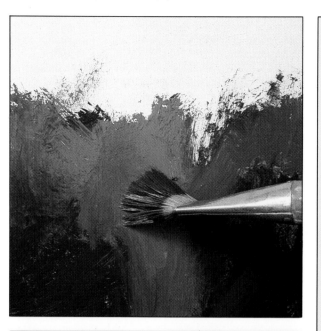

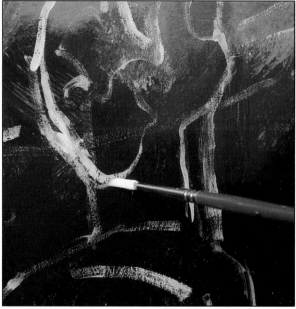

## USING GEL MEDIUM

Here the artist is using a knife to mix gel medium with the paint. In this case, the thickening agent is mixed with the color before being applied to the support — occasionally gel is used on its own to create brushmarks or other textures on the support and the color is then painted over this. The gel dries transparently, so although it lightens the color initially, the paint dries to its normal color.

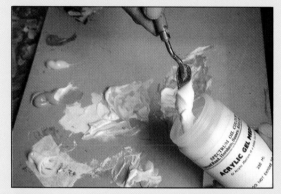

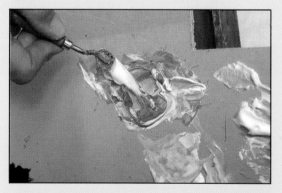

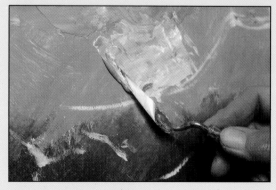

**3** *Top* The lower half of the support — the snow area — is blocked in with a mixture of black and burnt sienna; yellow ocher and red oxide are used as a similar base for the sky.

**4** Referring to the two sketches, the artist roughs in the general composition and main shapes in white paint *above*. No detail or tone is indicated at this stage.

**5** Warm, dark undertones provide a contrasting base ready to receive the cold, light tones of the snow and sky *right*. Because acrylic allows the artist to lay light colors over dark in a positive way, the white snow can now be applied directly to the darkened support.

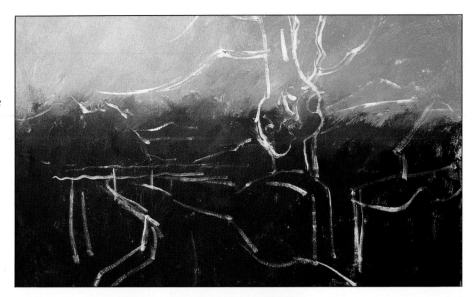

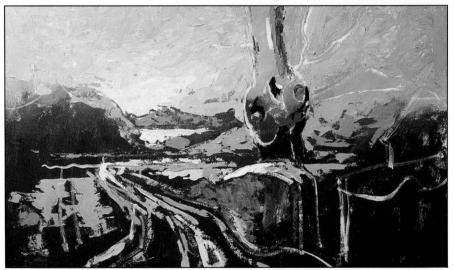

**6** *Left* The sky is blocked in with phthalocyanine blue and white, laid thickly and flatly with a painting knife. Before moving directly onto the bright whiteness of the snow highlights, the artist first lays the duller, muted colors of the tracks and shadows in the road with light yellow ochers and grays.

**7** Gel medium is mixed with the sky color to increase the rough, impastoed surface *left*. Small areas of the ocher underpainting are left showing through in patches; these unify the painting by picking up similar tones elsewhere in the picture.

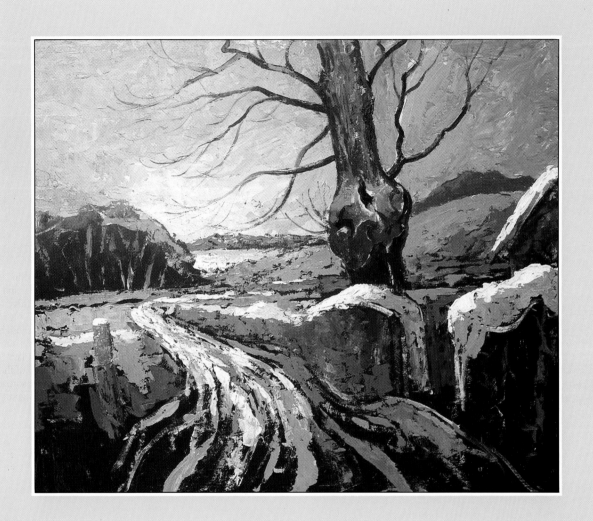

*Wintry Landscape*

## What the artist used

The hardboard support, measuring 30in × 24in, was treated with acrylic primer. For this snow scene, the artist chose a palette of ivory black, titanium white, burnt sienna, yellow ocher, red oxide, phthalocyanine blue, Payne's gray, raw umber, cobalt blue, ultramarine blue, cadmium yellow and Hooker's green. The color and gel medium mixture was applied mainly with a medium size painting knife, although round bristle brushes, numbers 2 and 5 were used for detail and line, and the tint was applied with a number 12 flat bristle.

# *Lanyon Quoit*

The artist and his family were driving in the south west of England when they came across this prehistoric stone monument in a remote part of Cornwall. The gray monolithic structure against the sunless sky and windswept landscape inspired the dark low-key color scheme of the painting.

An obvious composition would have been to show Lanyon Quoit standing out starkly against the lighter tones of the sky. But the artist preferred a subtler, less dramatic interpretation, with the stones portrayed not as a looming structure, but rather as an integral part of the Cornish landscape. The topstone is raised slightly above the horizon but, apart from this small bump on the skyline, the monument itself is almost totally blended into the surrounding fields and moorland.

An understated composition, subdued colors and restricted tonal contrast are masterfully combined in this painting to recreate this somber and overcast scene. There is also a slight air of mystery and a sense of foreboding in the picture. This is partly the result of the artist's handling of the subject and partly because of the subject itself – the monolithic stones which have stood for thousands of years and whose original purpose is unknown. They flaunt their secrets and impose their presence in the painting exactly as they do in the real life landscape.

Various techniques were employed to capture the ruggedness of the scenery and the windy weather. Before starting to paint, the artist first sketched in the outline of the composition, but the drawing was kept to a minimum and he very soon exchanged his pencil for a decorator's brush. This was used to roughly block in the cool tones of the sky and clouds and some of the gray-green of the hills and meadows. He worked quickly, allowing the shapes of the brushstrokes to suggest moving clouds and windswept grass.

The edges of the stones and some of the patches of light and shade across the landscape were particularly sharp and clearly defined. For these areas the artist decided to adopt a masking technique using torn strips of tape. This provided exactly the right degree of crispness for the outlines while at the same time producing natural rather than mechanical shapes.

**1** In this challenging subject *right*, the tones in the lower part of the rectangle are very similar, making it quite difficult for the artist to pick out different shapes and colors within the landscape.

**2** A hard H pencil is used for the initial outline *left*, enabling the artist to create accurate lines and to provide a clearly defined guide for the eventual color. Shadow tones are indicated with precise cross-hatching.

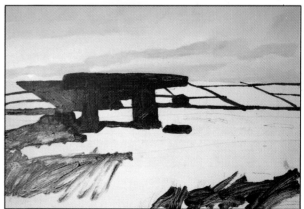

**3** The sky is blocked in with a mixture of white, Payne's gray and cobalt blue applied with a small decorator's brush *above*. White, black and Payne's gray are used for roughing in the dark tones on the stones and walls.

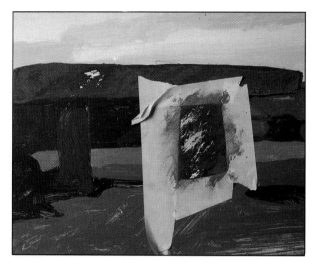

**4** *Above* The gray-green fields are painted in Hooker's green, black and white. Before the light tones of Lanyon Quoit are added, the areas are masked with newspaper strips to maintain the crisp graphic shapes of the stones.

**5** *Right*, the artist uses a lighter green to vary the tones of the fields and to provide greater contrast with the gray stone.

# USING TORN MASKING TAPE

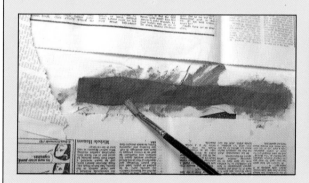

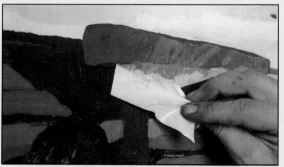

The crisp, yet irregular outlines of the stone monument prompted the artist to try a masking technique using torn strips of tape instead of the usual straight edge. The torn edges are pressed firmly in place around the stone shape, and pieces of newspaper used to protect the surrounding areas from splashes of paint. The color is then firmly painted over the masked area and across the edges of the strips. The paint is quite stiff, and the artist picks up a small amount of color on the brush at a time. A large quantity of over-diluted color would flood under the edges of the mask and spoil the shape.

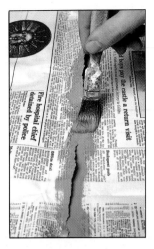

**6** *Left* Light green streaks of sunlit grass are created by painting over the torn edges of newspaper strips.

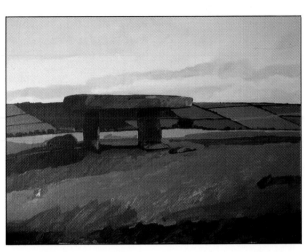

**7** *Right* The painting is almost complete. A variety of textures and loose brushstrokes have been introduced to relieve the similar tones within the subject.

**8** *Above* To brighten the sky tones and to introduce a more interesting, impastoed texture, the artist uses white paint squeezed directly onto the painting from the tube.

**9** *Right* The thick white paint is taken up to the edge of the monument with a small bristle brush, and the artist uses this to redefine the shapes of the dark stones against the sky.

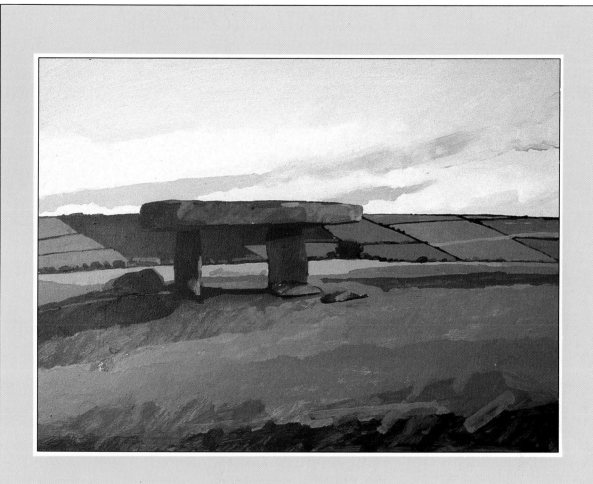

*Lanyon Quoit*

## What the artist used

The artist treated a piece of hardboard measuring 24in × 18in with acrylic primer for this painting. He worked with a palette of yellow ocher, cadmium yellow, brilliant blue, cobalt blue, Payne's gray, Hooker's green, ivory black and titanium white, using a little matte medium for the initial blocking-in stage. The drawing was done with an H pencil, and the color applied with a small decorator's brush, a number 4 sable brush, and flat bristle brushes, numbers 2 and 4. The artist also used masking tape, tissue and newspaper.

# The Thames at Richmond

This leafy river scene is a view from the artist's window. Although the sun isn't shining, the subject was painted in midsummer when the trees and banks were at their greenest.

Appropriately, the picture is done in pale, watery washes of acrylic and the result is exactly that of a watercolor. There were no preparatory sketches or initial drawing, and the artist started working directly with color on a sheet of stretched watercolor paper. The white of the paper was used to represent the pale, sunless sky and the smooth surface of the reflective river.

Working from light to dark, in the traditional watercolor manner, the artist began by blocking in the faint shapes of the distant trees. These were painted in a very transparent gray blue wash to indicate how far away they were. The introduction of a pale, hazy bluishness for faraway objects, often referred to as 'aerial perspective', is an effective way of describing spatial volume and distance in a painting — especially useful in a composition such as this, where there are no dominant receding lines or any other obvious indications of perspective to help establish space and distance.

The painting technique adopted here is not difficult. The few colors used were applied in loose washes, and the secret of the picture's success lies in its absolute simplicity. The artist knew exactly when to stop and resisted the temptation to overwork — a common tendency among inexperienced painters. Many artists who are new to watercolor techniques have a misguided notion that it is somehow vaguely 'wrong' if the brushstrokes can be seen, and try frantically to disguise them by blending them together. This is not only a mistaken belief — here, for instance, it is the loose, lively brushwork that gives the painting its freshness and spontaneity — but it is actually impossible to blend acrylic washes once they have dried.

Because the washes are so transparent, mistakes cannot be covered up. This makes it crucial to get things right first time — especially important with acrylic because the paint dries so quickly. The best way to work is to make a decision and then to go ahead and paint it, boldly and decisively — as the artist did in this painting.

**1** *Right* The river scene viewed from the artist's studio window, with its watery reflections and leafy foliage, proved an ideal subject for this demonstration of how acrylic can be used to create watercolor effects.

**2** The subject is a complex one, but the artist approaches it directly without any preliminary drawing or rough sketches. First the hazy gray trees in the distance are roughed in with a very thin wash of Payne's gray *left*. The color is applied quickly to create a flat area of color.

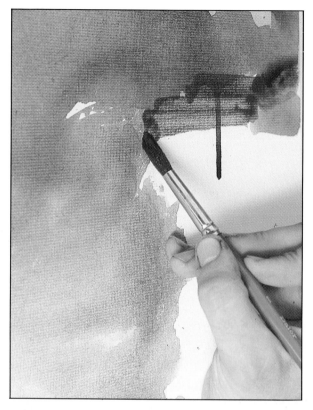

## WET INTO DRY

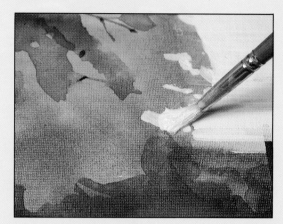

In this painting the artist has used acrylic washes, sometimes applying color over areas that are still wet, and sometimes — as he is doing here — painting wet into dry. The wet into dry wash technique is suitable when a neat finish with well-defined, crisp edges is required.

**3** *Above* The rest of the foliage is rapidly washed in with Hooker's green, mixed with a little raw umber in the shaded areas. Again, the color is diluted with lots of water to create transparency.

**4** While the first wash is still partially wet, medium-toned greens are worked into the trees and grass areas *right*. This 'wet into wet' approach insures a natural blending of tone, more characteristic of the subject than hard edges and clear shapes.

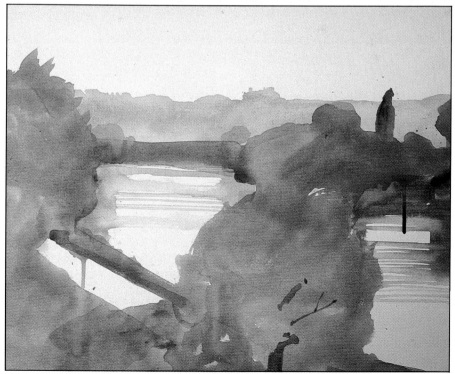

**5** The dark shadow color of the foliage is obtained by strengthening the green wash with a little Payne's gray *right*. Continue to work with very thin color — use dark colors to obtain deep tones; do not make the color itself thicker.

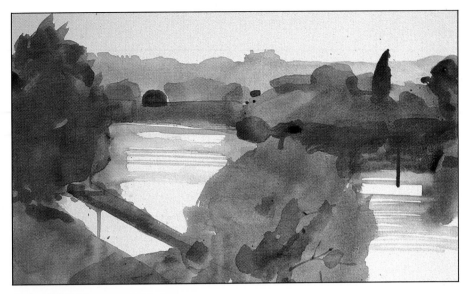

**6** Opaque white is used to redefine complicated edges such as the leaves on the tree *below*, but it is not used to lighten colors. This is done by mixing the paint with the appropriate amount of water.

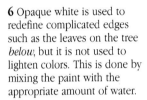

## What the artist used

A limited palette of Payne's gray, black, Hooker's green, yellow ocher, raw umber, burnt sienna and titanium white was chosen for this painting. The color was applied with sable brushes — numbers 10, 6 and 4 — to stretched Bockingford watercolor paper measuring 16in × 12in.

**7** Details are 'drawn' in with the tip of a sable brush *right*. These crisp lines are confined to the foreground of the painting in order to maintain the distance and recession created by the indistinct treatment and hazy shades in the distance.

**8** Acrylic washes look like watercolor but, unlike watercolor, they cannot be dissolved or blended once the paint has dried. Here the artist is 'blending' two acrylic colors by painting a soft, neutral wash over the offending harsh edge where the washes overlap, *left*.

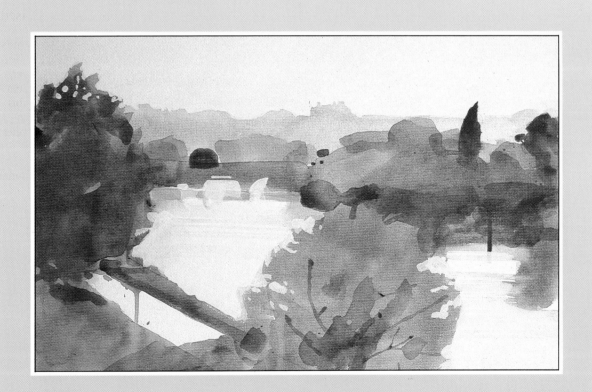

*The Thames at Richmond*

# CHAPTER TEN

# PORTRAIT PAINTING

The eyes are often called windows of the soul, but this is an idea which is potentially dangerous to the portrait painter, and it is best forgotten. One of the most common mistakes made by people embarking on the complexities of portrait painting is to concentrate too much on the eyes, becoming over-fascinated by them to the detriment of the rest of the face, so that the result is a glazed, masklike appearance.

Painting the human face involves a complicated study of the three-dimensional, and of skin tones and shadows. It is not a mask with slits. The mouth, for instance, needs to be carefully built up, so that it is portrayed as a protruding feature, not something which has been cut into a surface. The mouth protrudes because of a system of muscles around it which are known collectively as the orbicularis oris. It is muscle operation that creates the expressions of a face and places life over the skull beneath. The muscles dictate the planes of light and shade which fall upon a face, and the portrait painter should be aware of them even though they can be painted only by observing what is visible on the surface.

Many artists paint the subtle and varied skin tones of a face by building up glazes. Skin color is so subtle that there could be combinations of blues and reds and so on, all in the same face. This translucency can be captured by the layers of glazes, each one not quite obliterating the one beneath. The Venetian painter Titian, for instance, often worked in glazes for his portraits — but he had to lay aside his canvases and wait patiently for the oil paint to dry in each stage. With modern acrylic paints, however, the glazes can be built up immediately, as each one dries rapidly.

# *Melissa*

The girl in this portrait, the daughter of a friend of the artist, was not present when the picture was being done. The artist worked from a color photograph, blowing this up from a postcard to a life-size image, demonstrating that even professional painters can use photographs as a source of information and go on to make a personal and lively interpretation. Sometimes a portrait painter will use a photograph only when the subject isn't available and take this as second best. Many painters, however, including our artist, actually prefer working from photos and sketches, rather than from life.

Painting from a photograph means that two stages in the transference of objects to pictures have already been completed. The photograph has produced a two-dimensional image of a three-dimensional form. It has also simplified a mass of detail and superfluous information into a basic series of shapes. This is because a photograph loses some details, as is vividly illustrated when you blow up a small photograph into a large size and discover that what looked like a very precise feature on the original is actually a vague cloud of fuzzy dots.

The artist used a hard pencil to draw the girl's outline, looking at the photograph and drawing the outline on the support. The drawing is very simple but it is detailed enough to act as a precise guide for the tones and colors that are to follow. For instance, the artist has actually used line to draw the separate tonal areas of the skin. Where there is a shadow he has drawn precisely where the edge of the shadow falls. Therefore a lot of the hard work is done at this stage, even though it appears to be a rather elementary drawing.

The artist initially uses paint very thinly to block in the girl's clothing and hair. Any highlight areas, or areas that will later be painted a different color, he simply leaves. To counteract the slick flatness of the photograph, he has applied the paint in a very lively way, creating a spontaneous texture.

After painting the green background he uses a tissue to dab some of it off, to obtain a tonal contrast in the background and avoid monotonous flatness.

Next the artist begins to fill in the face, bit by bit, each portion completed before moving on to the next. Here he is following a personal approach. Many artists will establish tones, then change them to fit in with other tones, and keep the whole picture surface moving, but this artist completes an area at a time. Using his experience, he can assess a subject as a whole, breaking it down automatically into a limited set of tones and colors. Other experienced artists prefer nevertheless to build a whole surface layer by layer. It is a question of individual style.

**1** For this portrait of a little girl, the artist worked from a color photograph *right*.

**2** *Left* The subject is drawn in the lower half of the rectangular support because the artist wants to make a feature of the background foliage.

**3** *Below* Matte medium is added to the paint for the initial blocking in — black and raw umber for the hair; black and cobalt for the clothing.

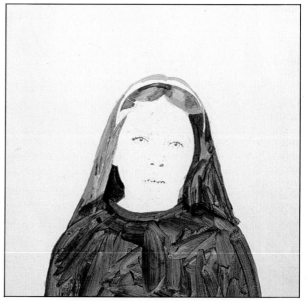

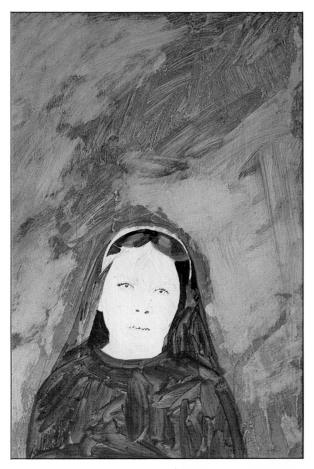

## RUBBING BACK

The artist was anxious to establish a background tone in the early stages, but wanted to avoid a deadening, flat colour or an overbearingly dark tone. This was achieved with a wash of diluted paint mixed with matte medium, which was then dabbed off to create a pale, mottled texture. Here the artist uses tissue to remove the excess color.

**4** *Above* The background is mixed from Hooker's green and yellow, and the wet paint is wiped with tissue to provide a transparent, textured base for the foliage.

**5** *Right* Cadmium orange, cadmium red, white and cobalt blue mixed together make the basic flesh color. The artist applies it in three tones — light, medium and dark — by varying the amount of white in the mixture. The features are defined in raw umber and black; the eye color is mixed from black and blue.

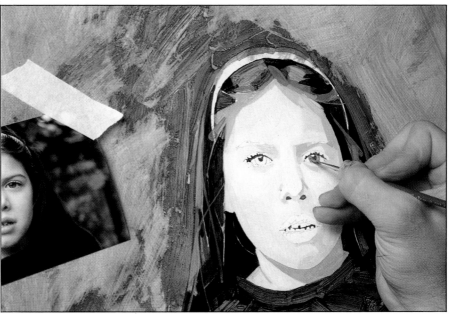

**6** The face and features *right* are gradually built up in small areas of light and dark flesh tones, each area being treated as a separate patch of unblended color. Here the artist adds small areas of shadow underneath the eyes.

**7** The background *below* is strengthened with a darker green mixed from cobalt blue and yellow. The artist keeps this deliberately loose and textural to contrast with the flat colors on the figure.

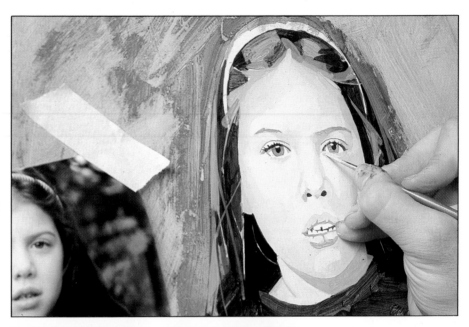

**8** Working across the face *left*, the artist refines the small areas of flesh tone, touching in highlights with a sable brush.

**9** *Below* The form of the mouth is described. Here the artist adds a deeper tone of the lip color to the underside of the upper lip.

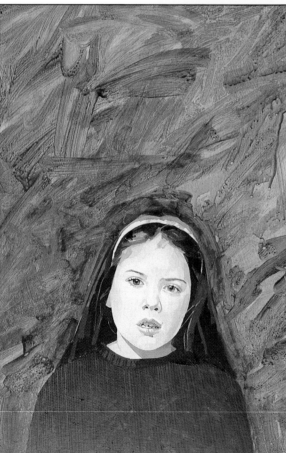

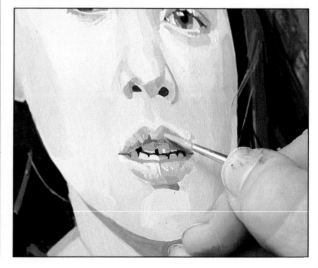

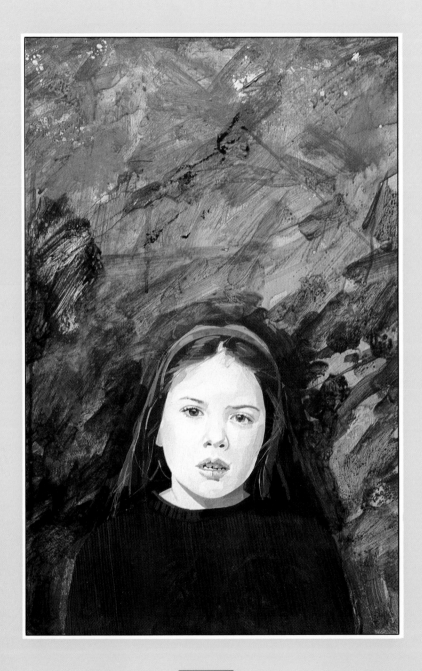

*Melissa*

## What the artist used

The artist worked on a piece of primed hardboard, measuring 22in × 18in. He used a palette of ivory black, titanium white, raw umber, Hooker's green, cadmium yellow, cadmium orange, cadmium red light, cobalt blue and yellow ocher. The colour was applied mainly with a number 6 round bristle brush, the background was painted with a decorator's brush, and the detail with a number 3 sable. The artist also used an H pencil and some matte medium.

# *Francesca in a Green Blouse*

The model stands in a sedate, dignified and very simple pose, presenting the artist with the problem of keeping the painting in a similar mood without making it too stiff and formal. The artist has solved the problem by keeping the contours flowing and free, but the cool and rather washy colors maintain a certain calm.

Lying beneath the process of this painting was more discipline than the informal and loosely treated image might suggest. The artist began by depicting the main shape and form with some basic outline and lightly suggested tone. One of the first things she did was to establish a warm yellow undercolor on the face and neck. She then used a surprising range of pinks. This is typical of the way the artist works, producing results from methods that often stray from the conventional path. By themselves these rosy pinks would seem unnatural, resulting in a rather clownlike or childlike face — but the yellow underpainting comes into effect to produce a mellow and harmonious result.

The effect of this portrait was made more striking because it seemed at first sight to be larger than life. In fact is was painted on a scale exactly life-size. When deciding on the scale of a portrait you should bear this factor in mind. Many portraitists work on a small scale. And we have also become used to seeing most of our pictures reproduced as illustrations in books or on postcards. As a result, it comes as something of a surprise to find a full-scale portrait, and it actually looks larger than life. Portrait painting can be fruitfully varied by being aware of the possibilities of scale and occasionally producing a life-size work which will stand out in this way.

**1** Francesca stands against a white wall wearing a silky blouse and blue jeans *right*. The mood is subdued and calm, calling for cool, washy colors and sensitive treatment.

**2** *Above* A large bristle brush is used to block in the washy, gray-green background and the contours of the figure. A basic flesh tone is mixed from yellow ocher, naphthol crimson and cerulean blue.

**3** The head is developed *right* by adding darker tones to the hair and broad planes of opaque pink and white to the face.

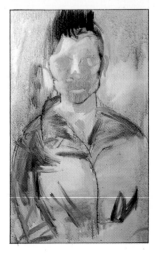

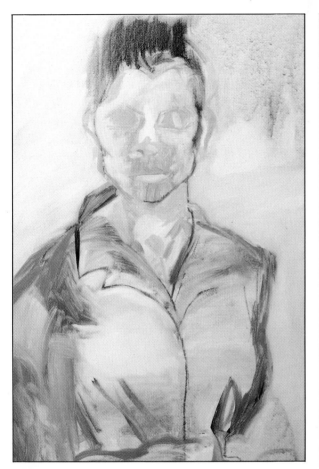

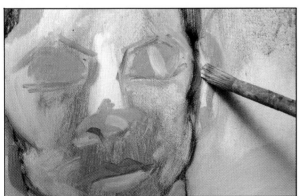

## MIXING FLESH TONES

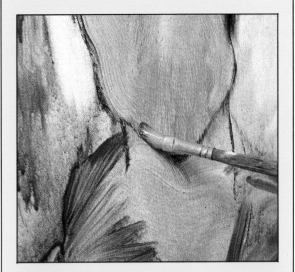

**4** *Top* The background is toned with opaque white, and corresponding white highlights are added to the face and clothing.

**5** The artist works back into the figure, redefining the shapes. Rich yellow and pink flesh tones are used to develop the forms within the face and head *above*.

Skin tones are normally built up from warm and cool planes of slightly varying color. The cooler white flesh tones usually have a touch of mauve or blue, whereas the warmer ones incline towards pink or yellow. Here the artist builds up the structure of the face using a basic skin color of white, yellow ocher, naphthol crimson and a touch of Payne's gray – varying this with touches of extra white, yellow and a little blue to indicate areas of shadow and highlight – over a yellow base tint.

**What the artist used**

The artist worked life-size on a primed canvas measuring 30in × 22in, and chose a palette of yellow ocher, cadmium yellow, naphthol crimson, Payne's gray, cobalt blue, cerulean blue, titanium white, cadmium red, ivory black, raw umber, Hooker's green, quinacridone violet and chrome green. She applied the paint with flat bristle brushes, numbers 10 and 8; and sable brushes, numbers 6, 8 and 10.

**6** A fine black outline is drawn around the eyes and eyebrows *above*. Careful observation and drawing are required here to retain the delicate tones and lines of the face.

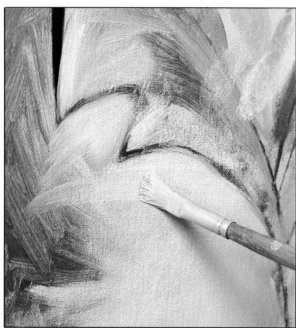

**7** Working into the clothing, the artist uses the folds and creases of the fabric to define the underlying form *right*. Color is applied in thin, broken layers to create a flimsy and transparent effect.

**8** Final linear details are added in charcoal *right*. The soft line is more in keeping with the delicate drawing and ethereal quality of the color than a solid, painted line which could easily flatten and dominate the finished painting.

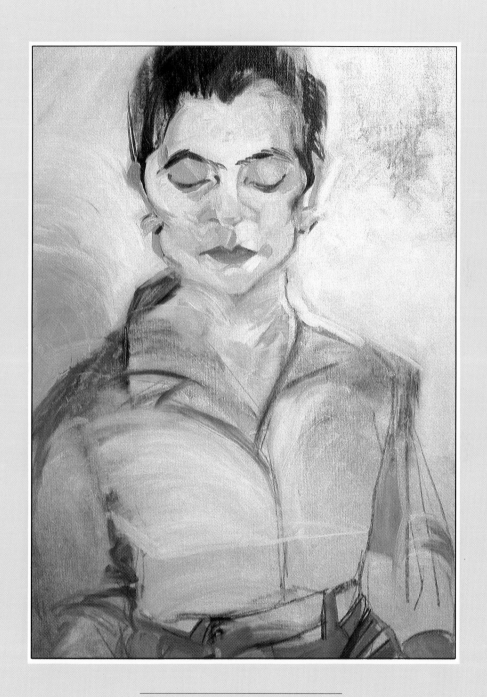

*Francesca in a Green Blouse*

# *Woman in a Dotted Dress*

Layer upon layer of color was applied to this picture to build up the tone in the face, and the use of acrylic meant that there was no question of the colors merging into a muddy neutrality. Once the layers were applied and had been interworked to form this cosmetic foundation, the finer details so essential to the individuality of a human face could be painted in.

But this portrait has other striking characteristics apart from facial ones. The woman is wearing a striking dotted dress and scarf, which gave the artist an opportunity to use a stenciling technique. First the overall shape of the figure was laid on the surface, using black, white, vermilion and burnt sienna. While this was being applied, certain areas were highlighted, so that body could be added later to the final toning of the dress. The patterns on the dress were then applied with bright colors, using thick and opaque paint. The dots were painted with the help of a piece of scrap metal acting as the stencil.

This is a standard three-quarter portrait, in which the head is facing at an angle halfway between a profile and a full frontal view. This is a favorite pose of many artists, as it seems more natural than either of the extreme positions.

Although the finished product is polished and realistic, this effect was built up from a loose and undefined beginning. The artist did not draw the model before applying the paint, but started painting directly, using thin washes of color to suggest the main areas of the composition.

**1** The colorful dotted dress is a focal point of this pose *right*. To get the full effect of the pattern and color, the artist decided to eliminate the obtrusive background and substitute a simple gray one.

**2** Working in black, white, vermilion and burnt sienna, the artist blocks in an overall impression of the figure *above*. There is no preliminary drawing, so the color areas are loosely laid in thin paint to allow for correction as the painting develops.

**3** The light flesh tones of the face *above* are applied in thicker paint than the first layer. Highlights and shadow areas are carefully put on to bring out the form and character of the face. Cobalt blue is added to a basic flesh tint for the cool shadow areas.

Stenciling is by no means confined to painting over cut-out shapes. Here the artist has adopted an unusual technique to paint the small colored dots on the model's dress — using a piece of perforated scrap metal as a stencil. He holds this firmly in position and uses a bristle brush to stipple the opaque color into the holes.

**4** Touches of vivid color are now introduced into the face *above*. Rich reds and browns are used to define the mouth; pale pinks and yellows for the highlights. Deep shadows on the underside of the chin and nose are painted as precise shapes of cool, gray purple.

**5** A basic black wash is applied, ready to receive the stippled dress pattern. To establish an approximate tone, the artist blocks in the background with a mixture of cobalt blue, yellow ocher, black and white *right*, using this to draw the shape of the shoulders and torso.

**6** *Right*, the artist goes over the dots with a brush to strengthen the color, using white, cadmium yellow and vermilion.

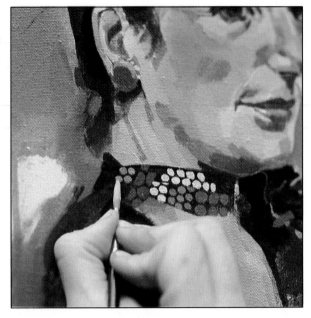

## What the artist used

The artist stretched and primed a cotton duck canvas measuring 20in × 18in for this portrait. He used ivory black, titanium white, burnt sienna, burnt umber, cadmium yellow, cobalt blue, vermilion and yellow ocher, applying the color with a number 6 flat bristle brush and a number 4 round brush.

**7** *Below* The small dots are painted in opaque color, causing the pattern to stand out prominently from the transparent black underpainting. Larger dots are painted freehand.

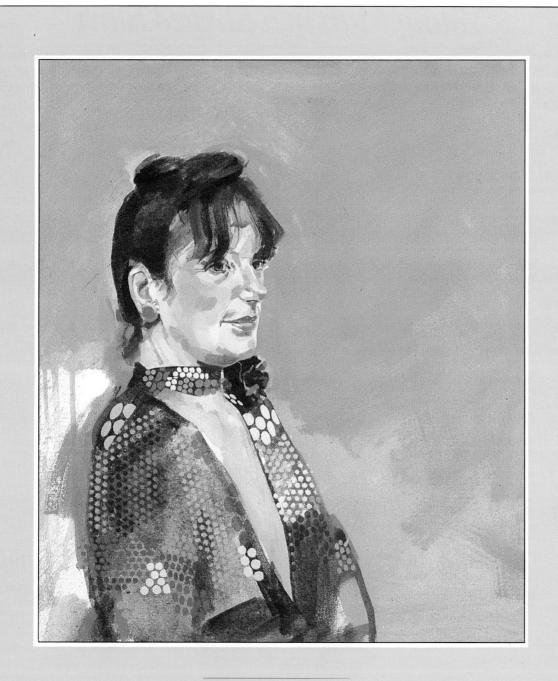

*Woman in a Dotted Dress*

# *Young Man in a Striped Shirt*

A young man sits in a pensive mood, in a setting which has few obvious features. Even the striped shirt is subdued and rather faint, and the figure is placed against a background of grayish white. So here is a case where the artist has in effect added to the subject, bringing out the interesting features of the man's face by building more character into the shirt and the background.

The artist drew some simple but accurate basic outlines in charcoal. Many portrait painters make the mistake of understating the features and facial expression, but this painter has moved in the other direction. She has slightly emphasized and strengthened the nose and the eyes of the face, but has achieved a likeness that reflects the personality of the subject, without turning it into a caricature.

The color is not literal. The artist worked from a slightly offbeat palette which reflected her personal style and included such colors as quinacridone violet, flesh pink and cerulean blue. She used a few areas of solid color in the background and one or two on the face, but in general the painting is composed mainly of line. These lines, constructed from bold brushstrokes, were used to suggest the form of the hair, facial structures and the clothing.

This is an artist who is very good at drawing. Not everyone can get away with such an unorthodox approach, but the underlying structure and draftsmanship here are basically so sound that the picture works beautifully.

**1** The pensive mood reflected in the expression of this young man is the artist's main concern here *right*. She succeeds in capturing it in a personal and intuitive way, without attempting to make a realistic image.

**2** *Top* Using charcoal and cerulean blue, the artist makes a rapid sketch of the subject. The background is indicated in black and white; flesh tones in yellow ocher and yellow.

**3** The drawing is developed in cadmium yellow and bright orange *above*. These vivid colors are used to describe the figure and develop the form.

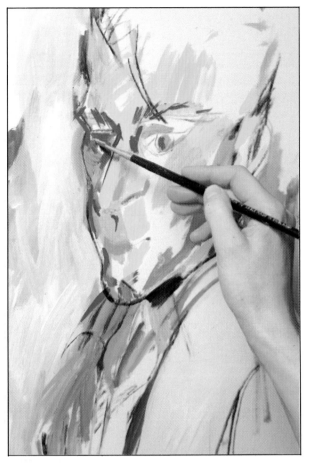

# OUTLINE AND UNDERDRAWING

The artist has deliberately chosen strong colors for the initial outline of the figure. This bright underpainting sets a theme for the rest of the painting, and the cerulean blue and cadmium red are echoed throughout the portrait, making it essential for the artist to maintain the pure colors and bold approach established by the drawing in the early stages.

**4** The background is toned with opaque white. *Left* The artist works into the face, developing the features and redefining the outline in cerulean blue. Confident drawing and constant checking for accuracy are crucial at this stage.

**5** Very light flesh color is applied around the eyes *left*. The colors are not those of the actual subject, but the realistic form and contours of the face are essential as a basis for the spontaneous and vivid colors that this artist uses. The drawing is therefore rigorously structured and convincing enough to carry the unusual color scheme.

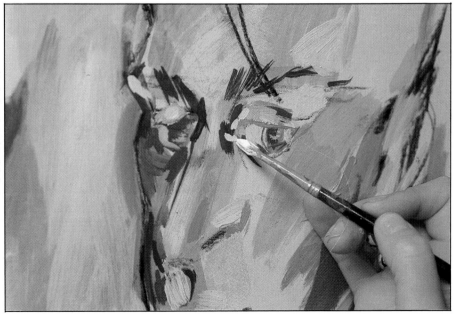

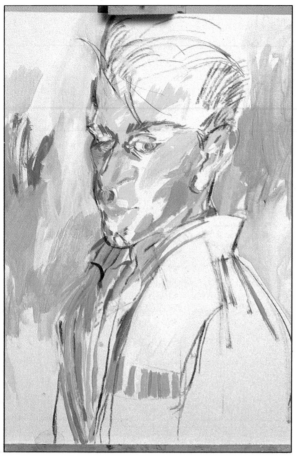

**6** The artist develops the background, *left,* working into the white with patches of yellow ocher, gray and blue. These tones are subdued versions of those used on the face and figure.

**7** The facial features are emphasized in strong linear terms with cerulean blue *below.* Again, touches of the same blue are integrated into the background tones.

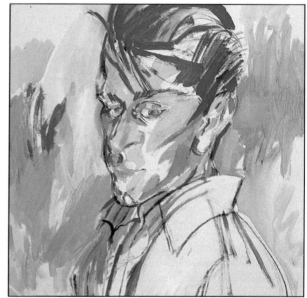

**8** A sable brush is used for the striped shirt *right.* The stripes are painted boldly in cadmium red, the direction of the stripes describing the form of the torso underneath. The artist exploits the dramatic combination of red and white to the full, exaggerating the pattern to enliven the lower half of the figure instead of allowing it to fade out of the picture.

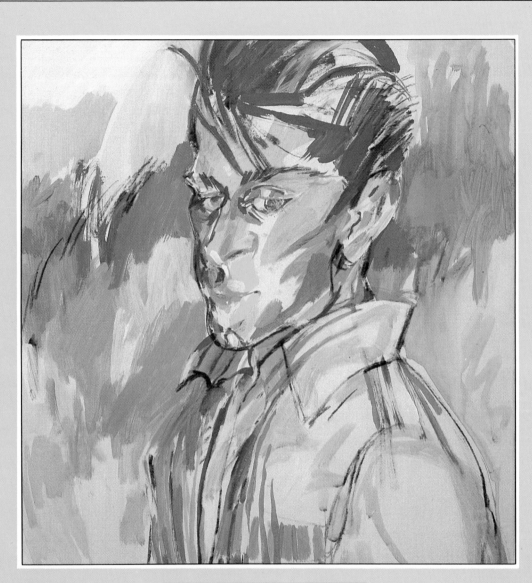

*Young Man in a Striped Shirt*

## What the artist used

A piece of hardboard measuring 24in × 20in was used for this colorful portrait. The artist glued fine muslin to the board because she wanted a surface which provided a 'key' for the paint, but which did not have the rather slippery quality of many bought and primed surfaces. The palette consisted of titanium white, cerulean blue, cadmium red, naphthol crimson, cadmium yellow, flesh pink, yellow ocher, quinacridone violet and burnt sienna. These were applied with flat bristle brushes, numbers 11 and 6; and sable brushes, number 4 and 6.

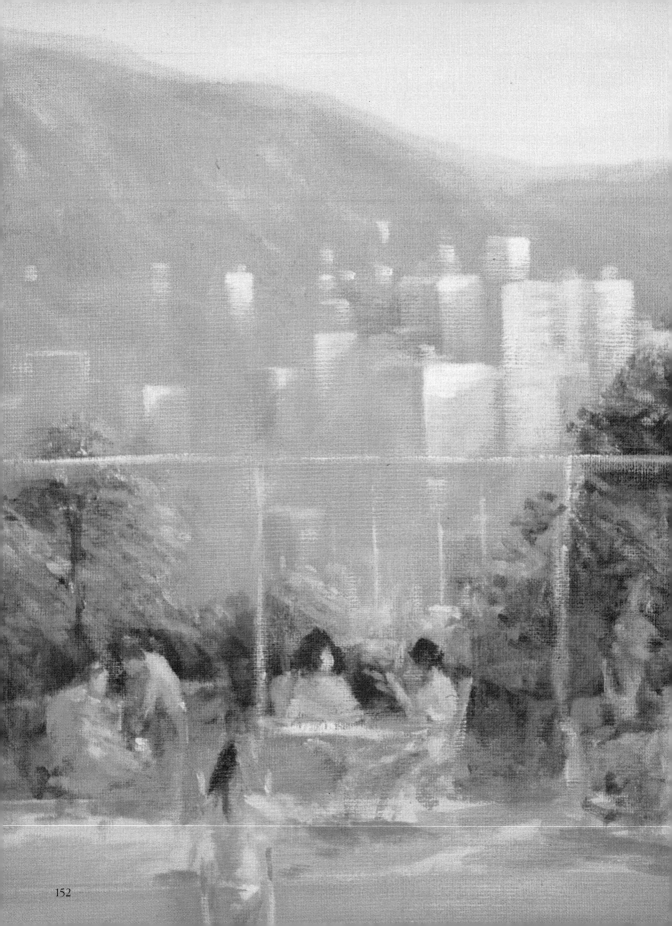

# CHAPTER ELEVEN
# COMPOSITION

Composition creates order out of the visual anarchy of everything we see around us. It is the way in which the artist takes a firm hold of the pictorial world and sets it into a particular context and arrangement. It can transform the painter into an active performer, rather than just being a passive recorder of visual data.

The word 'composition' needs to be defined carefully for the artist. It can mean at least two things. First, it can refer to the general placing of a subject on the canvas. For instance, you may be painting a simple object, and the apparently simple decision of how and where you position it is in fact the composition — the bringing together of many elements into one painting.

Another way in which composition comes into play is when the painter behaves in a manner similar to the photographer, exploring the seemingly endless vista that surrounds us, in order to find a self-contained picture containing all the criteria of a composition.

Very definite types of composition are found in this chapter and they relate specifically to acrylics. One is an abstract, using acrylic as it was first used in the 1950s, when abstract artists welcomed the new medium because it could be brushed directly onto untreated canvas to produce a 'stain' effect rather than a solid, opaque look. We asked the artist to use acrylic in as many experimental ways as possible for this composition. Another composition is more traditional — it is a figure composition using a lot of textures and glazes, and was completed within a day, something which was made possible by the advent of acrylics.

# Swimmers in Hong Kong

The artist, an untiring traveler, used camera shots of Hong Kong to compose this picture of figures in a modern landscape. This is not an accurate portrayal of an actual scene. Two different viewpoints have been brought together, with some other elements added, to make up an imaginary place.

The aim was to create a composition to capture the bustling holiday atmosphere of Hong Kong; a composition which, although non-existent in the real world, would faithfully echo the essence of the city and its waterside. It was a picture done essentially for pleasure — to begin with a basic landscape and then to people it with figures of one's choice, taking part in a variety of activities.

One interesting factor is that the picture looks highly realistic, but when viewed closely nothing is sharply defined. This applies especially to the figures. The artist has suggested movement by using a soft brushstroke to represent a plane of light across a person's back, or to indicate the whole of an arm or leg. This has been done so cleverly that it can deceive the viewer into thinking of it as a more finished product.

The artist used his photographs only as a reference point to begin with. They were then laid aside and he carried on, using his own imagination to fill in the remainder. The mountains, the trees and the water were painted first, and the buildings introduced afterward. The artist has not actually looked at the forms or shapes in the photographs; they have been used quite literally simply to remind him that a mountain, or skyscraper, or some such object, was present.

A formula has been used, very convincingly, to deal with each of the basic elements in the picture. Without looking at the trees in the photograph, the artist went ahead and painted the trees according to a formula obviously already very familiar to him. Using brushstrokes rather than painting in any realistic detail such as foliage, he built up the form of the trees with light and shade. They look totally like trees, so long as one does not view them too closely. The effect has succeeded.

The artist has created the effect of distance by mixing a lot of blue and white in the buildings and mountains, which has the effect of pushing them back to create more space between them and the foreground.

**1** Two different views of Hong Kong, *below*, provide the basis for this composition. The artist takes elements from each to create an imaginary landscape.

**2** The water is blocked in with phthalocyanine blue, and white. Hooker's green is added to these for the trees, and magenta for the hills, *right*.

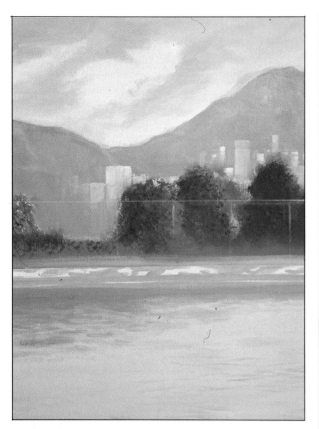

# USING BRUSHSTROKES TO SUGGEST FORM

**3** *Top* Brighter, opaque blue — phthalocyanine mixed with cobalt — is introduced into the sky area and the corresponding reflections in the water. The buildings are added in pale tones.

**4** Moving into the composition, the artist starts to suggest detail, *above*. This is done partly from the reference photographs and partly from imagination.

Many of the figures in this painting are too small and distant to be painted in detail. At the same time, the artist thought it important to make them as real and lifelike as possible. Here he is using simple, broad brushstrokes to simplify areas of tone and . Although the form lacks any detail — from close quarters the figure is merely blobs of paint — the  and tone are accurately observed, and the direction of the blurred brushstrokes carefully laid to suggest limbs and give a convincing impression of movement.

155

**5** A large brush is used for developing the tones of the trees and background *left*. The broad brushstrokes cause the painting to look out of focus when viewed from close quarters, but the image falls into place when seen from farther away.

**6** The skyscrapers are convincingly rendered in a similar way — in general terms with a large brush, *right*. The side of each block is represented by a single brushstroke. Colors are kept light and bluish to create visual space between the buildings and the stronger foreground colors.

**7** Each figure is painted with a few well-placed brushstrokes. Nothing is sharply defined, but the figures still look realistic and alive. The brisk strokes suggest movement, with the light and dark tones being used to create form on limbs and torsos *right*.

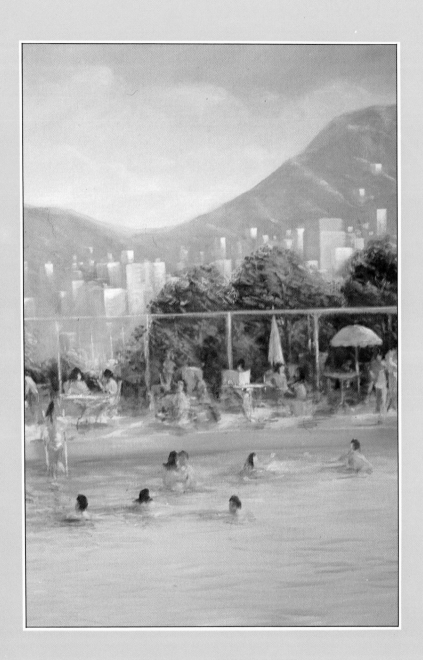

*Swimmers in Hong Kong*

## What the artist used

The support is bought canvas board measuring 36in × 25in and ready-primed for use with acrylics. A palette of Hooker's green, ivory black, phthalocyanine green, medium magenta, titanium white, cobalt blue, phthalocyanine blue and raw sienna was applied with bristle and synthetic brushes – round brushes, numbers 2 and 5; and flat brushes numbers 2, 4, 6 and 11.

# *Abstract Shapes*

The artist was asked to demonstrate some of the uses to which acrylic has been put since it first became popular. It seemed appropriate to use an abstract because acrylic, especially in its early days, was used mainly by abstract artists. One of the main differences between acrylics and traditional oil paints is that oil paints cannot be painted directly onto canvas without causing it to rot. The surfaces first have to be sized and primed, a procedure that also dictates to some extent the texture of the finished paint surface. When acrylic was introduced, artists realized that it could be used directly onto canvas without any detrimental effect. One of the first painters to take advantage of this was the American Morris Louis who diluted acrylic until it produced a transparent effect rather like colored inks or watercolor, and translated it into a larger scale by applying it to large canvas surfaces.

The picture here is totally abstract. Space is suggested by the use of graded wash, producing a floating effect which acts upon the eye with a sensation of depth, as if the colors and shapes are floating back into a dreamlike distance. The artist therefore is painting space and shape directly, rather than copying the objects of the real world, or using light and shade to imitate form such as roundness. For instance, in the center of the picture are four ellipses. They are in fact flat shapes. They have been given none of the familiar touches, such as highlights placed on a shape to suggest the three-dimensional, but because they have been painted with a certain solidness, and because their edges are hard and crisp in comparison with the nebulous background, they are not just parts of a pattern — they look like objects floating in space.

The artist used many basic techniques to achieve these effects. Masking tape was applied in order to obtain a definite edge on the ellipses. Texture paste, mixed with paint, then scraped with a plastic comb to produce a broken surface, helped to throw the ellipses forward into the picture plane. The artist used a painting knife to apply the solid opaque red foreground shapes.

**1** Before starting work on this painting, the artist first made a small pencil sketch *right.* The drawing is a loose arrangement of shapes to be used as a starting point for the larger painting.

**2** Masking tape is used, *top,* to delineate and protect the three main shapes before the background wash is applied. The tape must be pressed down firmly to prevent the paint from seeping underneath.

**3** Acrylic flow improver has been mixed with the blue background wash and applied directly to the unprimed cotton canvas with a large decorator's brush. The artist now adds dashes of black to the wet blue causing the two colors to merge *above.*

**4** More spontaneous splashes of color are applied across the wet background. When the paint is dry, the masking tape is peeled off to reveal the crisp shapes underneath *left*.

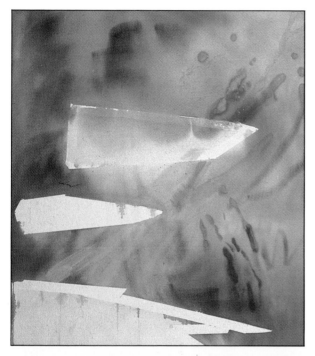

**5** Before painting the three floating shapes, the artist replaces the tape in order to retain their hard edges *above*. This time the tape is placed along the edge of the blue background. Again, splashes of color are worked into the thin paint.

**6** The artist now develops the opposite side of the work. Streaks of blue are painted across a red background in the right side of the painting. Because the washy red is already dry, the opaque blue streaks dry as definite shapes, floating in a misty, undefined space *left*.

7 Because the composition is composed of abstract shapes, there is no actual scale in the painting, nor are there any recognizable objects to indicate distance. Instead, the artist uses density of color to suggest space — solid colors, such as the yellow shape in the foreground, seem to jump forward; cool tones, as in the blue background, tend to recede *left*.

8 When all the colors are dry, the artist removes the masking tape *above*. The thin colors have seeped under the tape in places, but the general effect is one of crisp outlines. No attempt is made to correct or paint out these small runs and blots. Instead, the accidental marks are left to form part of the composition.

## MAKING TEXTURAL PATTERNS

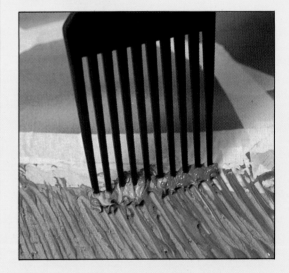

This painting relies heavily on a variety of textures and patterns to relieve the flat colors and abstract shapes. Here the artist is dragging a coarse comb across a thickly applied coat of paint and texture paste. When this ridged pattern is completely dry, the artist applies a second color, blotting this with newspaper to create a random, two-color pattern.

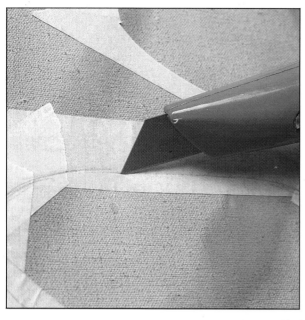

**9** To obtain the central floating 'saucers', the artist lays an area of overlapping strips of masking tape, using a sharp Stanley knife to cut away the oval shapes *left*. It is essential to use a sharp knife — a scalpel or razor blade can be used instead, but it must be sharp, otherwise the tape will tear and produce an indistinct edge.

**10** A painting knife is used to apply a thick layer of quinacridone violet, phthalocyanine blue and white *below*, which have been mixed with texture paste to obtain a thick, butterlike consistency. This layer is then ridged with an ordinary pocket comb while it is still wet. Various tools can be used to create textural patterns in acrylic paint, and many artists have techniques of their own.

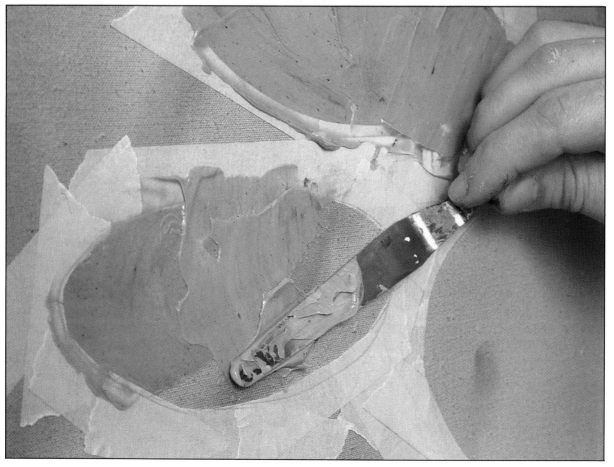

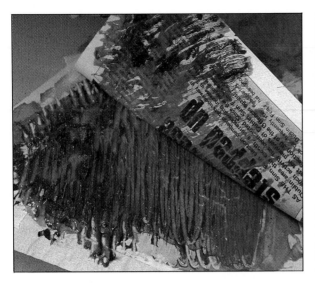

**11** Layers of color are painted over the textured area *above*. On this shape the artist uses cadmium red over a coat of red oxide and cobalt blue. This is blotted with newspaper to prevent the paint from obliterating the texture underneath.

**12** When the color is absolutely dry, the artist removes the tape to reveal the shapes *right*. The thickened color leaves raised edges, causing the shapes to stand out in slight relief from the flat surface.

**13** A small brush is used to define some of the uneven outlines *right*. This final touching up is kept to a minimum. It is only when a ragged edge becomes an unwelcome focus of attention that the artist removes the mistake. Generally, the whole idea of working on such a large scale is to avoid a precise finish, allowing unexpected effects to become part of the painting.

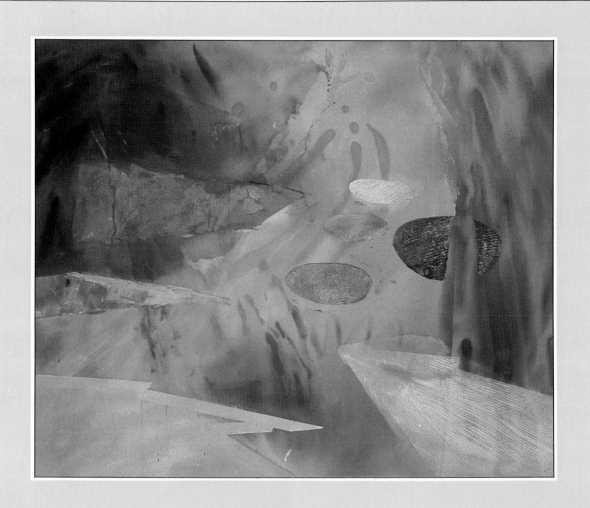

*Abstract Shapes*

## What the artist used

The artist made his own support, measuring 54in × 40in, by stretching cotton duck over a wooden stretcher. This was used unprimed. His palette consisted of phthalocyanine blue, Payne's gray, quinacridone violet, ivory black, cadmium red, cobalt blue, red oxide, cadmium yellow, titanium white, phthalocyanine green and medium magenta. The color was applied with a painting knife and bristle brushes, a number 10 flat and a number 8 round, and a decorator's brush. Other materials and pieces of equipment include masking tape, texture paste, flow improver, a plastic comb, newspaper, a Stanley knife, scissors and a hair dryer.

# *In the Artists' Studio*

There is a lot happening in this room where the three painters are working. Such a confusion of objects could have been a problem, but the artist has tackled this complicated mass of detail by developing only those elements which were most important to the composition. He concentrated initially on these principal shapes and the structure of the painting, ignoring superfluous and non-essential details.

The figures are looking into the picture toward the upright easel and rectangular painting, making this strong vertical shape a focal point of the composition. The viewer's eye is held comfortably within the area formed by the three figures, and the artist has taken care not to develop the edges of the picture or introduce any eye-catching shape or color outside this main group. Any discordant element in these peripheral areas could easily have become a distraction, leading the eye away from the main subject and destroying the harmony of the picture.

Although the picture is constructed as a conventional 'closed' composition — the idea of holding the viewer's attention within an invisible enclosed circle in the center of a painting, as the artist has done here, is a traditional technique — it is boldly constructed and the artist has made full use of the variety of shapes and linear divisions within the subject.

The artist covered the board with a warm tint before sketching in the outline of the composition. It was particularly important to get rid of the white ground because of the complexity of the subject — so much bright white showing through between the figures and studio furniture would have been too prominent and would have prevented the artist from establishing a general background tone and creating a sense of space in the painting.

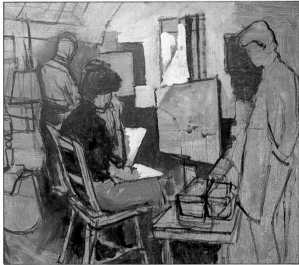

**1** A subject such as this, *right*, is too 'busy' for every detail to be included in a painting. In this composition the scene is seen in terms of the main shapes and colors, with much of the detail being left out.

**2** *Top*, the artist begins by covering the support with a warm tint mixed from red oxide and yellow ocher. After sketching the general shapes with charcoal, he then boldly outlines the composition in black.

**3** White, black, yellow ocher and cerulean blue are used for the initial blocking-in, *above*. The tinted support is used as a middle tone, and all subsequent colors are related to this.

**4** Working across the image, the artist continues to lay color *below*, allowing the orange base color to show through. Even in the finished picture, these warm patches are prominent, providing an overall harmonious theme.

# GLAZING WITH GEL MEDIUM

Here the artist is mixing a glaze from yellow ocher, a little Payne's gray and matte medium. The medium makes the glaze color more transparent, and this is applied over the warm background tint to create a shimmering, translucent patch of color which contrasts effectively with the opaque and dense areas in the painting.

*In the Artists' Studio*

## What the artist used

This composition was sketched in charcoal on a piece of primed hardboard measuring 30in × 24in. Colours used were ivory black, yellow ocher, raw sienna, red oxide, burnt sienna, ultramarine blue, cerulean blue, chrome green, vermilion, crimson and titanium white. These were applied with flat bristle brushes, numbers 11, 8, 7 and 4. The underdrawing was done with a number 6 sable brush, and the artist used matte medium for the glazes.

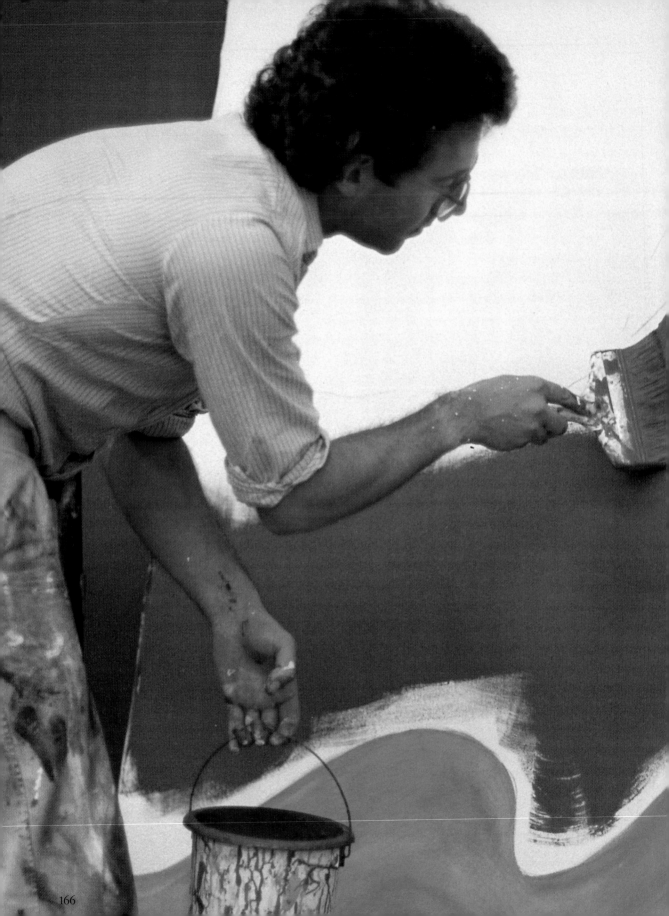

CHAPTER TWELVE

# MURALS

Painting walls is an art as ancient as building itself. Throughout history people have decorated both the interior and exterior walls of their buildings with colorful images — from the decorative friezes on the Greek Parthenon to the cheerful pictures that brighten our modern urban streets. The current popularity of mural painting owes much to the advent of acrylics, and when the muralists of Mexico City made their first experiments with the medium earlier in this century they paved the way for many hundreds of artists whose work can now be seen on the walls of schools, factories and houses in towns and cities all over the world. Nor is the current wall-painting fashion confined to the outsides of buildings. The traditional plain walls and patterned wallpapers hung with framed paintings and prints for decoration often give way to one huge wall-sized picture which is less fussy and has more visual impact.

Murals are direct descendants of the fresco paintings practiced in Italy since Roman times and still sometimes done today. But whereas fresco painting is extremely time-consuming and laborious — a painting had to be built section by section while the plaster was still wet — acrylic colors are almost instantaneous.

Like acrylic, true fresco painting was extremely durable, but the wall preparation was arduous and three different layers of plaster were necessary before the color could be applied. Any of this final layer which had not been painted by the end of the day was chipped away, leaving the areas ready for a fresh layer of plaster to be applied before the next painting session. With acrylic paints large areas can be covered at a time, and subsequent layers and details are then painted on top of this at any time during the execution.

# Unwrapping a Giant Present

Mural artist Lincoln Seligman was commissioned by a New York store to paint a display for their windows. They wanted a series of three murals, each one to be on show in their smart Manhattan store for a few weeks before being replaced. The approved designs showed a parcel being opened, the contents − items from the store − revealed gradually during the three display sequences. It was necessary to keep the design as simple as possible because the mural was prominently displayed and on view from Fifth Avenue, so the image had to be strong and clear enough to be recognizable from a distance. At the same time, pedestrians could see the mural from close quarters, making a perfect finish absolutely essential. It was also necessary to have a design which was tasteful enough to reflect the image of the store but was also eye-catching enough to be effective.

Seven panels were needed for each sequence, to be fitted inside the store's seven windows, each panel measuring 10ft × 8ft. Because the work was done in London and flown to the United States, the artist decided to work on stretched canvas, enabling the finished panels to be taken off their stretchers and rolled up for the journey.

Such large panels called for an unusually large working space, especially as the canvases had to be painted side by side to insure continuity of image and color. Eventually Lincoln rented an unused garage, and found someone to help with some of the painting. They had exactly one month to complete the job − 21 panels in all.

The stretchers were made in a day from unfinished softwood, 3in × 3in. These were nailed firmly together at the corners, with cross-supports to prevent warping (the quick-drying paint inevitably tautens the canvas).

Heavy cotton duck was then stretched across the frames and fixed at the sides with an industrial stapler. This whole procedure was completed quickly and efficiently in separate stages − canvas cutting, stretching and stapling − in a manner more reminiscent of a factory production line than of an artist's studio. By the end of the day the panels were ready for priming.

Following this they were dry enough to work on the next day.

Working from the drawings, the artist used charcoal to sketch the outline of the first sequence. In this case he worked without making a grid, relying on his own judgment and standing back from the work frequently to assess the scale. There is always a tendency to reproduce the image too small in relation to the overall shape when making a freehand enlargement in this way, and special care was taken to avoid this. The scale of the canvases did not really warrant an elaborate scaffold, and the artist and his assistant used a sturdy plank and trestle to reach the top of the panels.

One of the problems of working in an industrial space was keeping the dust and dirt away from any part of the canvas. The smallest particle is easily picked up on the brush and can spoil an area of flat color; sheets of heavy-duty polyethylene were therefore laid under the panels and around the working area.

Because the panels were for display behind glass, and would not be exposed to the weather, it was possible to use interior emulsion for the large areas of color. Both the purple background and green ribbon were painted initially in flat areas with household emulsion. Here the artist took a slight risk, because ordinary emulsion is designed to be used on a rigid surface, such as a wall, and is generally less flexible than acrylics. However, he first tested an area of emulsion on canvas to make sure the paint did not peel or crack when it was rolled. He also carried out tests to insure that the acrylic paint would adhere to the surface of this particular brand of emulsion.

Two coats of green and purple were needed to get a good finish, and these were painted with a large, decorator's brush; highlights, shadows and details were added in acrylic when the base colors dried. Throughout the painting, the artist stood back from the mural continually, always aware of the fact that the image must read from a distance as well as close-up.

As each of the series of seven panels was completed they were carefully removed from the stretchers and stacked, the painted surfaces placed together, ready to be rolled up and crated to their final destination in New York.

**1** Three gouache sketches which the artist submitted to the client were used as working drawings for the mural. These were referred to constantly as the work progressed.

**2** Seven stretchers for the first set were laid out on the floor, and pieces of heavy duty cotton duck cut to fit. A few inches of overlap were allowed at each end to enable the fabric to be stapled to the side of the stretcher at six inch intervals *left*.

**3** *Below* Each frame is given two coats of white emulsion primer. When this is dry the artist starts to block in the main color areas using a decorator's large brush and household water-based paint.

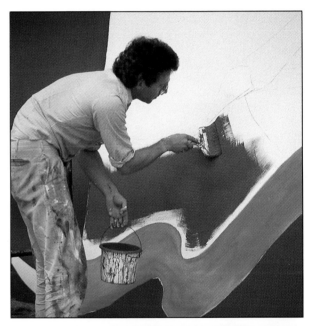

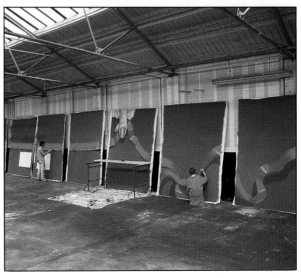

**4** A smaller brush is used to define the edges *above*. The large areas of purple and green need two coats to insure a completely flat finish.

**5** All seven panels are developed simultaneously to make sure the color and drawing are consistent from panel to panel. Details are painted in artist's acrylic color *right*.

**6** The three sequences of paintings depict a parcel being opened. Here, in the second set, the ribbon is untied and the wrapping paper torn open *below*. The image is simple and dramatic enough to be seen and 'read' from a distance, yet the finish of the work is good enough to stand close inspection.

*Unwrapping a Giant Present*

**7** In the third and final set the contents of the parcel are revealed *above*. The jewelry is painted on a grand scale, the watch face measuring over three feet across. The finishing touches and details are especially important here, because the objects are all recognizable items sold in the store.

# Glossary

ABSTRACT EXPRESSIONISM A school of painting based on the expression of the subconscious.

ACRYLIC A comparatively new paint in which pigment is suspended in a synthetic resin. It is quick-drying, permanent and colorfast.

ACRYLIC GESSO An acrylic primer which gives a bright white surface for painting on. Nothing to do with real gesso.

ALKYDS A type of acrylic paint which is soluble in turpentine instead of water.

ALLA PRIMA Direct painting in which the picture is completed in one session without any underpainting or underdrawing.

BLEEDING The effect created by wet color that runs. Sometimes used deliberately for its marbled appearance.

BLENDING Merging colors together in such a way that the joins are imperceptible.

BLOCKING IN The initial stage of a painting when the main forms and composition are laid down in approximate areas of color and tone.

CHIAROSCURO The use of light and shadow to create form in a painting.

CLASSIC METHOD A painting technique which involves making a monochrome underpainting before adding color.

COMPOSITION Arranging and combining different elements to make a picture.

COVERING The covering power of a paint refers to its opacity.

CROSS-HATCHING A method of building up areas of shadow with layers of crisscross lines rather than with solid tone.

FIXATIVE Thin varnish which is sprayed on drawing media, especially charcoal and pastel, to prevent smudging and to protect the surface.

FLOW IMPROVER A product that can be added to acrylic color to make the paint easier to spread. Usually used on large areas only.

FRESCO A wall-painting technique usually done with watercolor on damp plaster.

GLAZING Using a transparent film of color over another pigment.

GOLDEN SECTION A geometric proportion used by artists since classical times, and thought to produce the most harmonious composition.

GOUACHE An opaque watercolor similar to poster paint.

GRAPHITE A carbon which is used with clay in the manufacture of lead pencils.

HATCHING A shading technique which uses parallel lines instead of solid tone.

IMPASTO The thick application of paint or pastel to the picture surface in order to create texture.

IMPRESSIONISM A painting style founded in France during the late nineteenth century which aimed at a naturalistic approach by depicting the atmospheric effect of light using broken color.

LOCAL COLOUR The actual color of the surface of an object without modification by light, shade or distance.

MASKING The principle of blocking out areas of a painting to retain the color of the support. This is usually done with tape or masking fluid, and leaves the artist free to paint over the masked areas. The masks are removed when the paint is dry to reveal the areas underneath.

MEDIUM In a general sense a medium is the type of material used, such as acrylic or charcoal. More specifically, a medium is a substance mixed with paint or pigment for a particular purpose or to obtain a certain effect.

MONOCHROME A painting done in black and white and one other color.

NEGATIVE SPACE Drawing or painting the space around the object rather than the object itself.

'OP' ART Sometimes called 'Optical' art, this style of painting creates particular visual effects with optical illusions, usually with the use of flat color and hard edges.

OPACITY The ability of a pigment to cover and obscure the surface or color to which it is applied.

OPTICAL MIXING Mixing color in the painting rather than on the palette. For example, using dabs of red and yellow to give the illusion of orange rather than applying a pre-mixed orange.

PAINTERLY The use of color and light to create form rather than relying on outline.

PALETTE This term describes both the flat surface used by the artist to mix colors on and the color selection used by the artist.

PHOTOREALISM An ultra-realistic school of art, so called because the paintings often looked like photographs. The term is particularly associated with American art in the 1960s.

PIGMENT The coloring substance in paints and other artists' materials.

PLANES The surface areas of the subject which can be seen in terms of light and shade.

POP ART An art form that uses images and artifacts from mass media and advertising and other ephemera of contemporary, urban life.

PRIMARY COLORS In painting these are red, blue and yellow. They cannot be obtained from any other colors.

PVA PAINTS Colors mixed with polyvinyl acetate resin. These paints are cheaper than acrylics but share many of their advantages, such as their quick-drying and adhesive properties.

REALISM Art which takes its subject matter from everyday life.

RENAISSANCE The cultural revival of classical ideals which took place in Europe from the fourteenth to the sixteenth century.

RENDER To draw or reproduce an image.

RETARDER A transparent medium used to slow down the drying time of paints.

SEPIA A brown pigment traditionally made from the ink of cuttlefish.

'STAYWET' PALETTE A special palette, designed for use with acrylic paint, which keeps the paint moist for several hours. The plastic palette contains a layer of absorbent paper covered with a sheet of membrane. The paint absorbs moisture from the dampened paper through the membrane.

STENCIL A piece of cardboard or other material out of which patterns have been cut. The pattern or motif is made by painting a surface through the hole.

STILL LIFE A picture of mainly inanimate objects. The subject did not really exist in its own right until the seventeenth century.

STAINING Using diluted color directly on unprimed canvas or cotton.

STIPPLE A method of painting, drawing or engraving using dots instead of lines. A special brush is used for stippling paint.

SUPPORT A surface for painting on, usually canvas, board or paper.

UNDERDRAWING The preliminary drawing for a painting, often done in pencil, charcoal or paint.

UNDERPAINTING The preliminary blocking-in of the basic colors, the structure of a painting, and its tonal values.

VINYL PAINTS Cheap, plastic-based paints, marketed in large quantities and made specially for use on large areas.

WASH An application of thin color, diluted to make it spread transparently and thinly.

WET INTO WET The application of watercolor to a surface which is still wet, to create a subtle blending of color.

WET INTO DRY The application of watercolor to a completely dry surface causing the sharp, overlapping shapes to create the impression of structured form.

# *Index*

174

# *Credits*

QED would like to thank all those who have helped in the preparation of this book. We would like to thank all the artists, with special thanks to Ian Sidaway for expert advice and the use of his studio, to Rowneys, and to all the staff of Langford and Hill Ltd for their patience and generosity in lending materials and items of equipment.

Contributing artists
pp *28, 76, 78-81, 104-7, 108, 118-21, 122-5, 164-5* Gordon Bennett; pp *86-89, 158-63* James Nairne; pp *82-85, 90-93, 152, 154-7, 168-71* Lincoln Seligman; pp *94, 96-9, 100-3, 110-3, 114-7, 126-9, 130-3, 134, 136-9, 144-7* Ian Sidaway; pp *29, 54, 56-9, 64-7, 68-70, 71-73* Stan Smith; pp *60-3, 74-5, 140-3, 148-51* Rosie Waites.

Other illustrations
pp *6, 8, 9* John Wyand; pp *10* Daler-Rowney; pp *12* Private Collection, London; pp *13* © DACS 1985; pp *14* Tate Gallery, London; pp *15* © DACS 1985; pp *16, 18-19, 22, 24-5, 38* David Burch; pp *49* Alastair Campbell; pp *50* Mick Hill; pp *51* Gordon Bennett; pp *46, 52-3* Stan Smith.